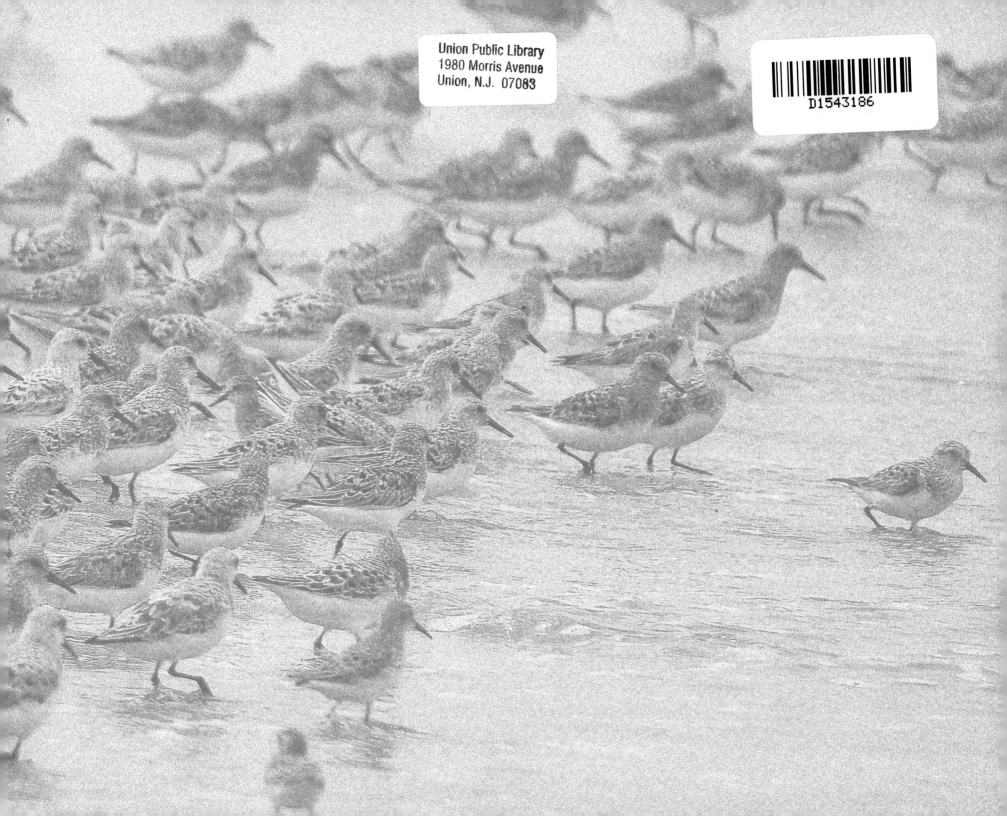

Union Public Library
1980 Morris Avenue
Union, N.J. 07083

D1543186

New Jersey Birds and Beyond

Susan Puder

Union Public Library
1980 Morris Avenue
Union, N.J. 07083

Schiffer
Publishing Ltd

4880 Lower Valley Road Atglen, Pennsylvania 19310

Printed in China

Dedication

In loving memory of my dear friends
Sheila Mars Trimmer and Martha Dimit.

Copyright © 2012 by Susan Puder

Library of Congress Control Number: 2011945133

All rights reserved. No part of this work may be reproduced or used in any form or by any means—graphic, electronic, or mechanical, including photocopying or information storage and retrieval systems—without written permission from the publisher.

The scanning, uploading and distribution of this book or any part thereof via the Internet or via any other means without the permission of the publisher is illegal and punishable by law. Please purchase only authorized editions and do not participate in or encourage the electronic piracy of copyrighted materials.

"Schiffer," "Schiffer Publishing Ltd. & Design," and the "Design of pen and inkwell" are registered trademarks of Schiffer Publishing Ltd.

Cover and book designed by Bruce Waters
Type set in Zurich BT

ISBN: 978-0-7643-4021-5
Printed in China

Photographs and text by author unless otherwise noted

Schiffer Books are available at special discounts for bulk purchases for sales promotions or premiums. Special editions, including personalized covers, corporate imprints, and excerpts can be created in large quantities for special needs. For more information contact the publisher:

Published by Schiffer Publishing Ltd.
4880 Lower Valley Road
Atglen, PA 19310
Phone: (610) 593-1777; Fax: (610) 593-2002
E-mail: Info@schifferbooks.com

For the largest selection of fine reference books on this and related subjects, please visit our website at **www.schifferbooks.com**
We are always looking for people to write books on new and related subjects. If you have an idea for a book, please contact us at proposals@schifferbooks.com

This book may be purchased from the publisher.
Include $5.00 for shipping.
Please try your bookstore first.
You may write for a free catalog.

In Europe, Schiffer books are distributed by
Bushwood Books
6 Marksbury Ave.
Kew Gardens
Surrey TW9 4JF England
Phone: 44 (0) 20 8392 8585; Fax: 44 (0) 20 8392 9876
E-mail: info@bushwoodbooks.co.uk
Website: www.bushwoodbooks.co.uk

Acknowledgments

My grateful thanks to all those dedicated birders who have helped me along the way, including Tony Geiger, Becky Hedden, Fred Lesser, and Nancy Lynch. Thanks to Patricia Konover, Nancy Ori, Ted Osborn, David and Carol Yorkanis, Bob Birdsall, Terri Loy and the Woodford Cedar Run Wildlife Refuge, Carson, Captain Bob Lubberman, The Raptor Trust, Kathie Boyd, Nancy Gallagher, my neighbors and friends who granted me access to their backyard feeders, Tina Goffred and Damean Searle. My thanks to Dr. Howard Eskin for the use of several of his bird photographs of those species I have seen but not photographed. Warm thanks and much appreciation to Linda Gangi for all the invaluable help she provided. My gratitude to my editor, Dinah Roseberry, and to Schiffer Publishing, Ltd. for providing me with the wonderful opportunity to publish my first book. And finally, thanks to my Mom for all her help and support over the years.

Contents

Foreword

Using a keen eye and wry wit, the author, through her photographic images, provides an intimate look at the resident and visiting bird species that inhabit the shores, fields, and forests of the most unlikely of state: New Jersey.

The state's geographic position along with its vast treasure of natural resources combine to provide a haven for birds, mammals, amphibians, and reptiles, thus providing ample viewing opportunities for photographers and nature lovers.

Each photograph in this book is a testament to the beauty of the individual species; but collectively, they tell a story of survival and adaptation and speak to the astounding diversity of wildlife and habitat that New Jersey has to offer.

Our state is recognized around the world for its birding opportunities. Positioned along the Atlantic Flyway, an important avian migration route, people flock here all seasons to revel in the variety of birding opportunities, and I am confident that after you have absorbed this photographic tribute, you will do the same.

~Linda Gangi,
Manahawkin, NEW JERSEY
Master Naturalist

Introduction

Even though New Jersey is one of the smallest states in the United States, it has over 1.1 million birders, according to the U.S. Fish and Wildlife Service. New Jersey is located along the Atlantic Flyway, and thus affords a great variety of species at different times of the year. Over 435 species of birds have been recorded in New Jersey, and some day, I hope to see and photograph them all.

Birds are fascinating creatures and can be readily seen by everyone. You can just look out the window of your home or office to see birds in flight. They come in various shapes, colors, and sizes. Just tell a child that they are living dinosaurs, and you will have hooked them for life. Some birds migrate thousands of miles from South America to breed in the Arctic, while others are year-round residents choosing to nest in the trees around your home.

There are over 44 million birders in the United States, making bird watching the second fastest growing outdoor activity in the country. You may be considered a birder if you take a ride further than one mile from home to observe birds or try to identify birds in your backyard. Some birders keep life lists of every species they have seen, while others are just happy to see a beautiful male Northern Cardinal, gloriously red, sitting outside their window.

The rich variety of habitats in the state range from the Kittatinny Ridge to the mountains of the Highlands, to the Meadowlands' marshes that seemingly merge with the Manhattan skyline, to the grasslands of the Piedmont Plateau, to the Pine Barrens Preserve and coastal plains. It all culminates at the southern tip of the state, with a peninsula that acts as a funnel for migrating birds, making Cape May and the surrounding area one of the best birding locations in the world. New Jersey also provides habitat for a variety of other animals, with an array of rare flowering plants in the Pine Barrens.

Having a bird feeder is one of the best ways to attract birds to your yard. If you have trees that offer protection, various types of seeds, and a clean water source, you may be visited by dozens of different species of birds, and be able to observe their behavior. Feeding preferences demand different seed blends, and your local bird store is the best place to find what will work best in your area. Suet provides food for a variety of woodpeckers; attracting birds that will be more than happy to drum you awake in the morning. The best way to see hummingbirds is to have a feeder, and having one that can be attached to a window will provide a whole summer of entertainment. Clean water provides not only a drinking source, but allows the birds to preen and bathe.

A variety of birdhouses are available that can be installed in your backyard, providing a safe haven for the birds and many hours of bird watching for you. Various small birds will be drawn to your birdhouse; chickadees, titmice, and even perhaps bluebirds will stay to raise their young. Different species require different size houses, and your local bird store can help you decide what birds you will be able to attract.

New Jersey is the most densely populated state in the country. This exerts enormous pressure on its wild lands. Threats to birds include loss of habitat, pollution and pesticides, office buildings with large windows, automobiles, wind turbines, hunting using lead bullets, and most of all, outdoor cats.

I have been interested in birding for only about a decade, but after moving to the Jersey Shore in 2004, that interest has exploded and as a result, I founded the Southern Ocean Birding Group in 2008. As a nature and landscape photographer, I find taking photographs of birds provides a great test of my abilities and patience. Whether perched on a tree branch, flying across the sky, or running along the beach, birds present many more challenges than stationary landscapes, both with composition and exposure. To be able to combine my twin passions of photography and birding makes me a very lucky person.

As a shore resident, I have better access to our shore and ocean birds than those found in woodlands or grasslands. Thus, the majority of birds contained in this book are ones found within fifty miles of my home. I must add that many birds seen in New Jersey can also be found in Florida, and some photographs were taken in the Sunshine State; and there are some photographs of captive animals. This book is not meant to be a comprehensive collection of all birds documented in New Jersey, but a good overall selection of ones that I have sought out. If you are the casual birder or someone who is visiting from out of state to watch our birds, I hope that these photographs will give you and your family a sense of the great diversity in habitats and species that can been found in New Jersey all year round.

~Susan Puder

Along the Shore

New Jersey has 127 miles of Atlantic coastline and is bordered on the west by the Delaware River and Bay, which provides habitat for thousands of birds all during the year. The resulting salt marshes, wetlands, beaches, and estuaries provide habitat for a large variety of birds that nest or pass through our coastal waters during migration season.

Edwin B. Forsythe National Wildlife Refuge, Atlantic County.

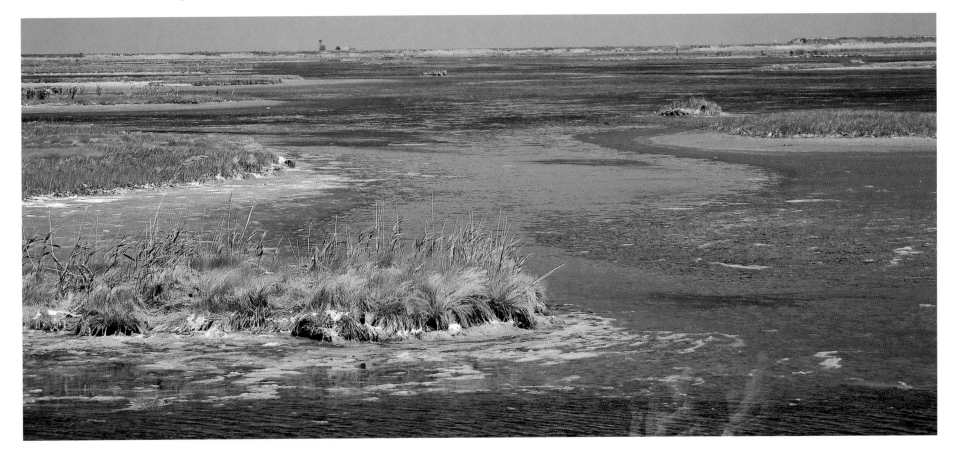

Many may think that in winter all the birds have flown south, but it is a great time to get out and look for migrants from the north; such as sea ducks, loons, grebes, and uncommon gulls. During the spring, one of the greatest migration events occurs with the arrival of Red Knots and other shorebirds along the Delaware Bayshore area in Cape May and Cumberland counties. In the summer, most birds are nesting and raising young, but later, August brings on the fall migration.

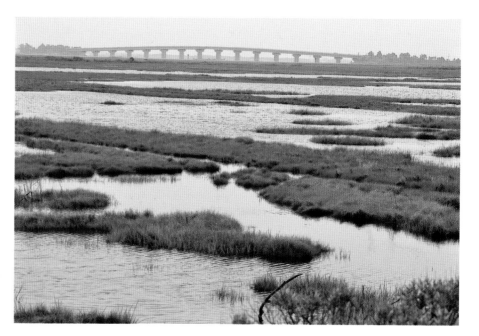

Manahawkin Wildlife Management Area, Ocean County.

Island Beach State Park, Ocean County.

There are many places along our coastal areas to enjoy the best bird watching in the state, depending upon the season, including Sandy Hook (part of the Gateway National Recreation Area), the North Shore in Monmouth County, Island Beach State Park, Barnegat Lighthouse State Park, the Edwin B. Forsythe National Wildlife Refuge (Brigantine, also known as Brig), Stone Harbor, Cape May, and the Delaware Bayshore areas. Not only are these areas abundant in birds, but many species of butterflies and dragonflies are also found during the summer months.

The threats to these areas are many, foremost being the desire of people to live at the beach. As President John F. Kennedy eloquently said,

We are tied to the ocean. And when we go back to the sea, whether it is to sail or to watch—we are going back from whence we came.

In the last decade, the density of people living in Monmouth and Ocean counties has greatly increased, with the other southern counties not far behind. Overdevelopment along the coasts is one of the greatest pressures to the natural habitats that birds and other wildlife require to survive.

Rea Farm "The Beanery," Cape May County.

Our wild barrier islands and inland salt marshes suffer from erosion and sea level rise, resulting in the loss of habitat and the destruction of nesting environments necessary for many of our coastal birds. Global climate change affects all areas of New Jersey, but not more so than along the shore. A late nor'easter or early hurricane can decimate the nests of Piping Plovers, Least Terns, Black Skimmers, American Oystercatchers, and other shorebirds. Dozens of species that migrate through New Jersey heading up to the Arctic and Alaska to breed during the summer months also face threats from climate change and energy development.

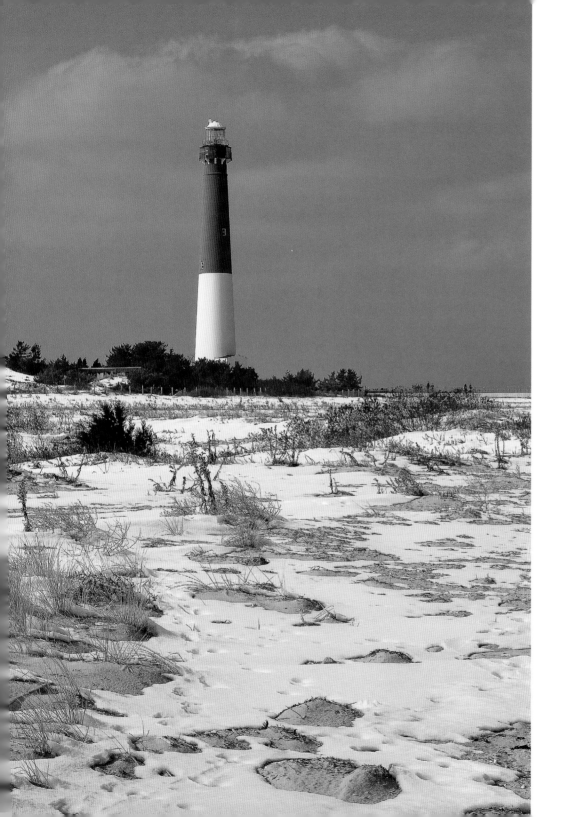

Winter Birds

Barnegat Lighthouse State Park, Ocean County

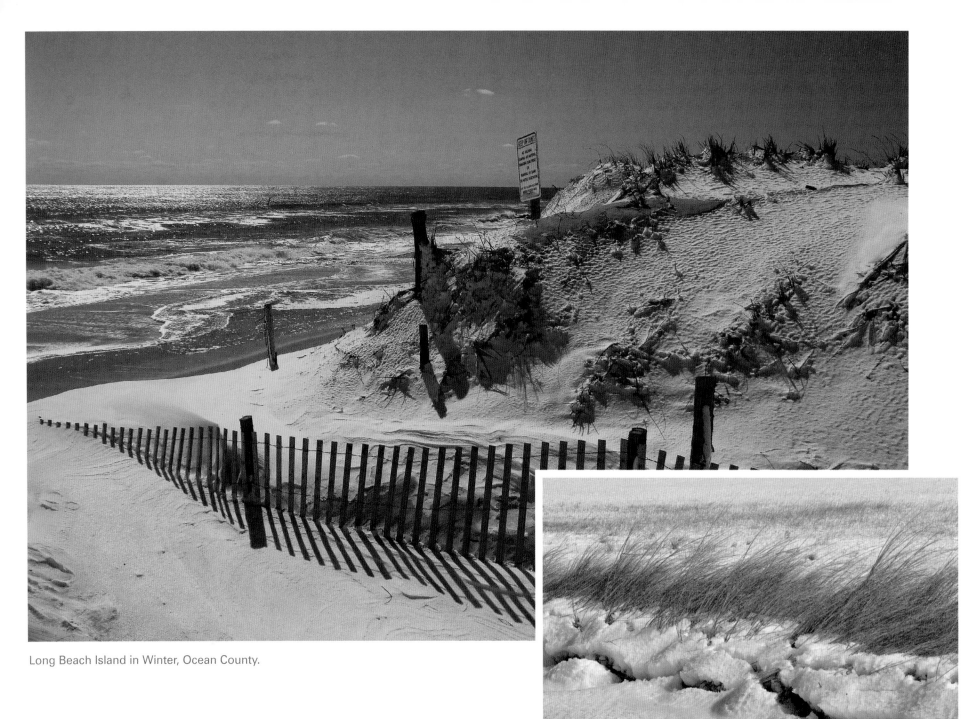

Long Beach Island in Winter, Ocean County.

Coastal Marshes in Winter.

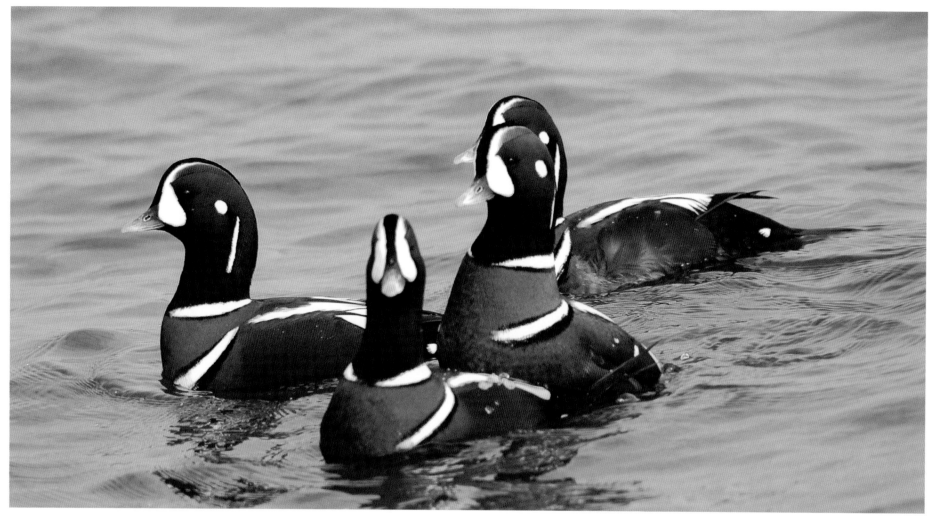

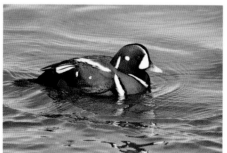 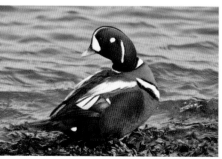 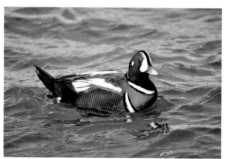 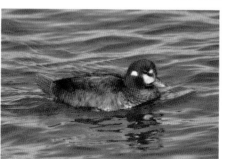

A small diving sea duck, the Harlequin drake has beautiful coloration of bluish slate and cinnamon, while the female is considered rather drab. Why is that so common in nature but not so much with humans? Though these agile birds nest and breed in northern New England and eastern Canada, they migrate south for the winter, and can be easily found from late November to mid-April at Barnegat Inlet on Long Beach Island.

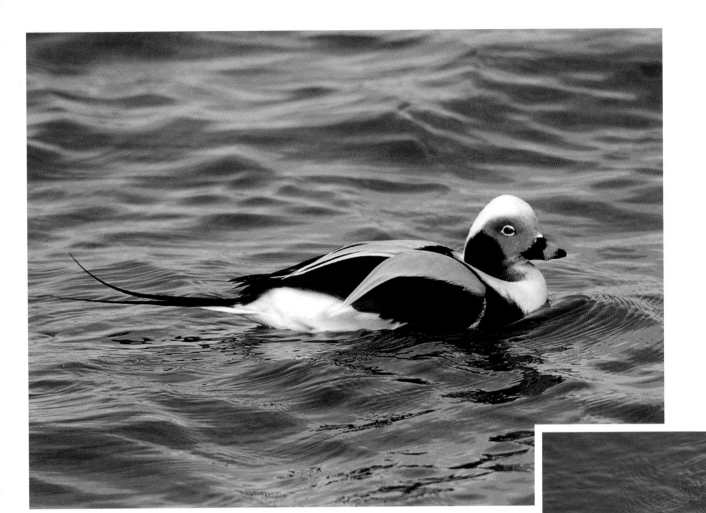

The Long-tailed Duck is a sea duck with a heavier body than the Harlequin, and was formerly known as the "Oldsquaw." Occasionally, names of species change, probably to force birders to buy new field guides. However, in this instance, the new name is very applicable as the drake has this beautiful long tail. These ducks nest in the tundra, and winter in groups all along the Jersey coast.

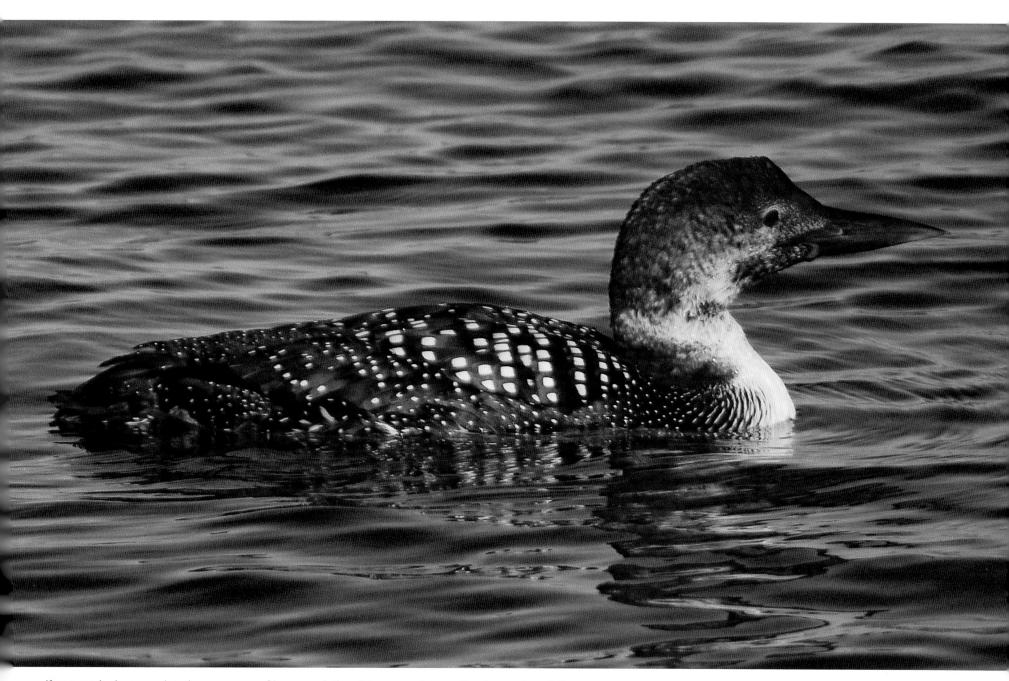

If you are lucky enough to hear a group of loons yodeling, it is a sound you will not soon forget. Common Loons winter along the New Jersey coastal water, and unfortunately for us, do not usually have their breeding plumage while here. But if some stay until April, their plumage may have almost changed. These species of loons breed in the northern lakes of North America, and return to our waters around December.

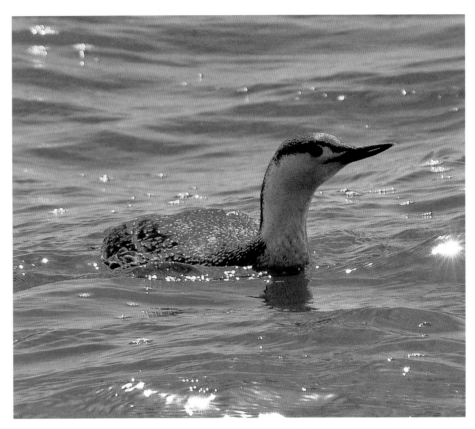

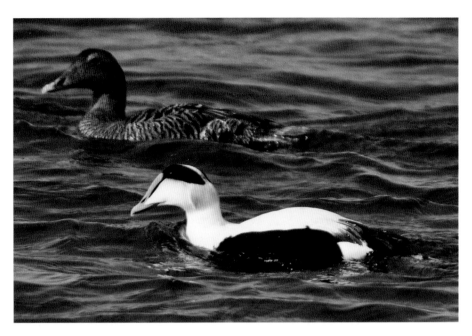

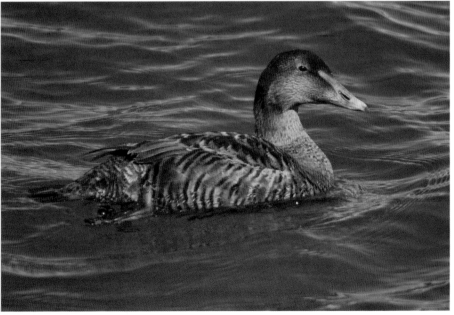

Smaller and more delicate than the Common Loon, the Red-throated Loon will form large flocks off Cape May before heading north to the Arctic to breed. Rarely seen here in their beautiful breeding plumage, Red-throated Loons can be distinguished from Commons by a white neck and a thinner upturned bill.

A visitor from the tundra during the winter, the Common Eider is a large stocky diving sea duck that can be easily found at Barnegat Inlet. In the case of the Common Eider, the female has rust or gray feathers, while mature drakes have prominent white and black plumage.

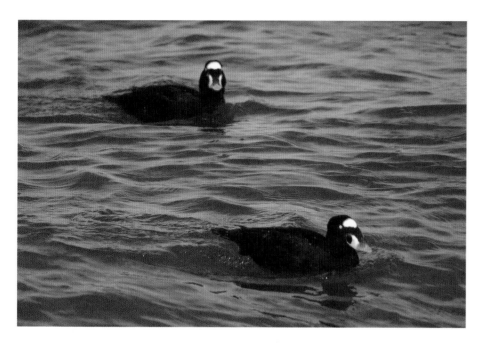

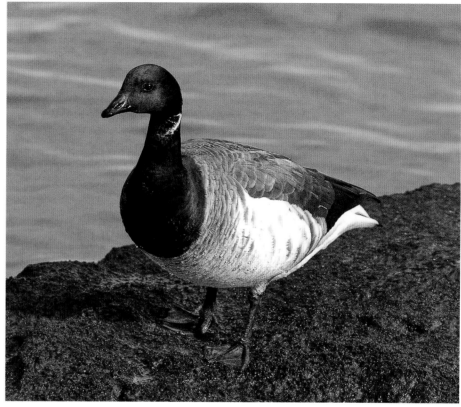

Also known as the Sea Goose, the Atlantic Brant can easily be seen along our shorelines and estuaries during the winter. During the early 2000s, the population of Brant at the Edwin B. Forsythe NWR had large die-offs due to an unknown cause. These small geese breed in the eastern Canadian arctic tundra, and most spend their winters along the New York and New Jersey coasts.

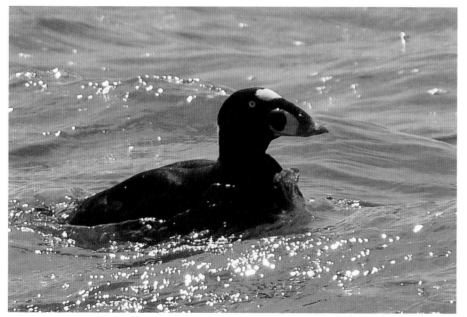

Common around Barnegat Inlet and other ocean areas in the winter, the Surf Scoter is a chunky diving sea duck. They breed during the summer up in the tundra, and head south afterwards.

The smallest of the scoters, the Black Scoter is another winter resident along the coast. Usually flocks can be seen flying along the coast from Sandy Hook to Cape May.

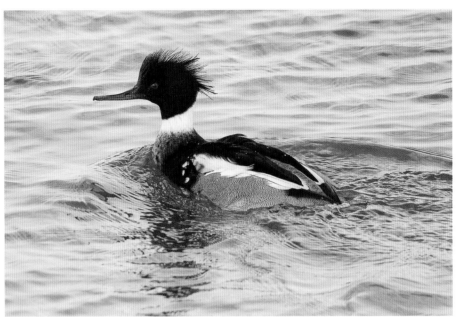

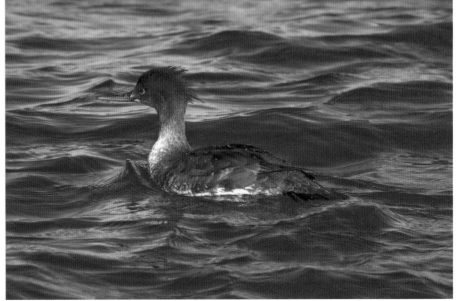

Red-breasted Merganser is a common winter resident along the coastal inlets and estuaries of New Jersey. The drake's dark green or female's rusty head has the look of a bad hair day. Both sexes of these diving ducks sport a jaunty bright orange bill.

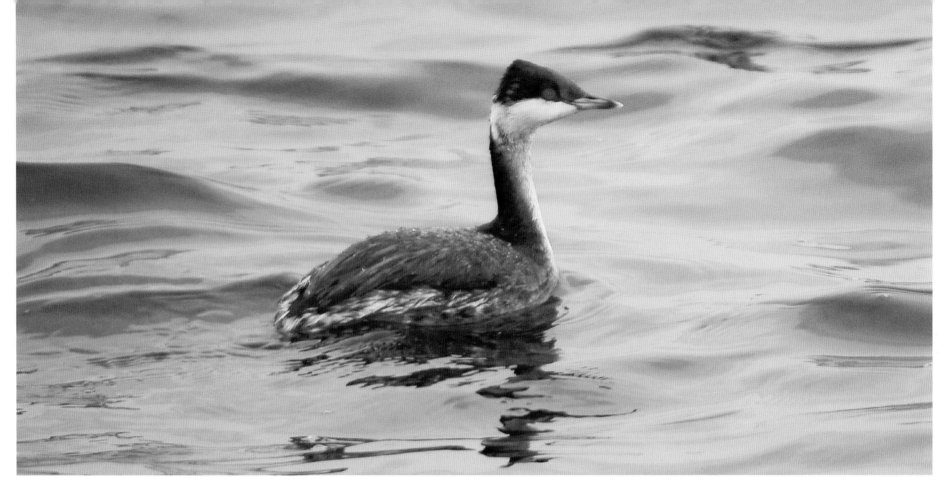

A winter resident from Canada where it breeds, the Horned Grebe can be found on our coastal bays and estuaries. One of several species of grebe found in New Jersey, the Horned Grebe is not usually here in its beautiful breeding plumage.

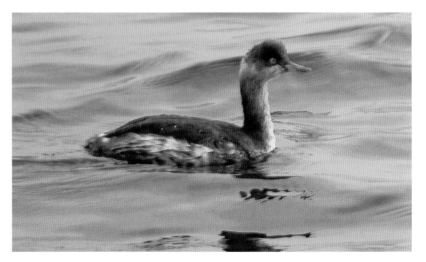

A very rare visitor to New Jersey, an Eared Grebe was spotted swimming along the Barnegat Dock several years ago. The Eared Grebe is slightly smaller than the Horned Grebe, but both share short, pointy bills.

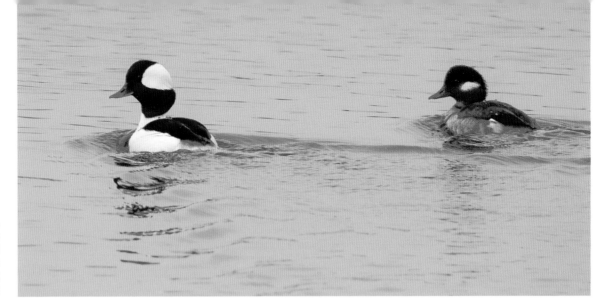

A small diving duck that winters along our coastal bays, ponds, and lakes, the Bufflehead male is distinguished by the large white patch on the back of the head with a white and black body. Of course, the female is duller with only a white cheek patch. These sleek ducks are easy to find in Barnegat Bay and the North Shore ponds, and in the spring they head up north to Canada and Alaska to breed.

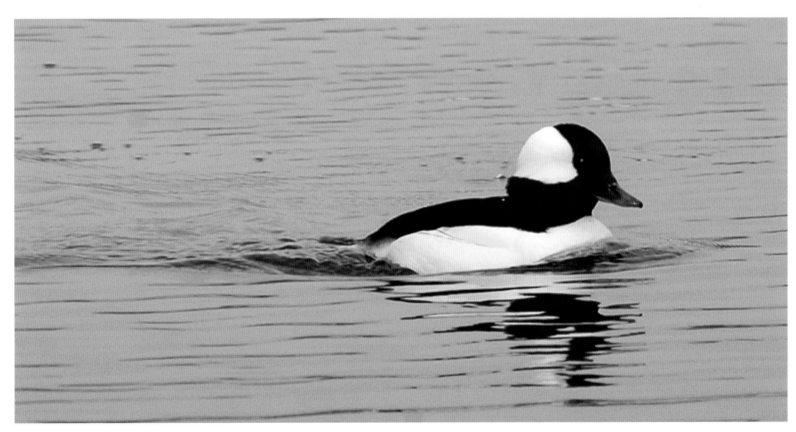

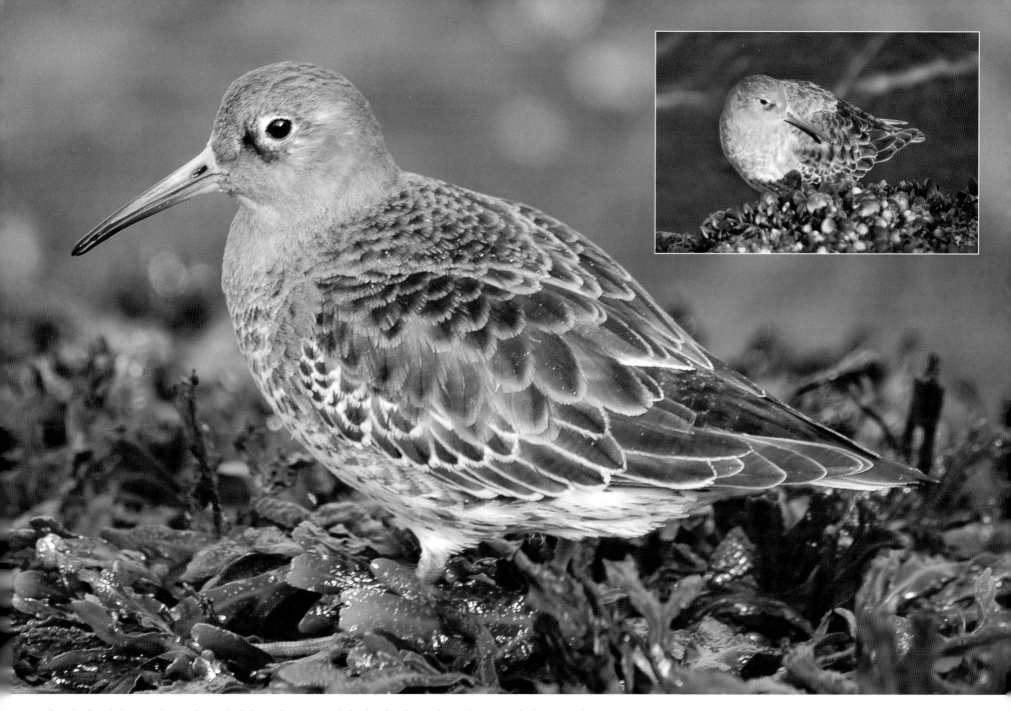

Purple Sandpipers migrate from their breeding grounds in the Arctic to along the coast during the winter and can be found on jetties. When seen in the right light, the scapulars are tinged in purple. These chunky sandpipers are pretty hardy, and feed upon the rocks along with other wintering birds.

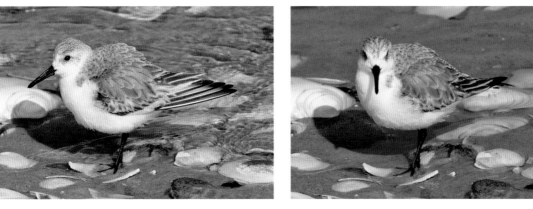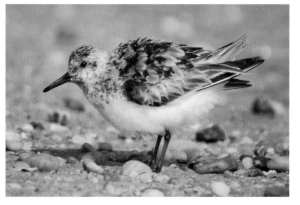

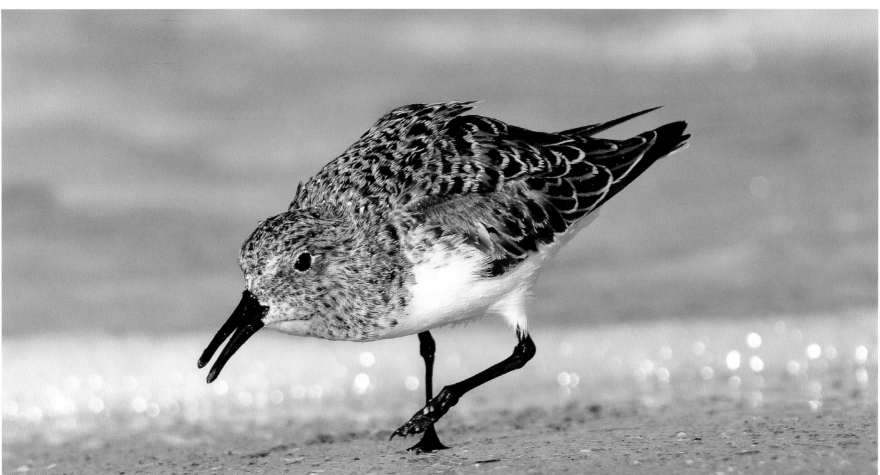

Running along the beaches just ahead of the next wave as they search the surf for food, Sanderlings are small, chunky sandpipers constantly in action. In summer, they have a dappled rust/gray/white head and back with white underparts, while in the winter they fade to a gray top and white below.

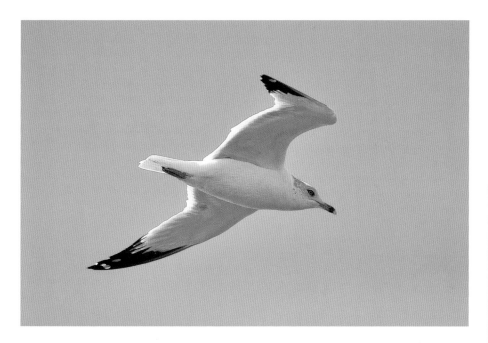

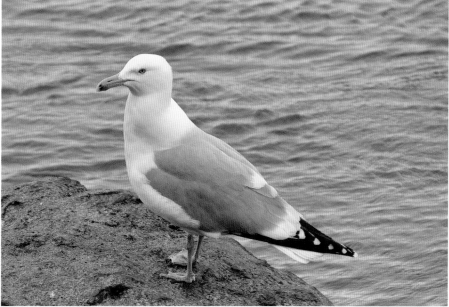

With a voracious appetite and willingness to eat almost anything, the Herring Gull is pushing out other species and is found almost everywhere. Taking four years to mature to pale gray and white plumage, they can be identified by their thick yellow bills with the red patch on the lower part. This patch provides the target for young to tap in order to be fed regurgitated food from the parents.

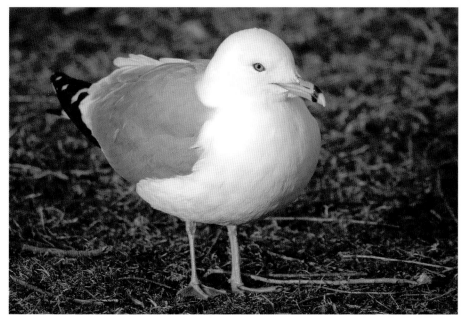

Smaller than the Herring, the mature Ring-billed Gull is a light gray and white bird with the distinctive black ring around its thick yellow bill. This common gull can be found almost anywhere in the country, including urban vicinities.

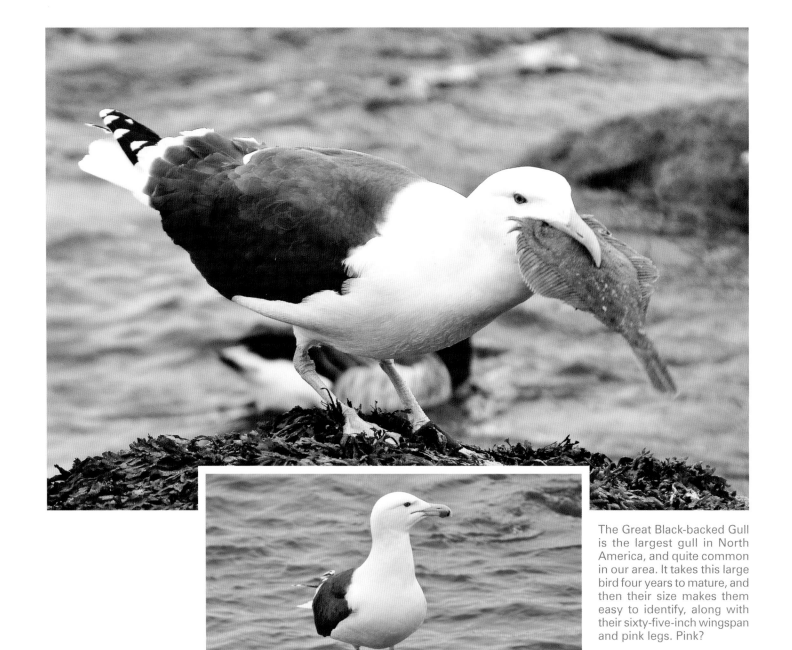

The Great Black-backed Gull is the largest gull in North America, and quite common in our area. It takes this large bird four years to mature, and then their size makes them easy to identify, along with their sixty-five-inch wingspan and pink legs. Pink?

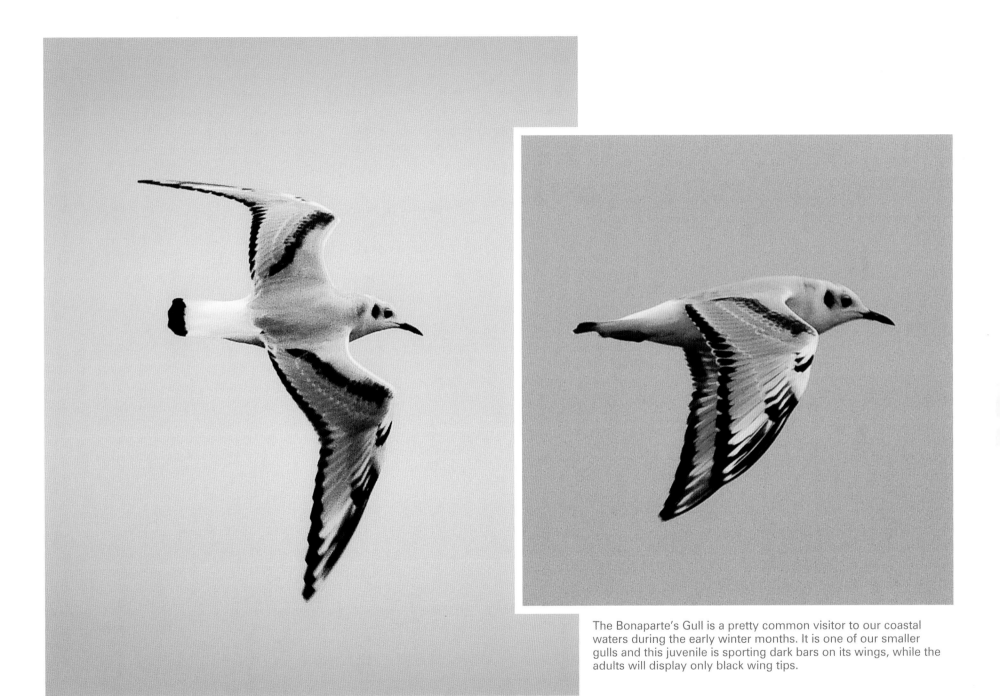

The Bonaparte's Gull is a pretty common visitor to our coastal waters during the early winter months. It is one of our smaller gulls and this juvenile is sporting dark bars on its wings, while the adults will display only black wing tips.

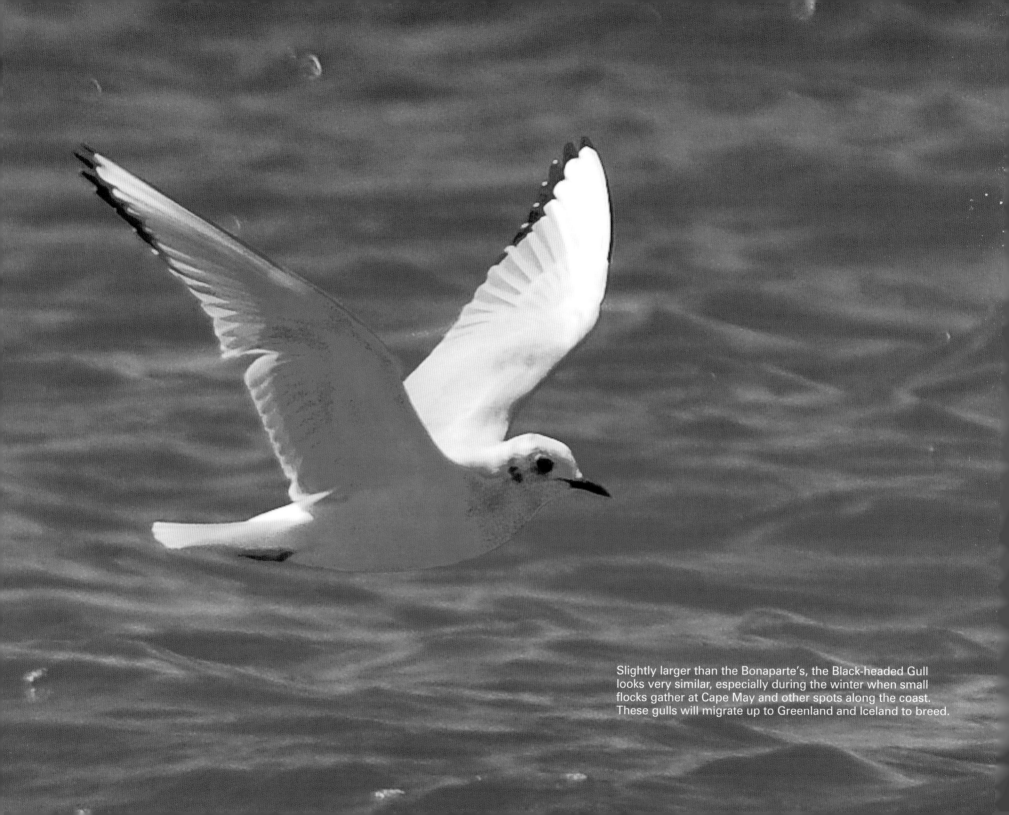

Slightly larger than the Bonaparte's, the Black-headed Gull looks very similar, especially during the winter when small flocks gather at Cape May and other spots along the coast. These gulls will migrate up to Greenland and Iceland to breed.

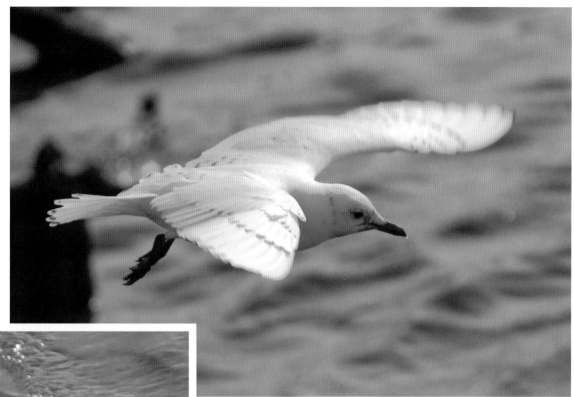

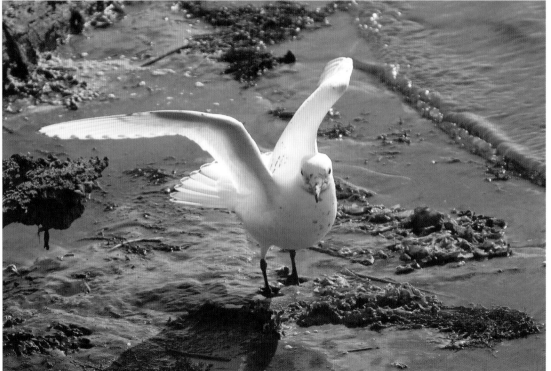

On the day after Thanksgiving, 2009, a star flew into New Jersey. No, not the Boss. The Ivory Gull came for a brief visit to Cape May from the ice pack of the Arctic. The immature Ivory's visit was only the fourth recorded in the state, and the first for Cape May. Thousands came from far and near to photograph and add this smaller gull to their life lists.

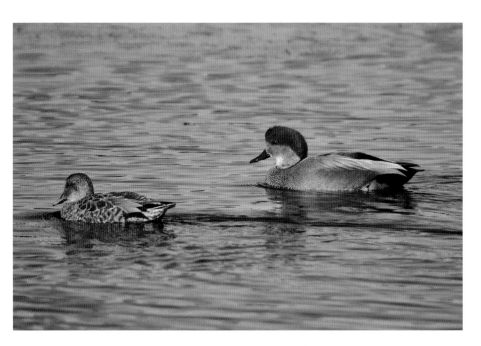

Fairly common from North to South Jersey in fresh water ponds, the small Pied-billed Grebe is rarely found flying or walking on land. They are rather drab and get their name from a black band that circles their short, thick bill during mating season. The breeding population is considered endangered in New Jersey due to habitat loss.

Easily overlooked because of their plainness, Gadwalls winter along our shallow marshes and ponds. The males of this dabbling duck are grayish with chestnut on the wings and the give away is the black butt. Most breed in the northern Midwest, but some are establishing breeding populations here in New Jersey as noted by these ducklings at Cape May Meadows. (Right and opposite page)

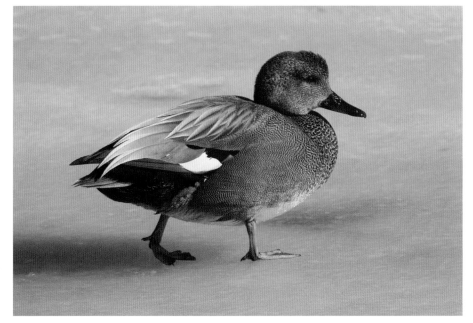

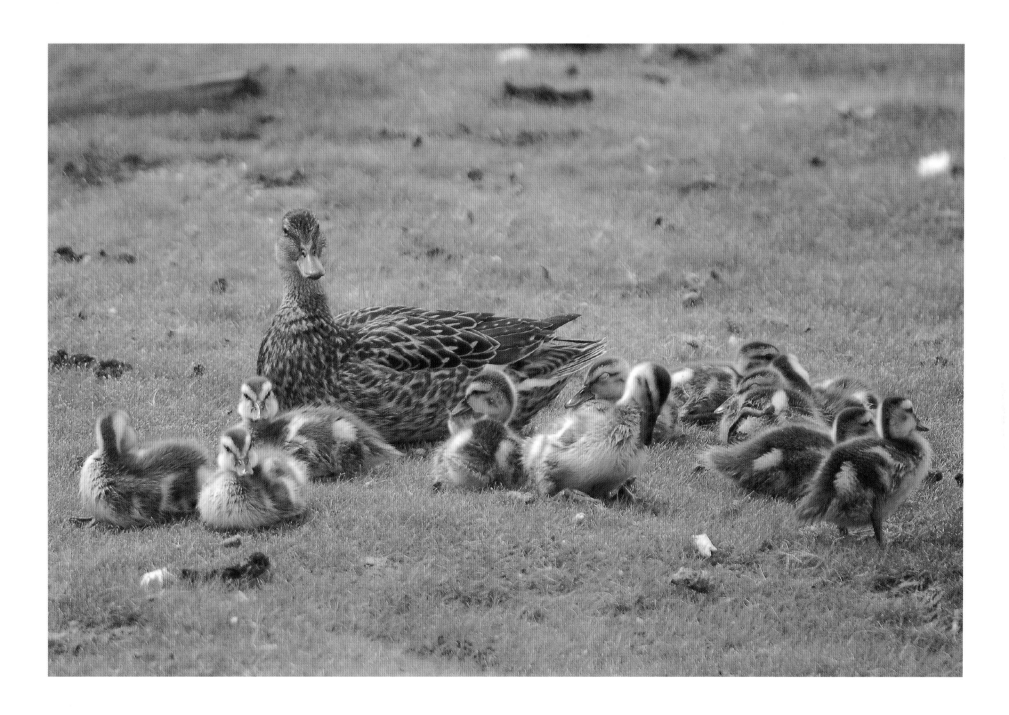

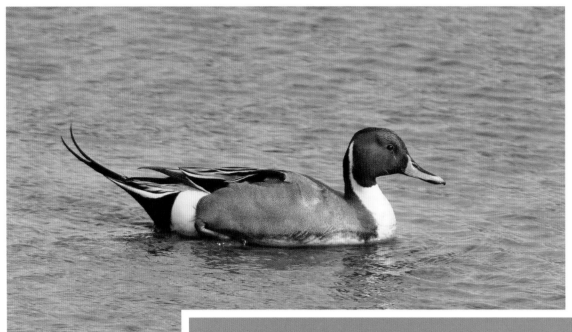

Northern Pintail drakes are quite attractive with their dark brown heads, slender white stripe down their long necks, and gray and white bodies. Large populations are found in New Jersey during the winter at our shallow ponds, especially at the Edwin B. Forsythe NWR and Cape May, before taking off in the spring for parts north to breed.

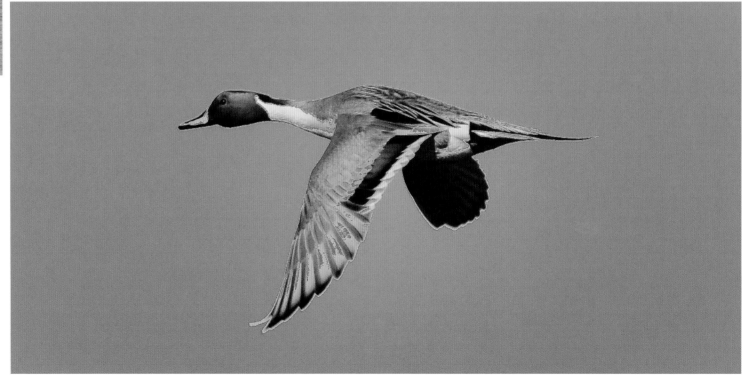

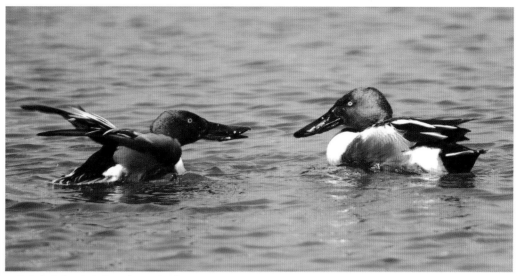

With its long spatulated bill, the Northern Shoveler is a very odd-looking duck indeed. Fortunately, his beautiful plumage makes this pond and marsh feeder always a joy to find in the winter.

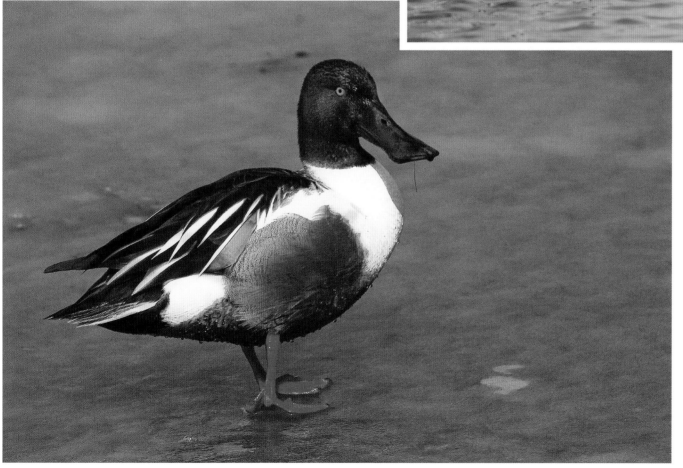

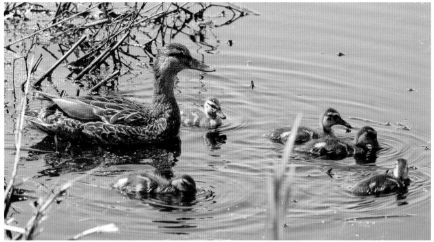

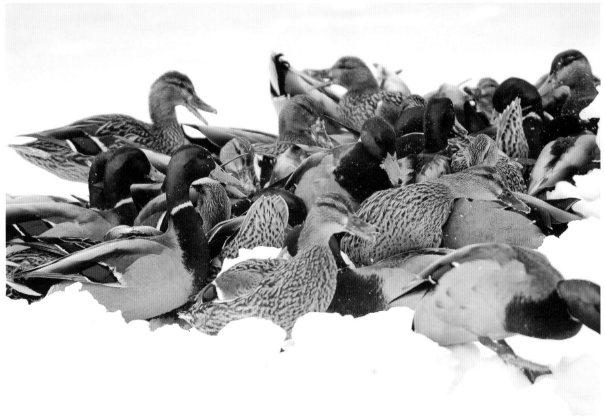

We seem to take the Mallard Duck for granted as they are so common, but a good look at the drake will reveal a very handsome fellow with an iridescent green head, yellow bill, chestnut chest, and distinctive black curled rump feathers. The female is more brown and black, as seen here with her ducklings.

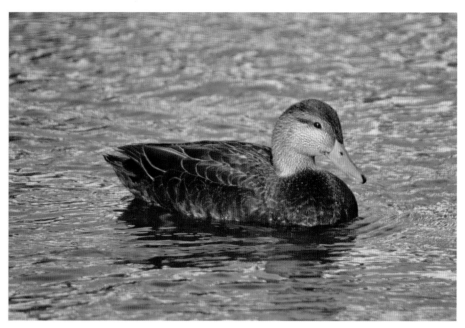

Island Beach State Park, Ocean County.

You may think you are seeing a flock of female Mallards on a girls' night out, but look closer for the yellow bill with a black tip and a violet wing patch and you realize it's an American Black Duck. This dabbler is a common winter resident, but populations are declining nationwide due to interbreeding with Mallards.

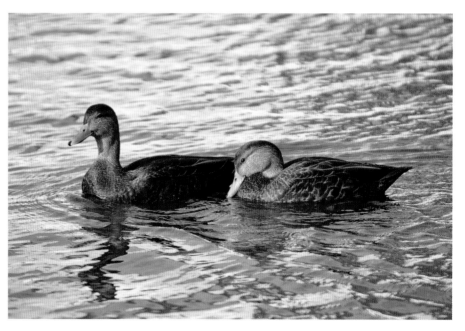

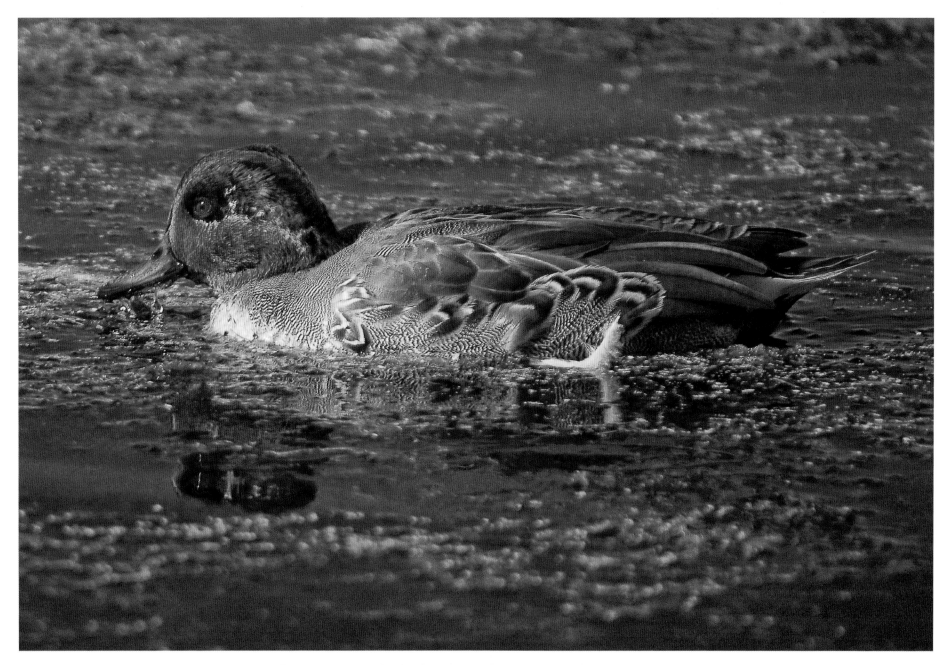

The smallest dabbling duck is the Green-winged Teal, where yet again, the drake has the best plumage. With a chestnut head, dark green ear patch, and a white vertical side bar, this gent has it all. Found on ponds and marshes, it is a cold weather migrate to New Jersey, and leaves in the spring to breed in Canada.

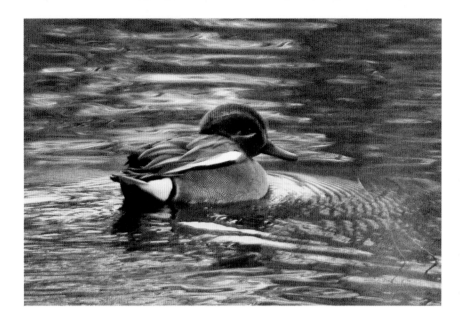

A rare find is the Common Green-winged Teal, an Eurasian race, which is distinctive by the horizontal white bar on the side and no vertical bar. During the winter months, one may be found at Lake Takanassee in Long Branch, and it is well worth braving the cold winds of winter to view such a rare guest.

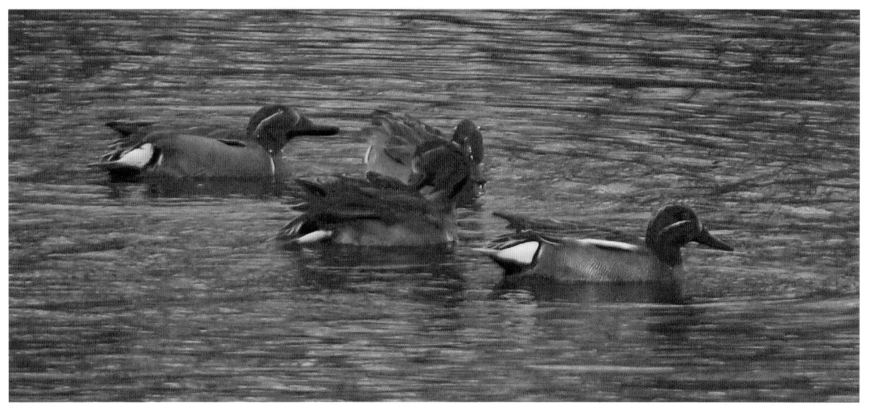

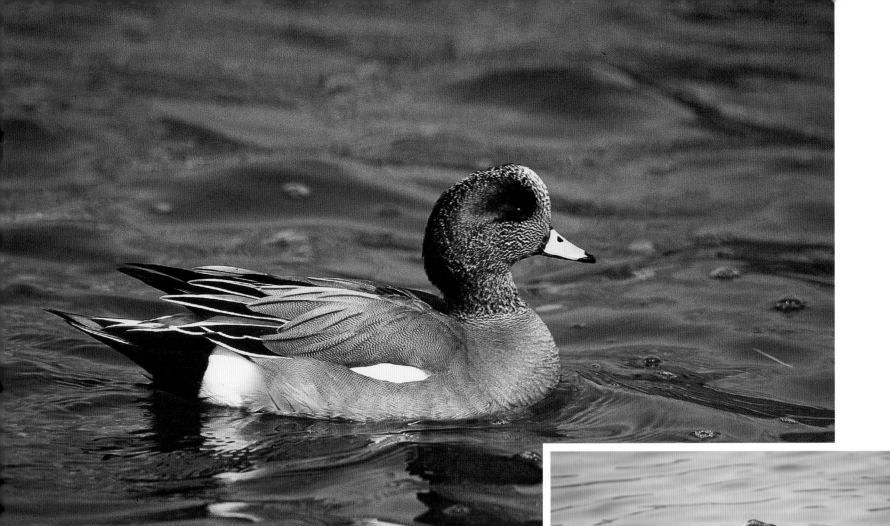

Another dabbling duck is the American Wigeon, a relatively common winter visitor to our shallow lakes and ponds along the ocean shores. The drake is distinguished by the bold green patch by the eye and white forehead. Come spring they will head up to Canada for their breeding grounds.

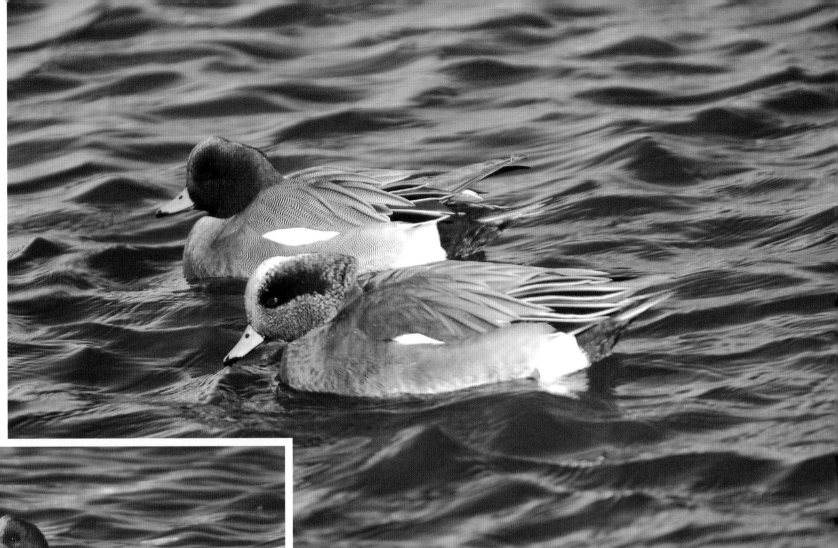

A rare but frequent visitor is the Eurasian Wigeon, with a rufous head, buff forehead, and gray body. Usually found within groups of their cousins, the American Wigeons, during the winter, these birds breed in Eurasia and Iceland during the summer months. Look along the North Shore of Monmouth County and Cape May to find these rarities.

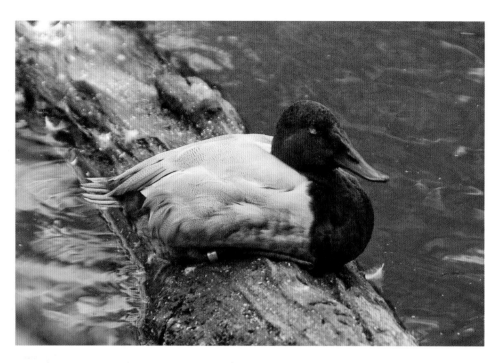

Found occasionally on coastal ponds and estuaries, the Canvasback is one of the largest diving ducks that visit in the winter. The long sloping black bill is a good identifier, which helps to distinguish it from the Redhead.

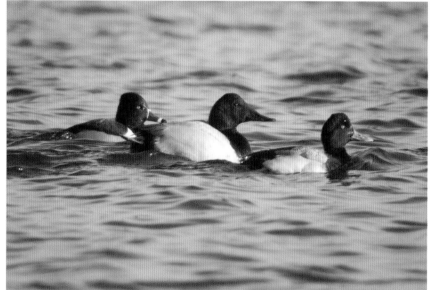

It is a rare moment when you see three species swimming along together. Here we see a Ring-necked Duck, Canvasback, and a Lesser Scaup enjoying time together in Belmar.

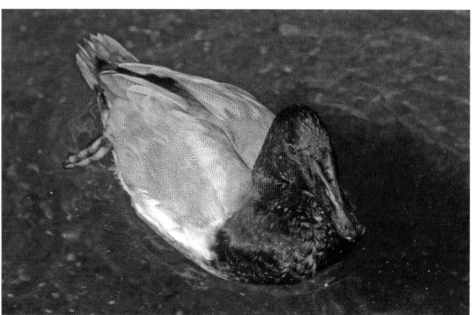

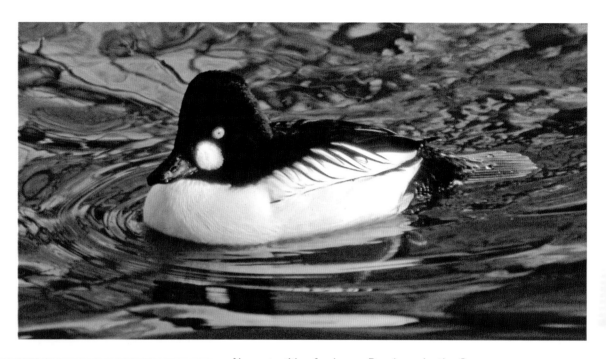

No, not a title of a James Bond movie, the Common Goldeneye is a diving sea duck occasionally found during the winter months. The bright yellow eye really stands out, along with a white cheek patch for males or a chocolate head for the females.

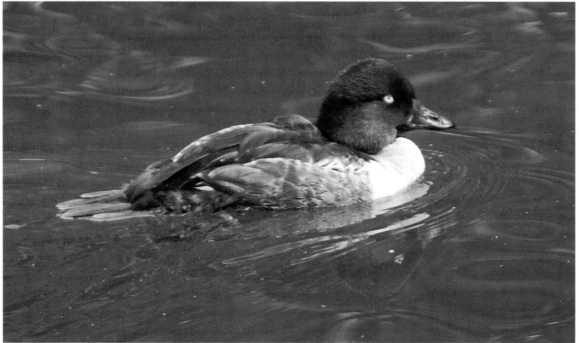

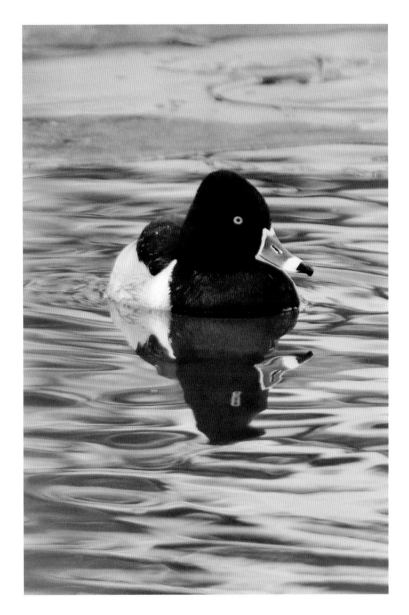

The Ring-necked Duck has a dark chestnut ring around its neck that is almost impossible to see with its dark head and black chest. What it does have is a very distinctive white ring around the base of the bill, making you wonder, "Who named this bird?" A diving duck that is common in marshes and ponds during the winter, it heads north to Canada to breed in late spring.

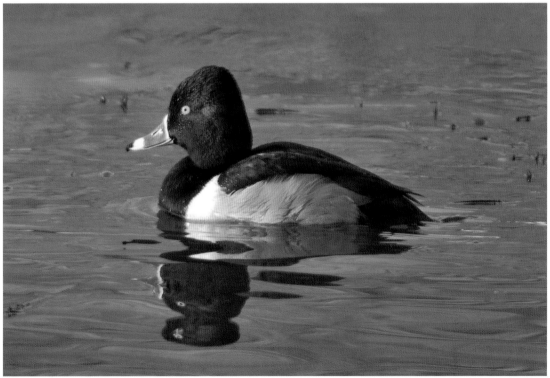

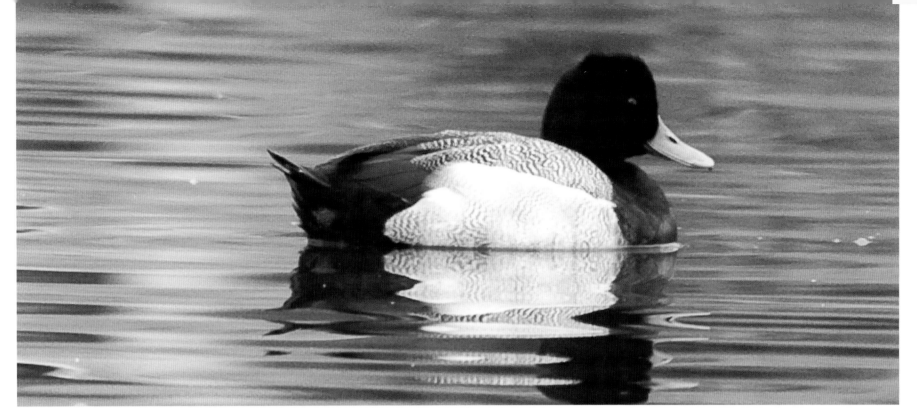

The Greater and Lesser Scaup plumage is very similar, making it hard to distinguish between the two. The shape and size of their heads are a bit different, which helps. The Greater has a larger and rounder head, while the Lesser has a taller and thinner one. These diving ducks are winter residents to our fresh and salt water ponds. Pictured are the Lesser Scaup, the Greater Scaup, and a flying group of Greater Scaup.

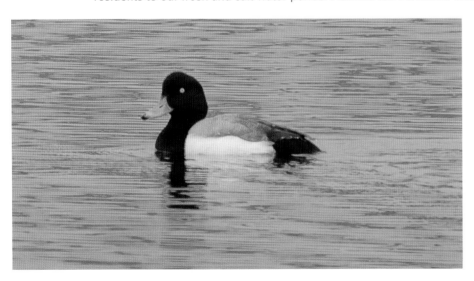

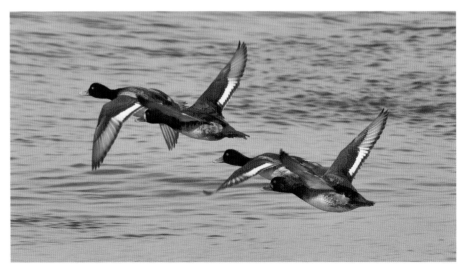

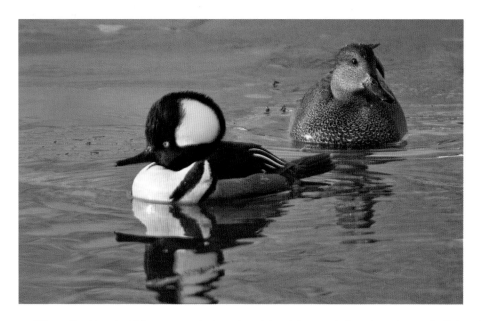

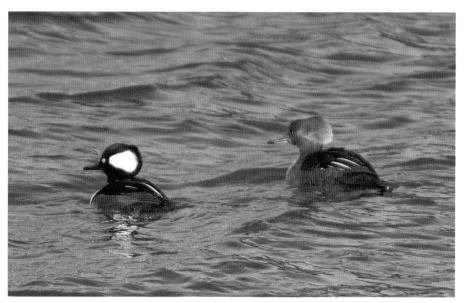

When the Hooded Merganser drake raises his white crest, the show is on. A diving duck found during winter months along bays and coastal ponds, these are North America's smallest mergansers. Look for these beautiful birds along the Northern Ponds in Monmouth County, Barnegat Bay, and the Edwin B. Forsythe NWR.

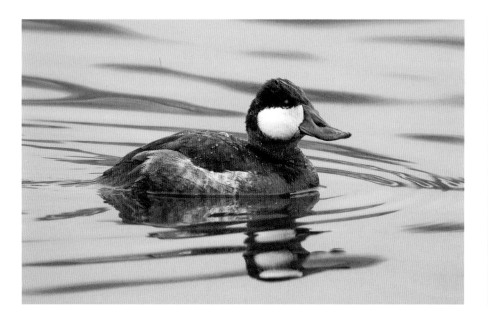

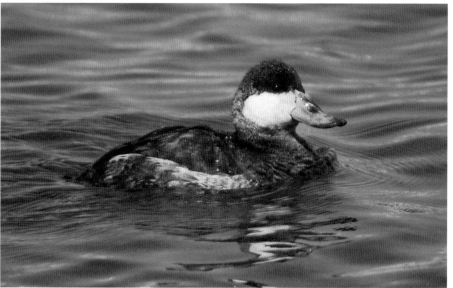

Who knew that it takes a pale blue bill to attract the ladies? The Ruddy Duck is a small diver who can be found wintering in our lakes and ponds. They are dark with white cheeks, and a cocked tail. When breeding season begins, the male's plumage changes to a rusty red and the bill turns a lovely light blue. These ducks, like loons, are very awkward on land and are rarely seen walking due to their legs being so far back on their body, which enables them to be great divers.

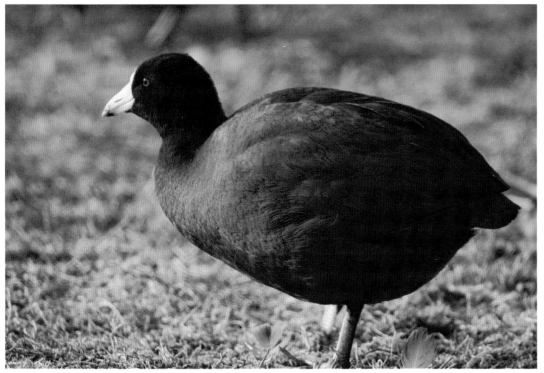

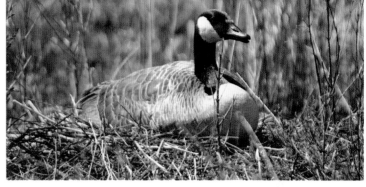

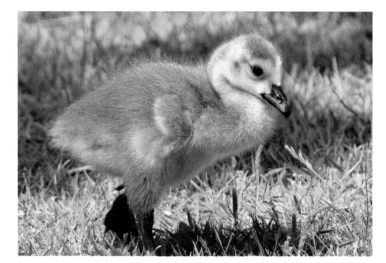

The American Coot is a chubby marsh bird that can be easily found during the winter on both salt and fresh water ponds and lakes. Black with a white bill, these birds will usually dive to feed or to avoid being prey for large gulls or raptors.

The Canada Goose could be described as the visitor from Canada who never left. During the 1950s, the numbers of these geese were quite small, and birds were reintroduced to the Mid-Atlantic states; bet they would like to rethink that decision.

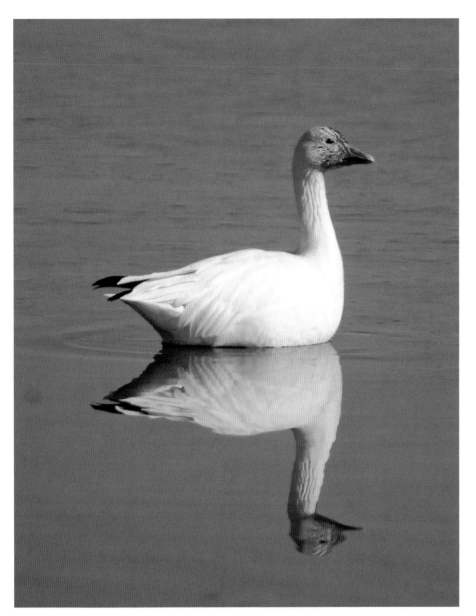

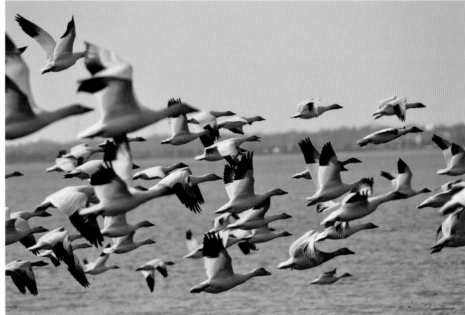

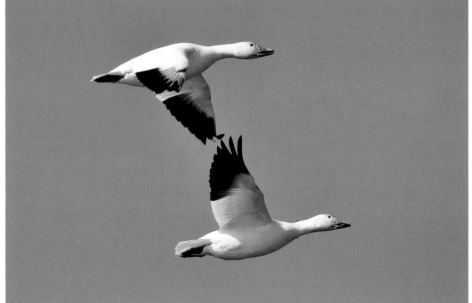

Come winter, tens of thousands of Snow Geese descend along our coastal wetlands. Smaller than the ubiquitous Canada Goose, these white geese with black wing tips can be found in the thousands at the Edwin B. Forsythe NWR from early winter through early spring. There is now a hunting season on them as their great numbers are damaging to the fragile wetland plants that other species depend upon.

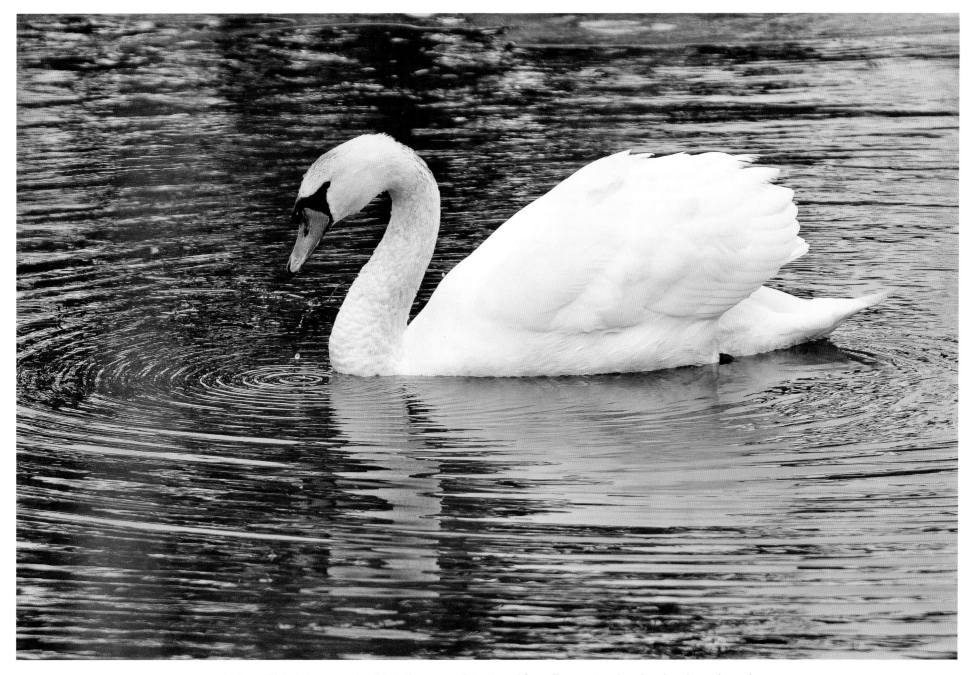

The beautiful, but aggressive Mute Swan was introduced from Europe to adorn local parks and ponds.
Escaping from its intended habitat, it has now established breeding populations around the country.
They mate for life, and are very protective of their territory to the detriment of native species.

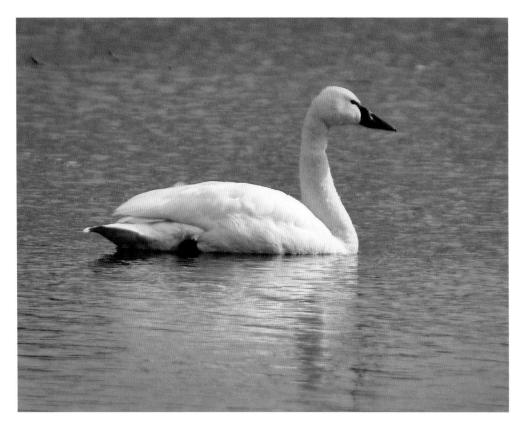

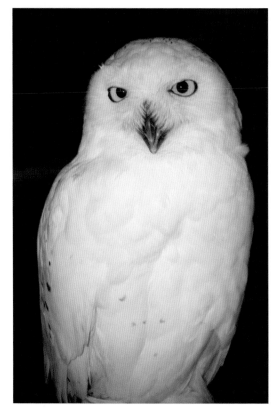

Found occasionally along the coast during the winter, the Snowy Owl is a rare visitor from the Arctic tundra, or maybe it's Hedwig escaped from Harry Potter. Preferring to sit on the ground or low-lying rocks or stumps, this white owl has one the largest wing-spans of any owl.

Arriving in late fall from the far north to the marshes and bogs of southern New Jersey, the Tundra Swan is the smallest of the swan family. Formerly known as the American Whistling Swan, Tundra Swans have a wingspan of sixty-six inches, and are all white with a long black bill.

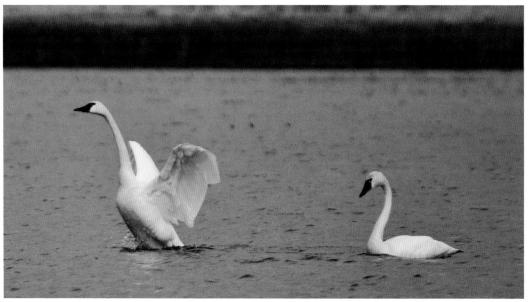

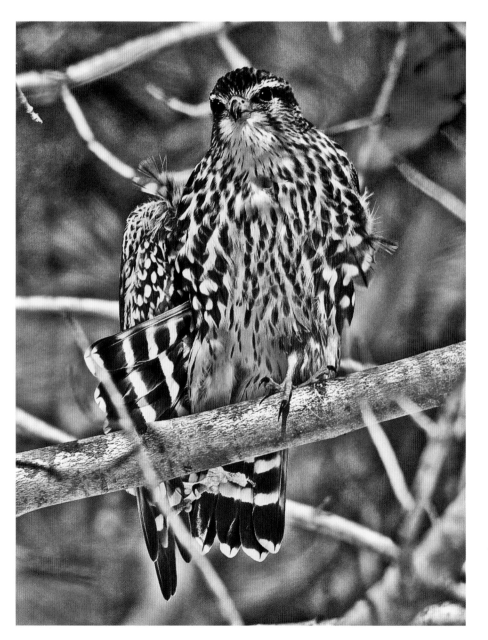

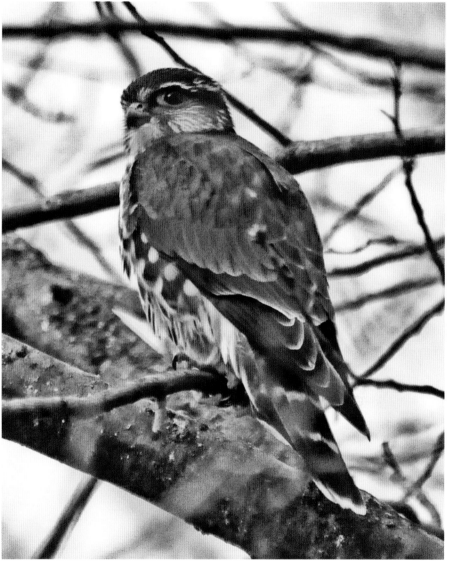

A larger falcon than the American Kestrel, the Merlin can easily be seen hunting small birds along coastal areas during both spring and fall migrations. Blue-gray above and a bold barred tail, helps to identify this fast raptor. *Both images courtesy of Dr. Howard B. Eskin*

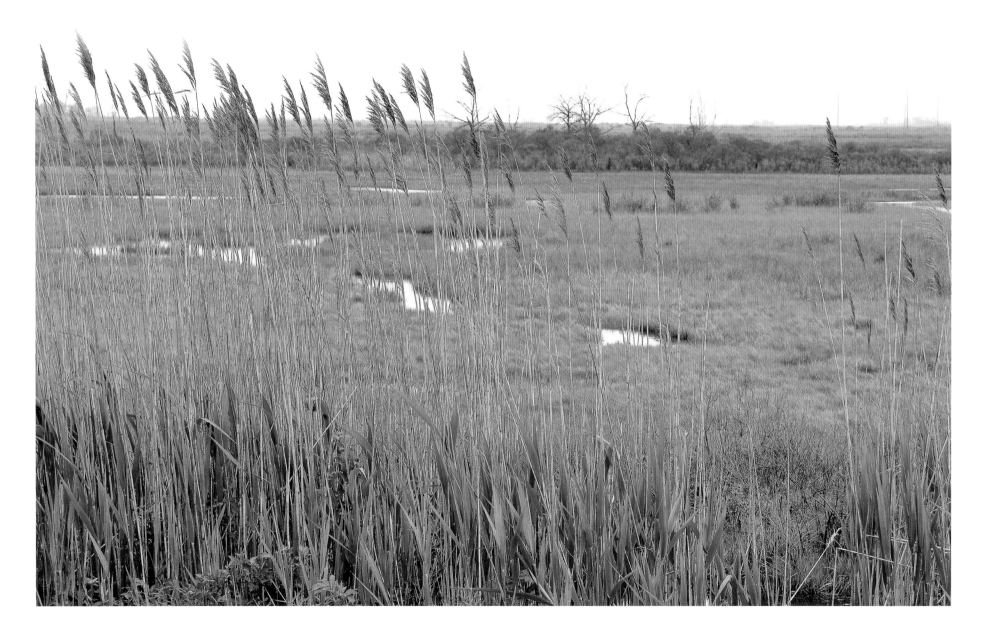

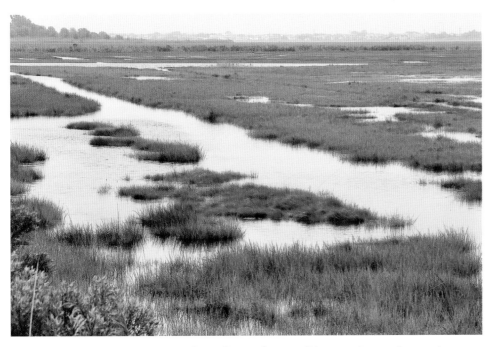

Manahawkin Wildlife Management Area, Ocean County. (Above and opposite page)

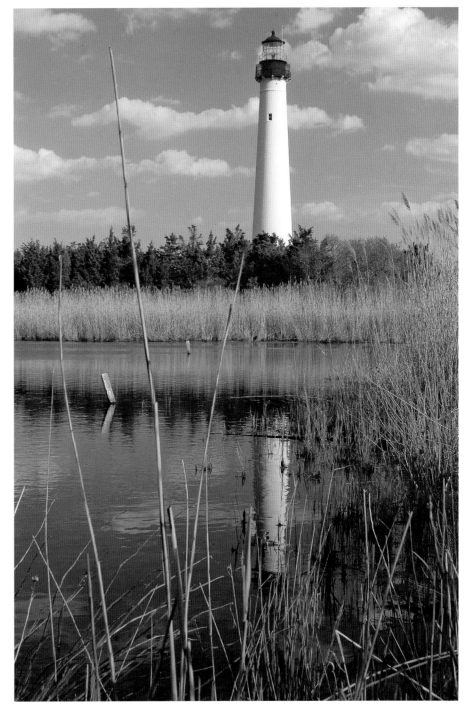

Cape May Lighthouse State Park,
Cape May County.

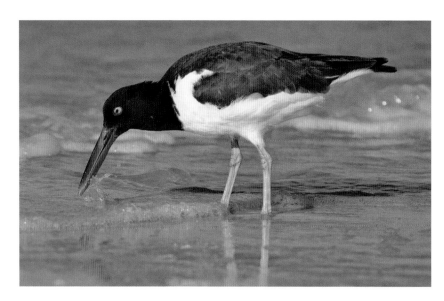

The large orange-red bill is so striking that the threatened American Oystercatcher is a great favorite with birders. It's relatively common along coastal beaches and mudflats, especially from late spring through fall, using its distinctive bill to open oysters and mussels.

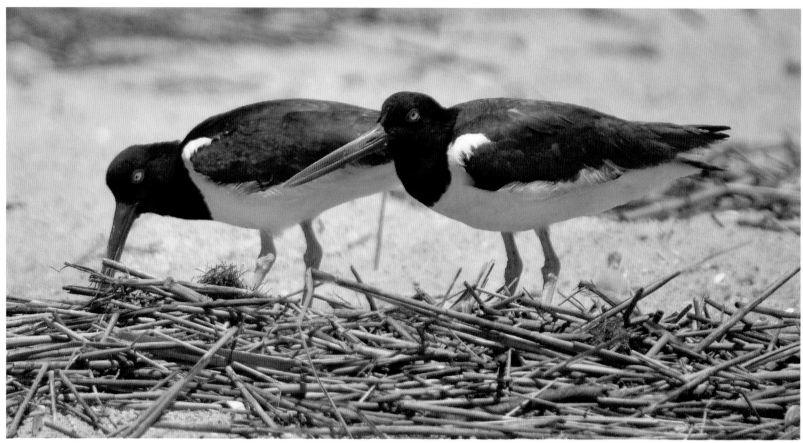

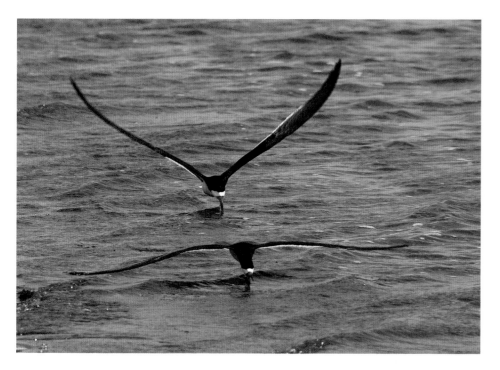

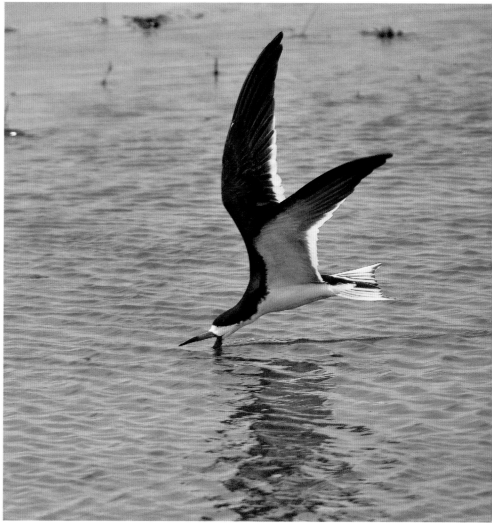

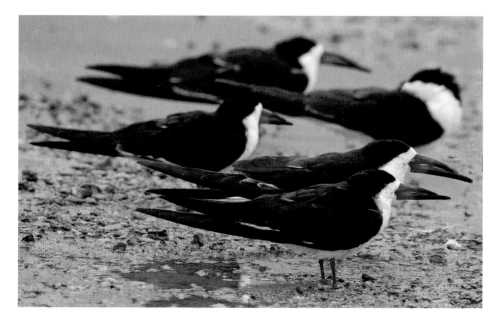

The only bird with the lower mandible longer than the upper, the state endangered Black Skimmer is readily identified. With their forty-four-inch wingspan, they glide gracefully across the waters with that long mandible cutting the surface water looking for fish. Once it finds one, the jaw snaps shut and lunch is served.

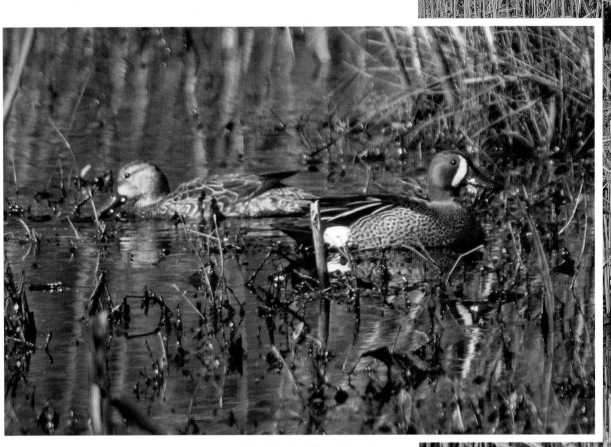

With a violet-gray head and white crescent on the side, the Blue-winged Teal drake is a shy marsh and pond feeder. About the same size as the Green-winged Teal, this species is a relatively common migrant found usually on the ponds and marshes of coastal southern New Jersey.

The Nature Conservancy Cape May Meadows, Cape May County.

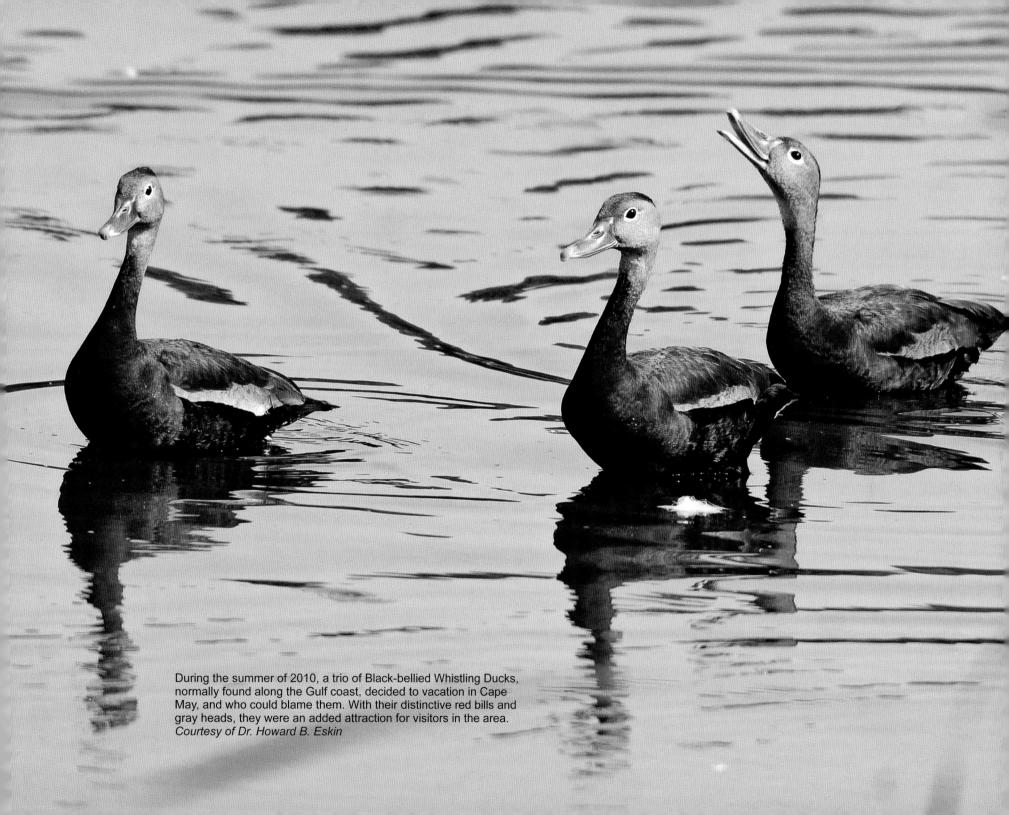

During the summer of 2010, a trio of Black-bellied Whistling Ducks, normally found along the Gulf coast, decided to vacation in Cape May, and who could blame them. With their distinctive red bills and gray heads, they were an added attraction for visitors in the area.
Courtesy of Dr. Howard B. Eskin

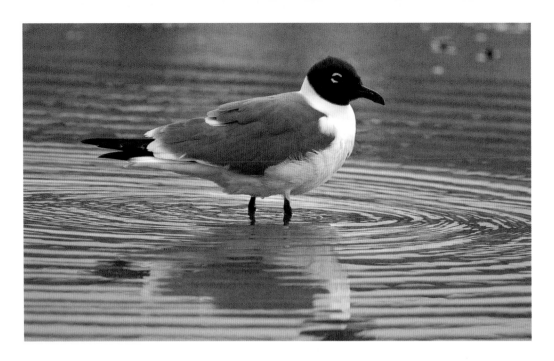

Living up to their name, the Laughing Gull has such a raucous call that you wonder what the joke was. These smaller gulls have distinctive black heads in the summer along with a longer reddish bill and white around the eye. After wintering along the coasts of the southern United States, they return in the spring and are pretty common along the shores, wetlands, and shopping malls—always looking for a steal.

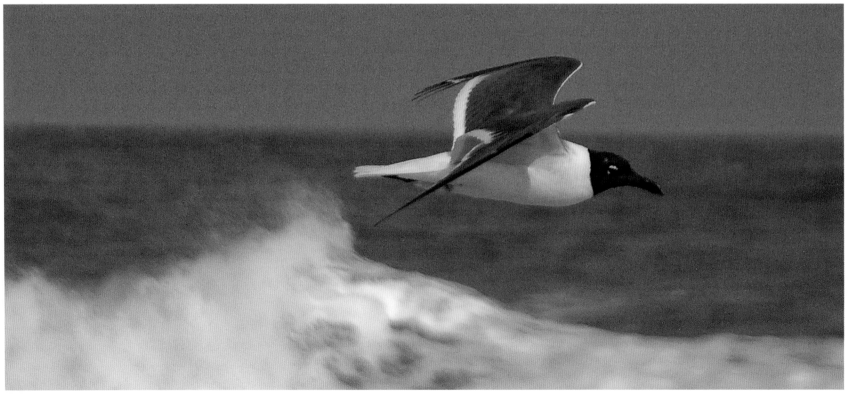

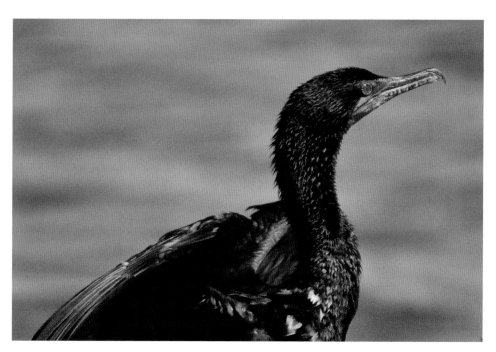

Decades ago, Double-crested Cormorants were very rarely seen, but now they are everywhere, along the coast and inland rivers and lakes. Whether swimming low in the water, diving for fish, or just hanging out on a dock drying its wings, this common bird carries its hook-tipped bill in an upward position and has an orange throat pouch that extends to the eye. During breeding season, little tufts of feathers will appear on each side of the head, thus giving these birds their name.

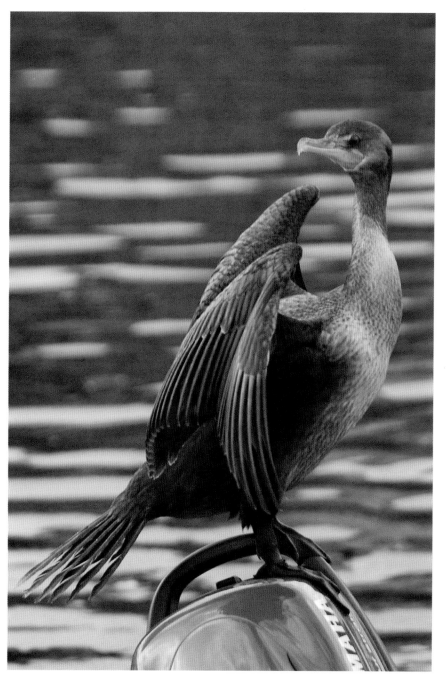

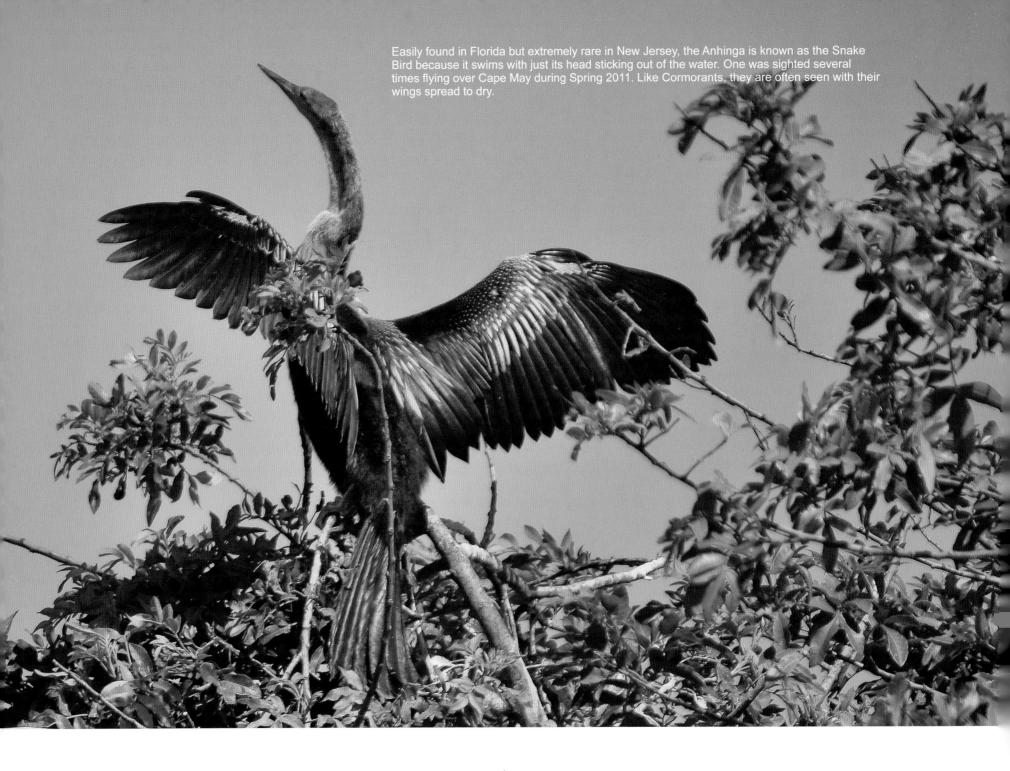

Easily found in Florida but extremely rare in New Jersey, the Anhinga is known as the Snake Bird because it swims with just its head sticking out of the water. One was sighted several times flying over Cape May during Spring 2011. Like Cormorants, they are often seen with their wings spread to dry.

Easily seen along beaches and open water during the summer months, the Common Tern, with its smart black cap, is very similar to the Forster's Tern; however, the outer wingtips are darker. These two Common Terns are in a tussle above Great Egg Harbor Bay.

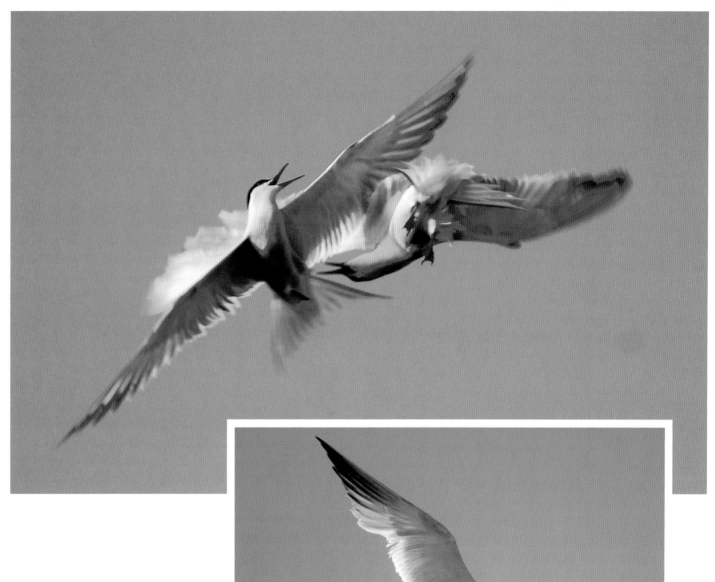

The Caspian Tern is the largest tern in North America, and can be easily identified by their black crown and a large orange/red bill. They are rather common migrants in southern New Jersey during the fall; just watch for a bird who looks like it's carrying a carrot.

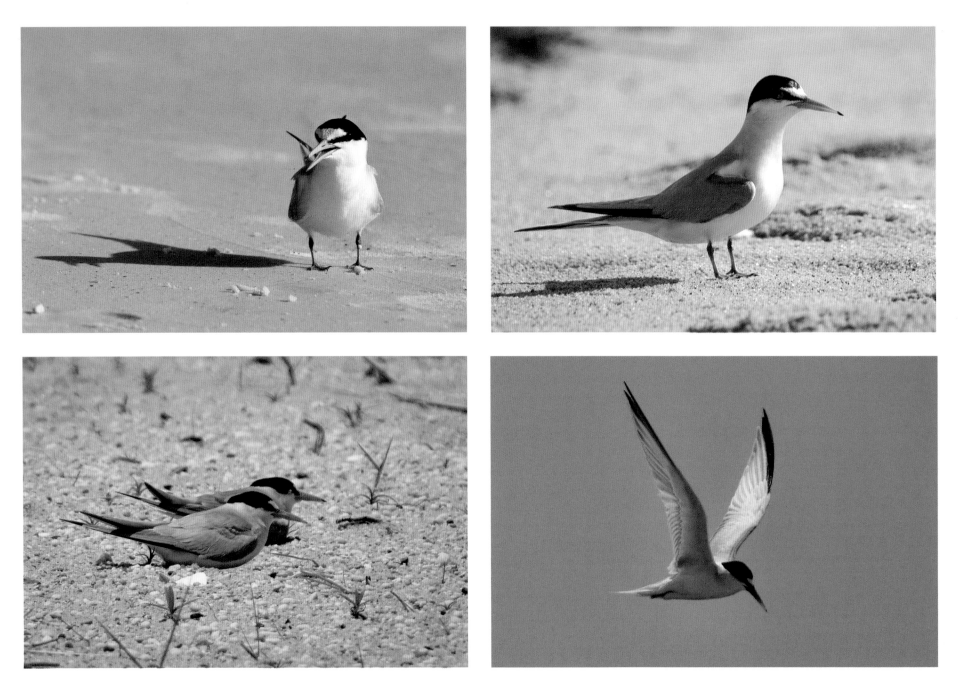

The endangered Least Tern is the smallest tern in North America, and nests in large colonies along protected beaches. Trying to make a comeback, they are extremely protective of their nests and won't hesitate to dive bomb any intruder.

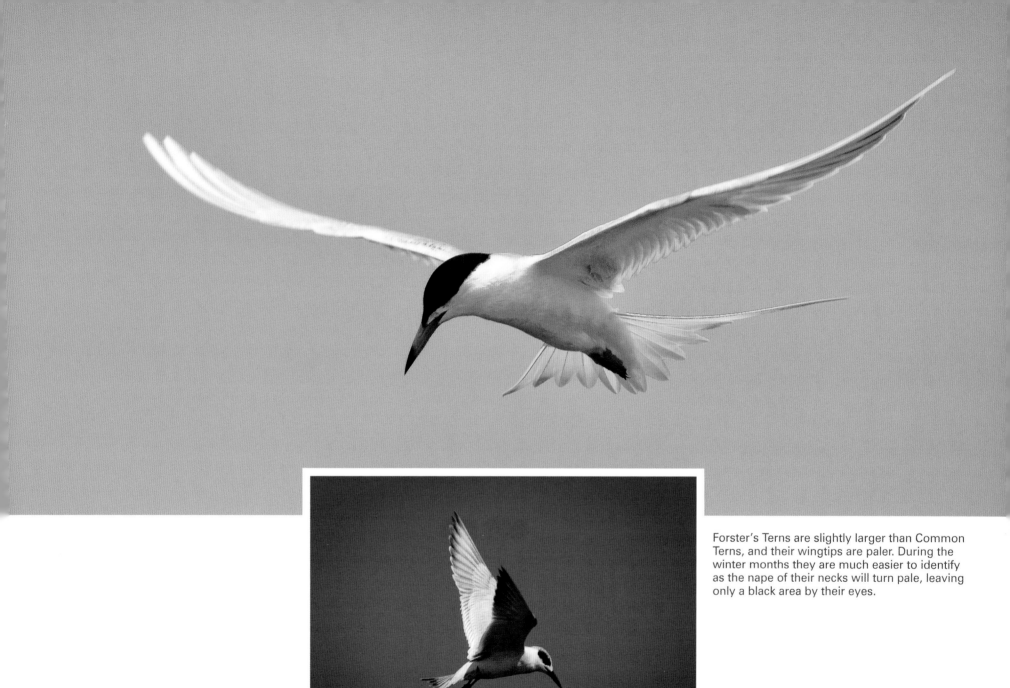

Forster's Terns are slightly larger than Common Terns, and their wingtips are paler. During the winter months they are much easier to identify as the nape of their necks will turn pale, leaving only a black area by their eyes.

The Royal Tern is a large crested bird occasionally seen migrating in the fall through New Jersey. These powerful terns only show their black caps during breeding season.

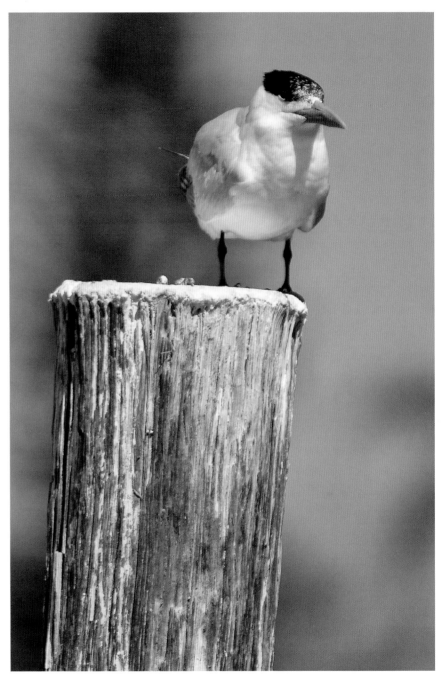

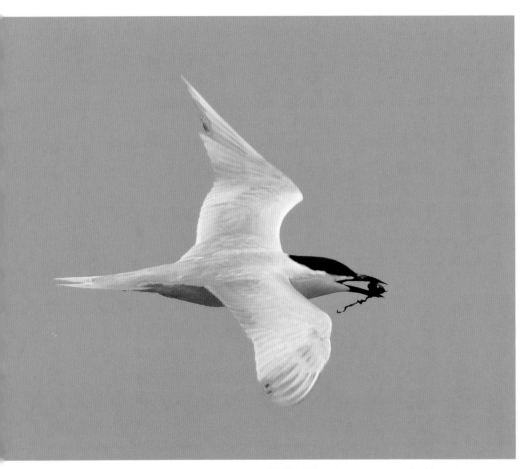

Sounding like a Frankenstein bird, the Gull-billed Tern is uncommon in New Jersey, though a few may nest in the summer at the Edwin B. Forsythe NWR. Not a tern to dive for its food, these birds will grab insects from the water surface and marsh flats. They are easy to identify by their thick black bill and cap.

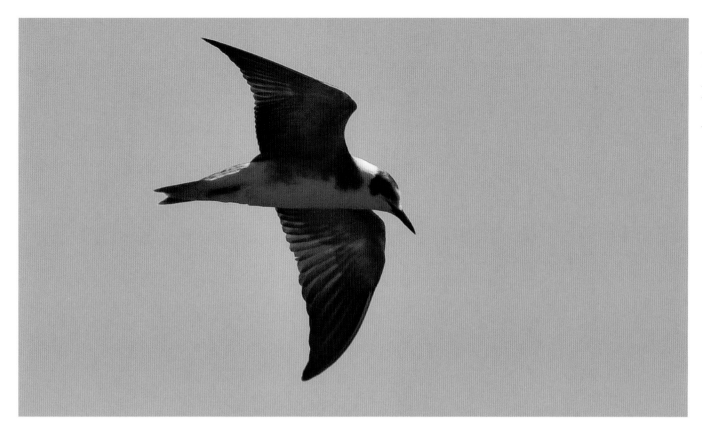

A rare fall migrant to our coastal bays and inlets, the Black Tern is usually seen in New Jersey with other terns, but these terns have dark gray underwings. Though we miss their beautiful black breeding plumage, birders will seek them out as their numbers are declining.

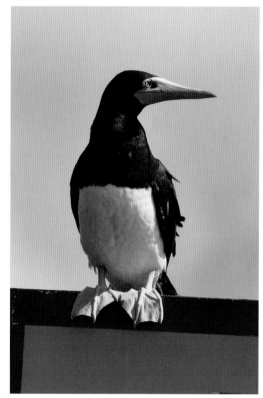

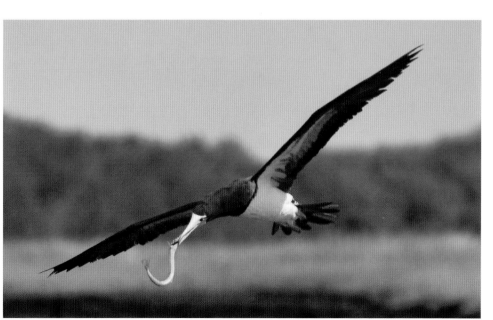

Making an appearance in Cape May during late summer 2011, the extremely rare Brown Booby caused a sensation in the birding world. Normally found in the Gulf of Mexico, this was only the second sighting in recent memory. She posed on a mile marker in Jarvis Sound for all those who wanted to get once in a lifetime photographs.

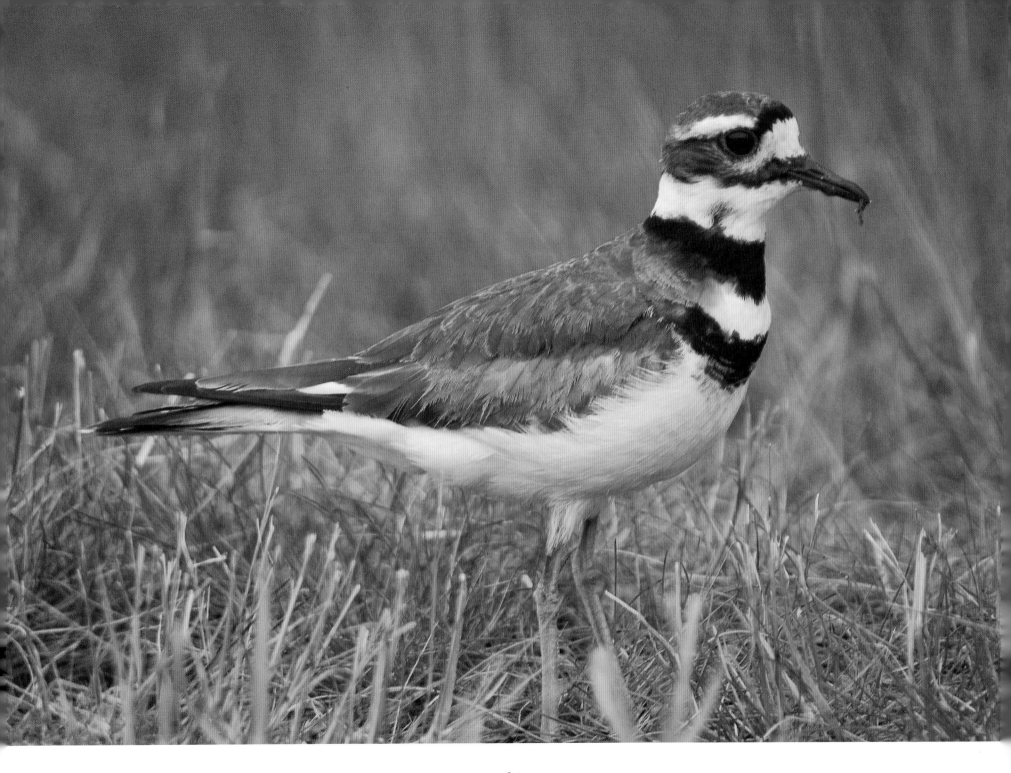

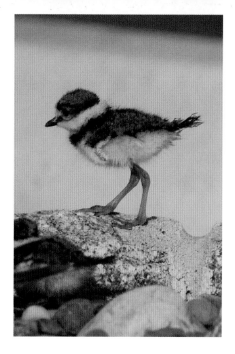

Many may think a Killdeer is a large furry animal with antlers that got hit by a car, but no, it is a member of the plover family. Instead of living by the shore, they are usually found in upland habitats, often far away from the water, such as golf courses, parking lots, and ball fields. This bird is the least associated with water of all shorebirds, and run across the ground in spurts looking for insects. (Left and opposite page)

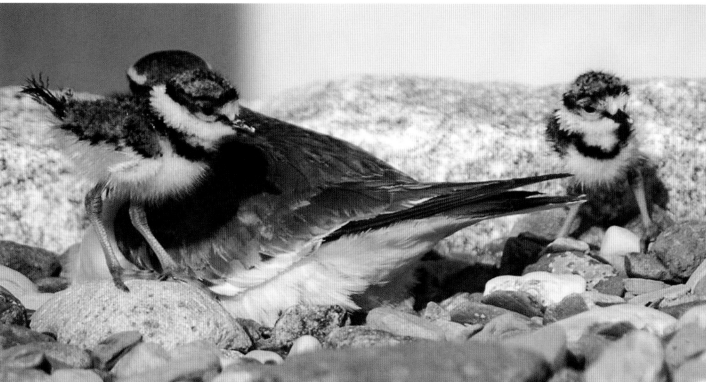

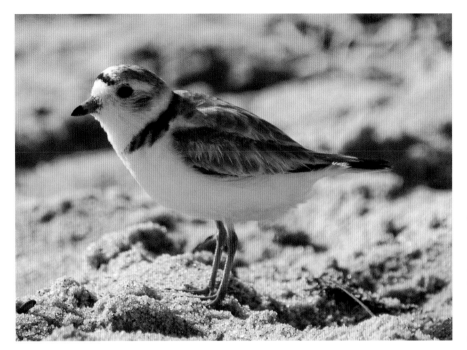

Both Federal and State endangered, the Piping Plover is a small, pale plover camouflaged to match their sandy nests on ocean beaches. This causes an issue with some beach lovers and dune buggy enthusiasts who don't want any of the beach shared with this little bird.

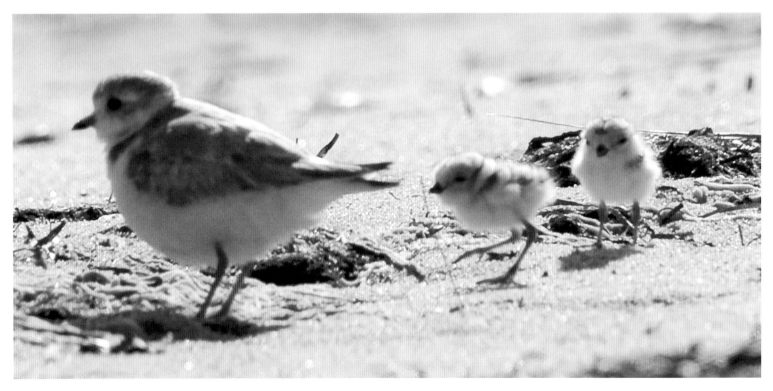

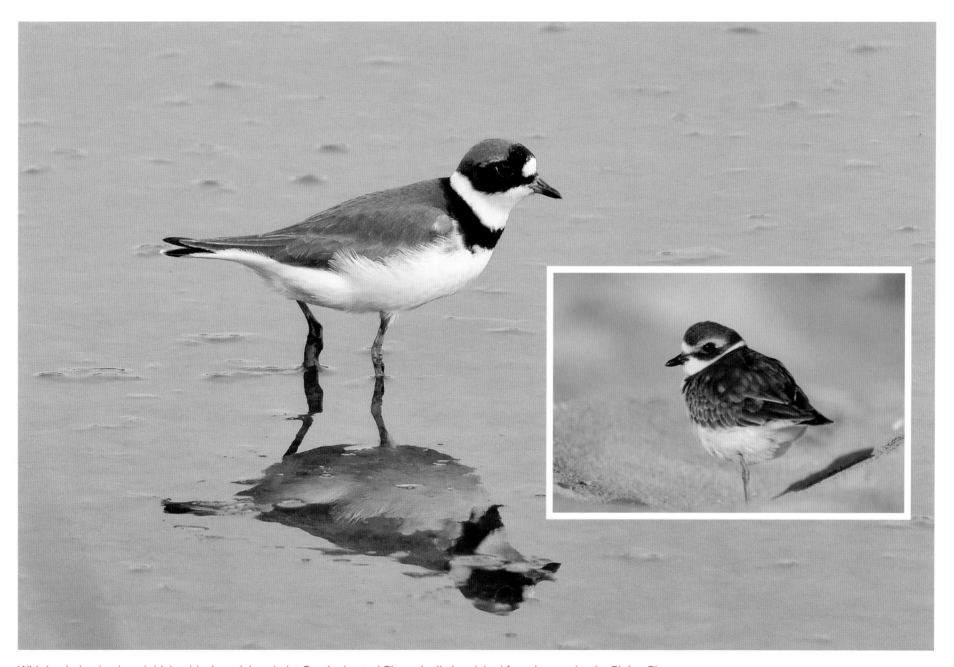

With its darker back and thicker black neck band, the Semipalmated Plover is distinguished from its cousin, the Piping Plover. The term semipalmated describes several species, meaning that the bird shows partial webbing between the toes. This common migrant is easily seen feeding on the mudflats. Shown are both the winter (duller) and summer plumages.

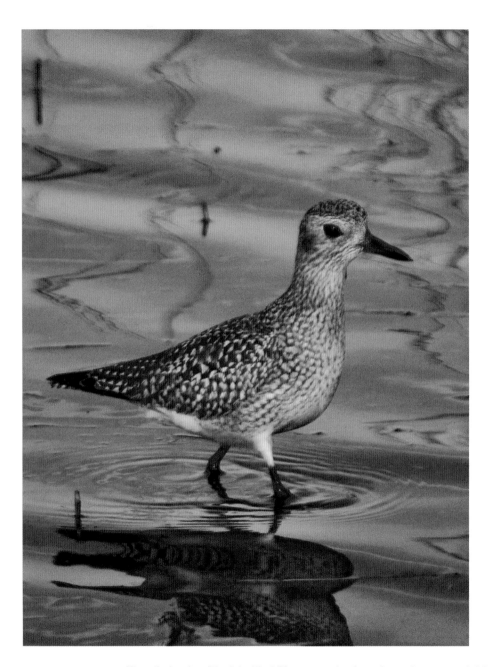
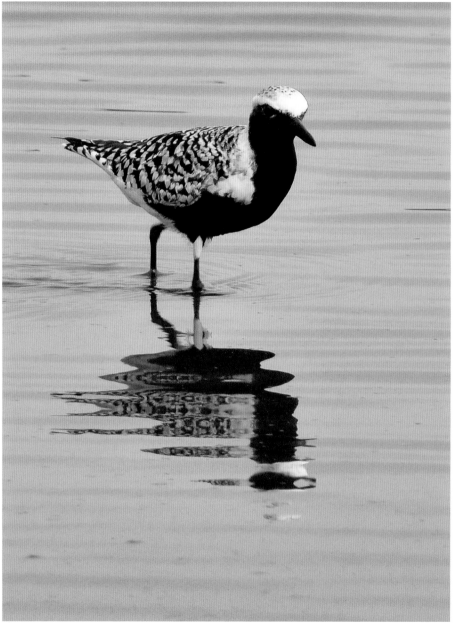

The distinctive Black-bellied Plover can be found running around tidal areas. Though they breed in the Arctic, this plover can be found during migrations and in winter when dressed in ordinary gray plumage. Shown are both the winter (duller) and summer plumages.

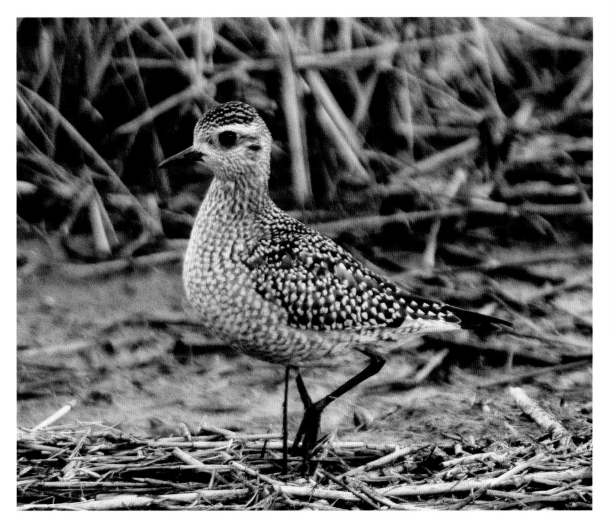

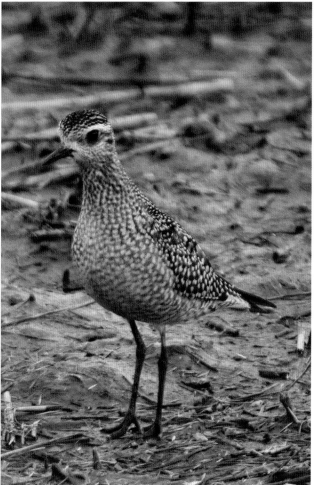

The American Golden Plover migrates through New Jersey in small numbers. During the non-breeding season, as this one is, the plumage is very similar to its cousin, the Black-bellied Plover. However, the difference is notable when they are seen together.

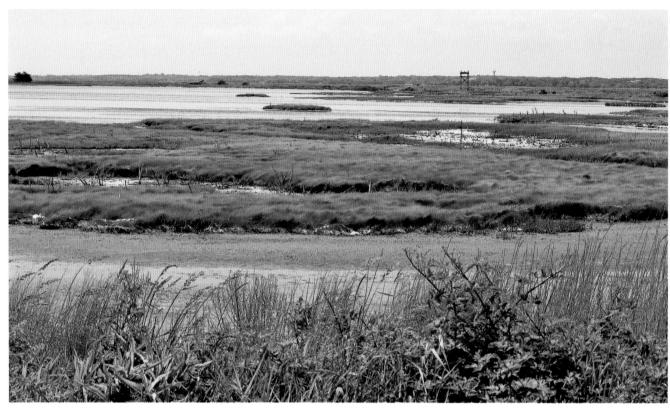

Edwin B. Forsythe NWR, Atlantic County.

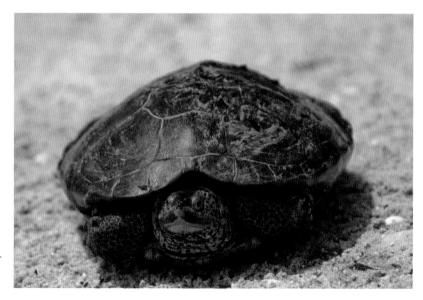

Diamondback Terrapin.

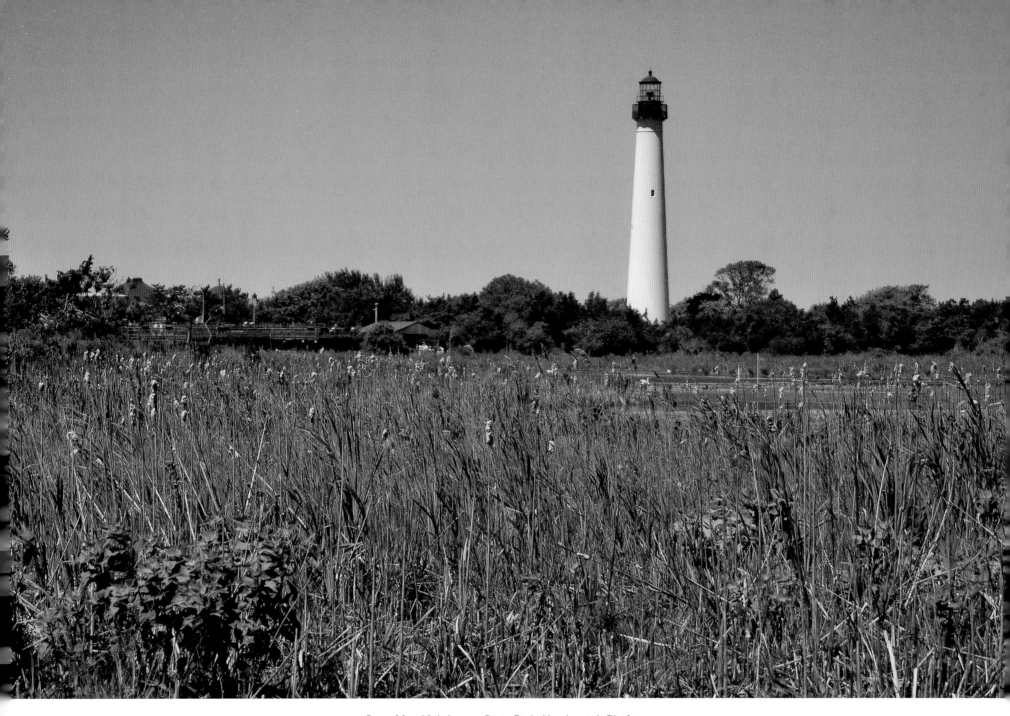
Cape May Lighthouse State Park, Hawkwatch Platform.

Blue Dasher Dragonfly.

Needham's Skimmer Dragonfly.

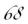

A rare visitor to southern New Jersey's ponds and marshes, the Black-necked Stilt may remind you of the song, "Ebony and Ivory," with its stark black and white plumage. It sits atop thin red legs as it stylishly wades looking for food.

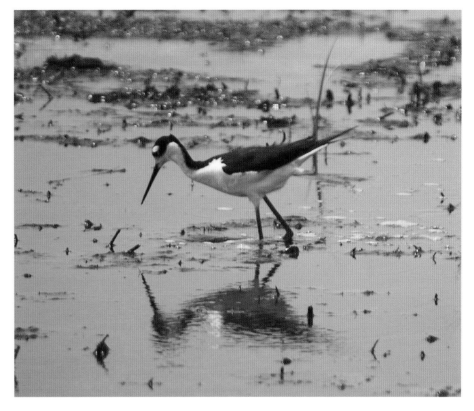

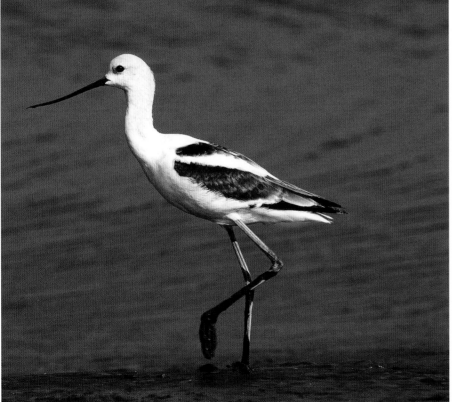

Another rare species that may be found in Cape May or at the Edwin B. Forsythe NWR is the American Avocet. Unfortunately, it doesn't usually visit during breeding season, so we miss out on the beautiful black, white, and cinnamon plumage. When here in New Jersey, the Avocet is usually gray and white. *Courtesy of Dr. Howard B. Eskin*

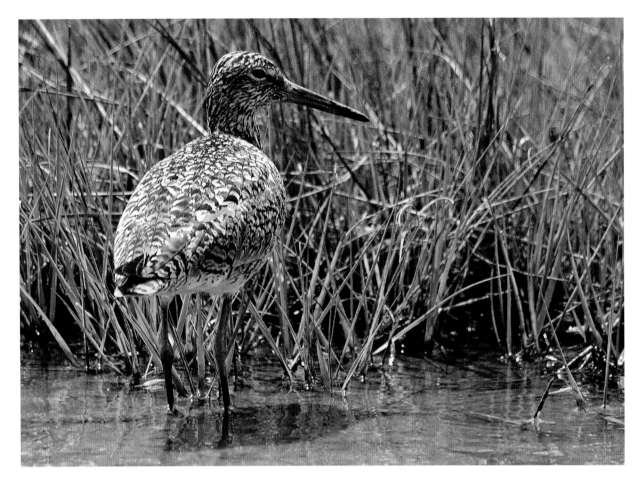

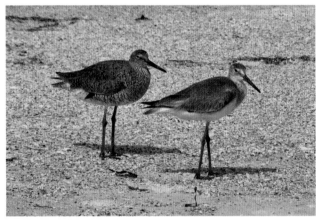

Willet or will it not? That is the question. A large, stocky shorebird that always seems to have a lot to say, the Eastern Willet is very common along our marshes and estuaries. Heavily dappled during the summer, it's the striking black and white wing pattern in flight that draws your attention.

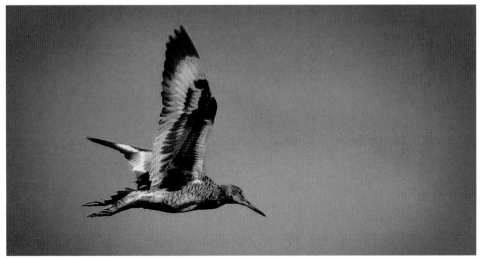

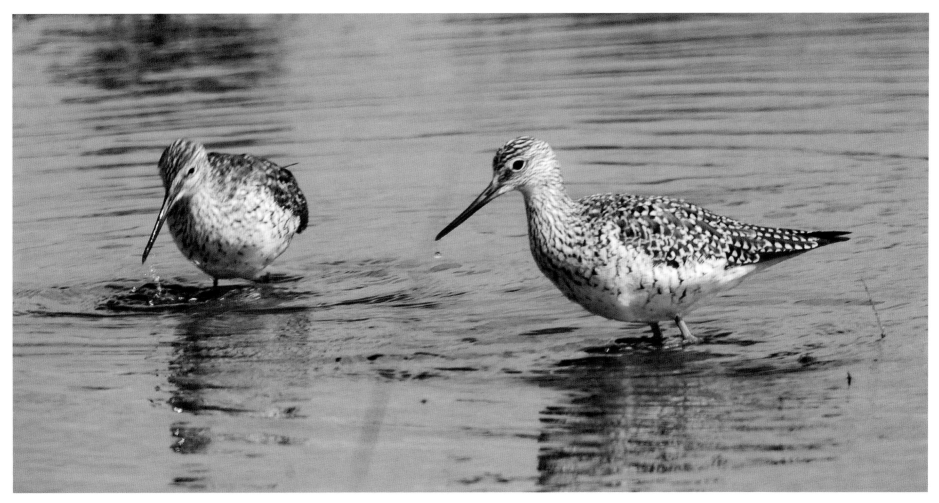

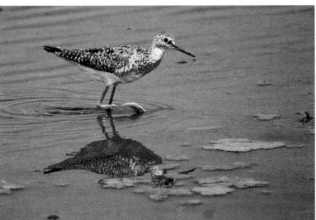

A common resident during the warmer months, the Greater Yellowlegs (facing left) is one of the larger shorebirds found along our coastal waters. Of course, it has prominent yellow legs, with a long, slightly upturned bill. The Lesser Yellowlegs (facing right) is very similar, but well, lesser with a shorter, straighter bill.

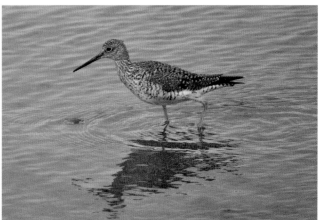

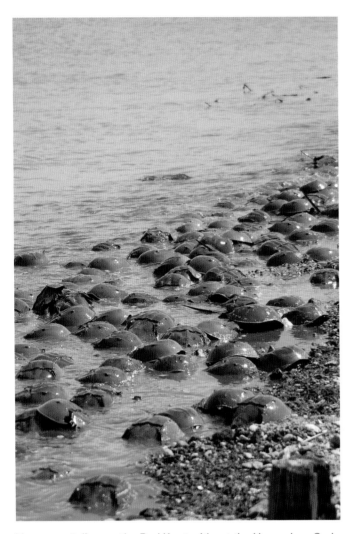

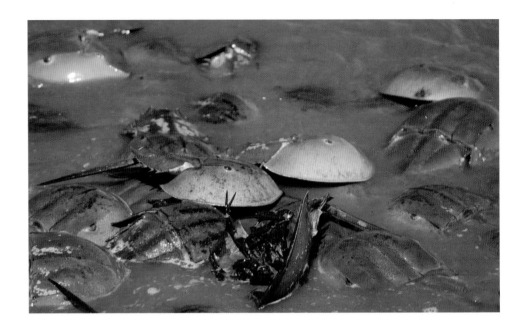

You cannot discuss the Red Knot without the Horseshoe Crab. These two species are inextricably connected especially along the Delaware Bayshore. The Knots are on their migration from Patagonia to the Arctic to breed, flying thousands of miles during May. When they reach the Delaware, they are exhausted and must fatten up for the rest of the flight north. Horseshoe Crabs are laying their eggs in the tens of millions during the full moon in May. The two species' cycles coincide at this moment of the year. But, even with the prohibition on harvesting the crabs, the Red Knot population has suffered drastic declines over the past decade, and was recently listed as endangered in New Jersey. (Above and opposite page)

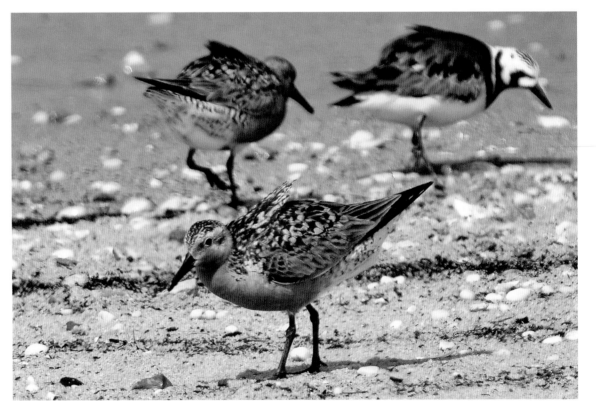

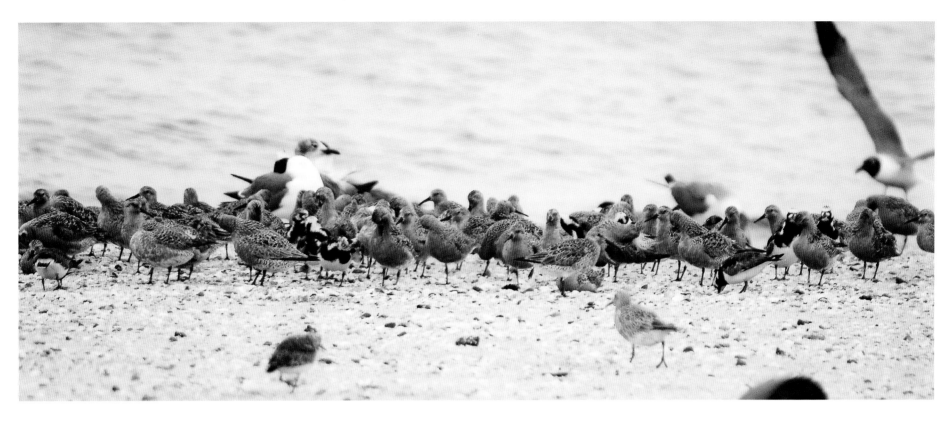

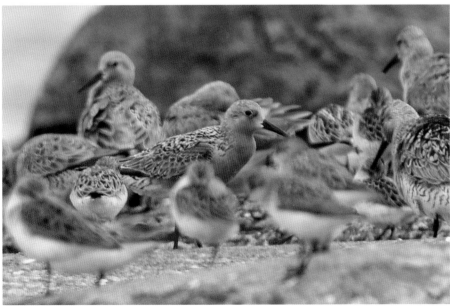

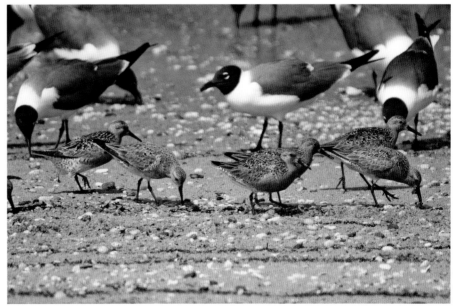

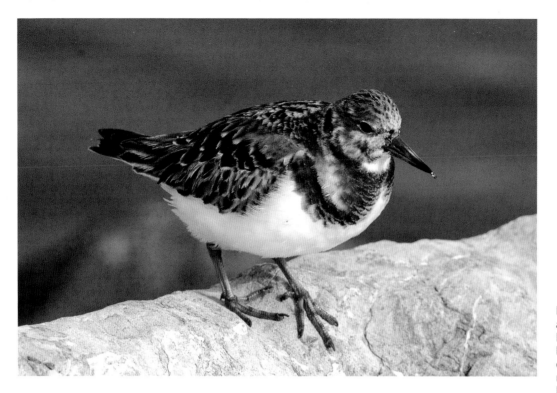

Ruddy Turnstones sometimes stay along Barnegat Inlet and Cape May during the winter, but the large populations pass through during the spring migration, many showing up at the Delaware Bayshore feast in late May. These sturdy shore birds with bright orange legs, actually do turn over stones to find their food. Shown are both the winter (duller) and summer plumages.

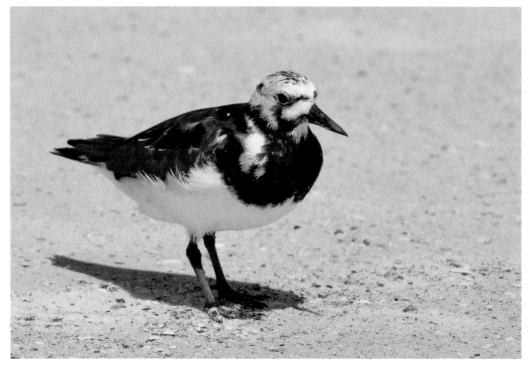

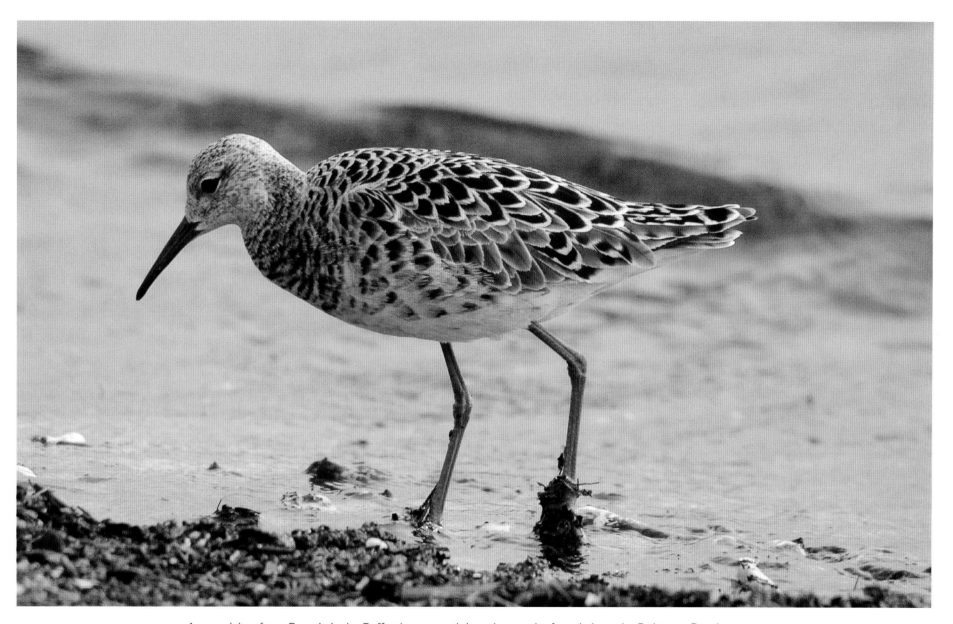

A rare visitor from Eurasia is the Ruff, a larger sandpiper that can be found along the Delaware Bayshore area in the spring. Unfortunately for us, we normally don't see the male in mating plumage, which is quite dramatic, especially when he displays. This is the female called a Reeve, and she does not have a ruff – go figure.

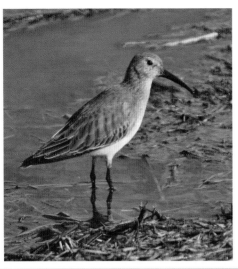

The easiest way to distinguish Dunlin during the breeding season is the large black belly patch. Dunlins are the most common sandpipers in the state, with large flocks covering mudflats all along the coast even during the winter. (Below and opposite page)

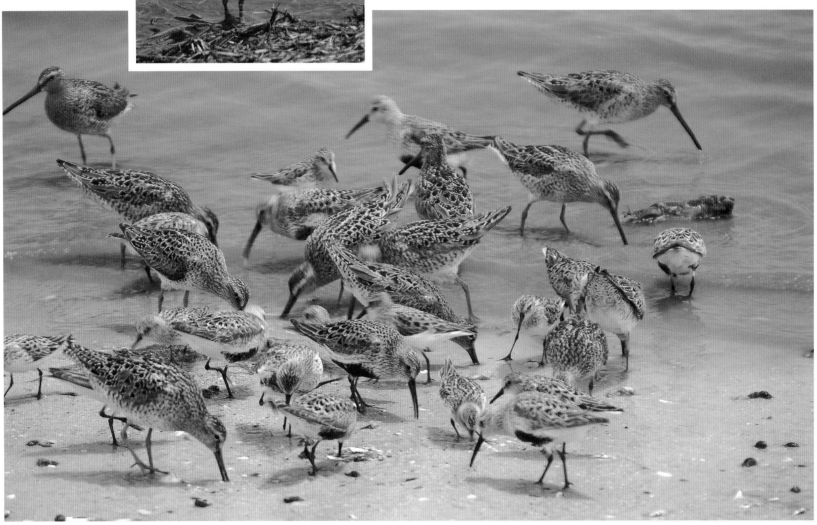

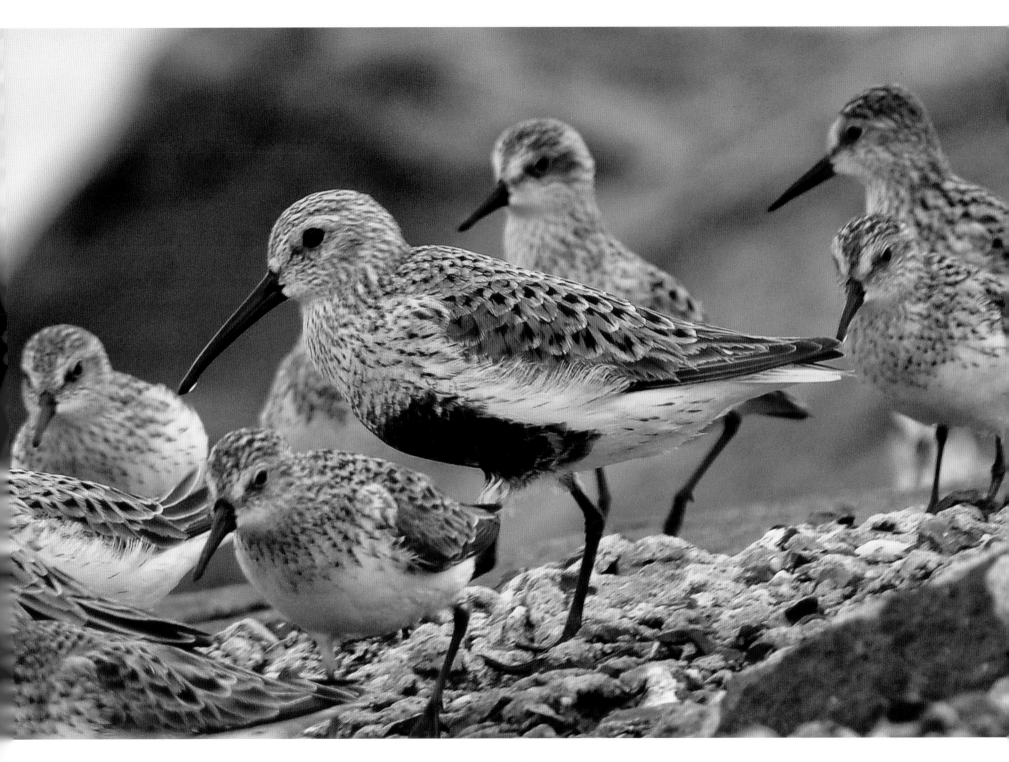

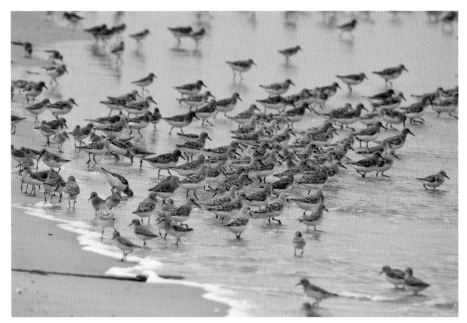

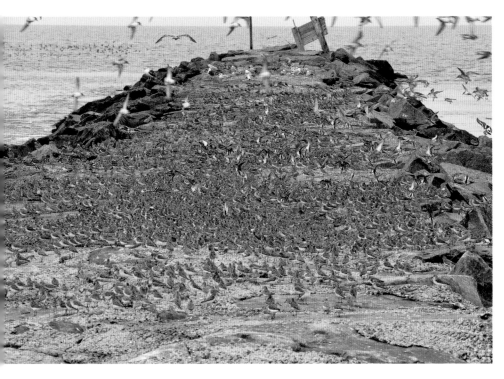

Reed's Beach along the Delaware Bay during Spring migration, Cape May County.

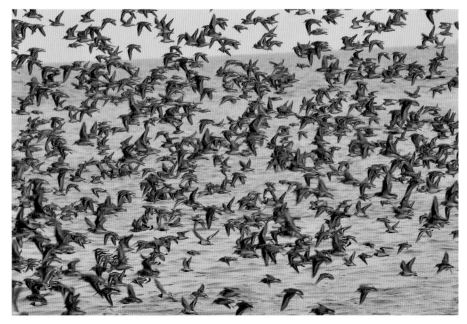

In New Jersey, we are more likely to see Short-billed Dowitchers than Long-billed ones, though both migrate through the state. Experts state that the easiest way to tell the two apart is the flight call—good luck with that.

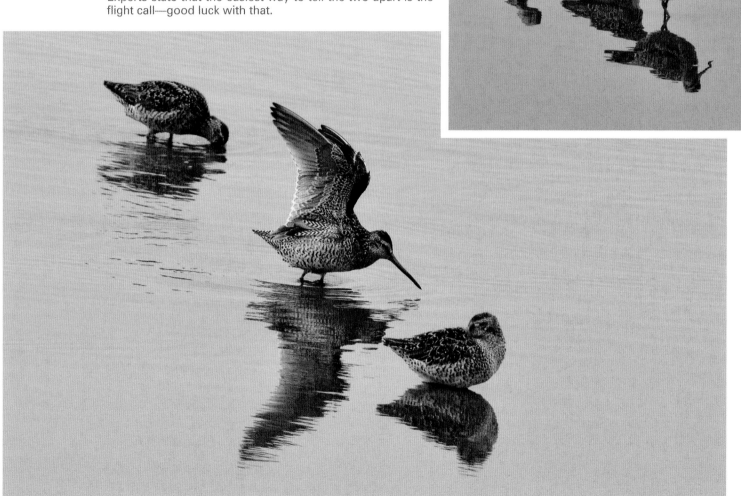

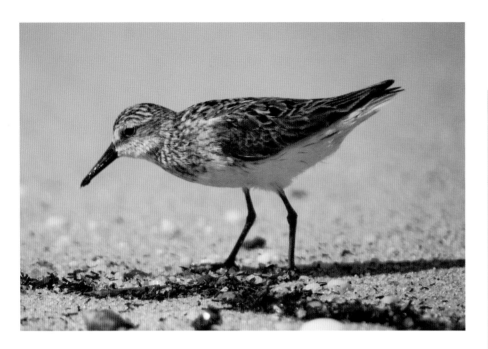

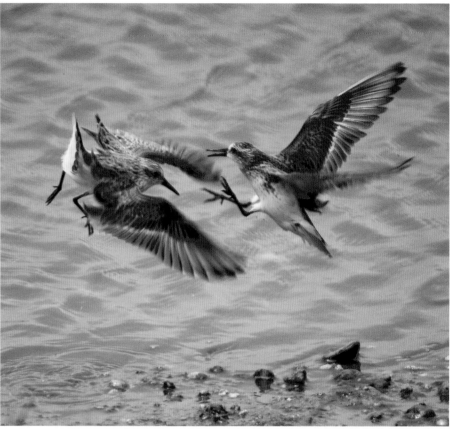

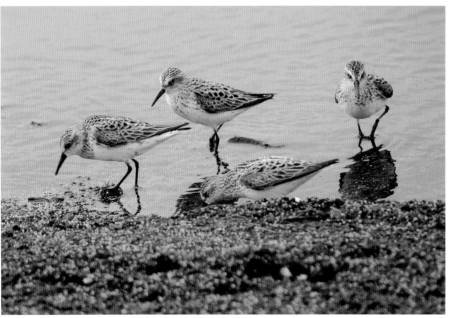

Semipalmated Sandpipers pass through New Jersey from wintering areas in South America to breeding grounds in the Arctic and back again. To fuel up for these treks, the Semipalmated Sandpipers feed at tidal mudflats for insects and small marine invertebrates.

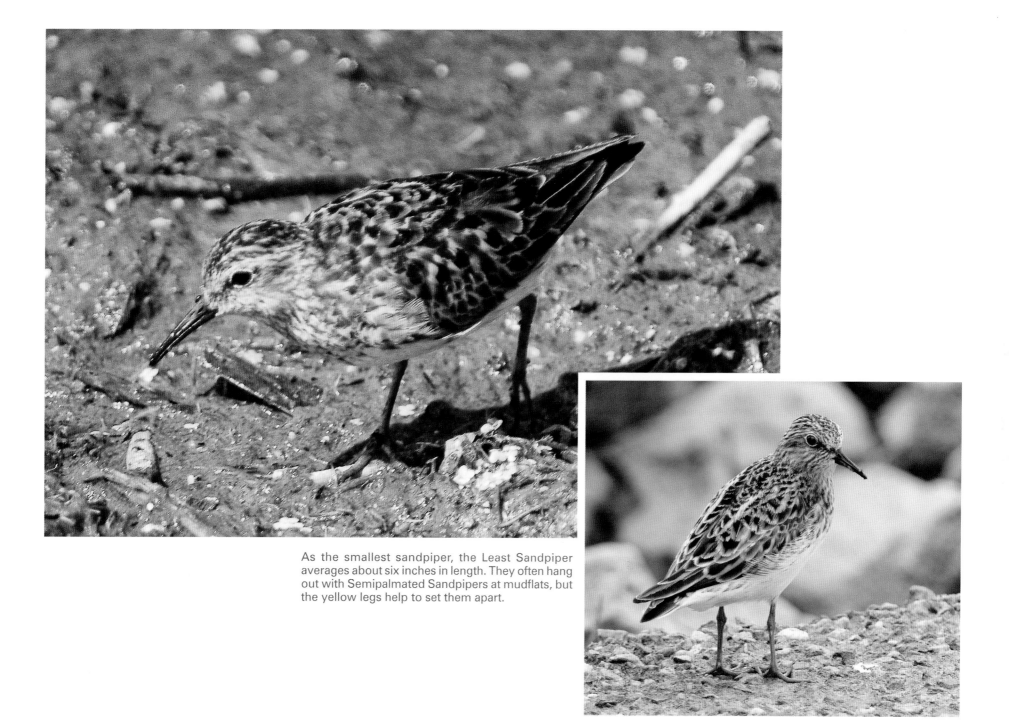

As the smallest sandpiper, the Least Sandpiper averages about six inches in length. They often hang out with Semipalmated Sandpipers at mudflats, but the yellow legs help to set them apart.

Snapping Turtle.

Familiar Bluet Damselfly.

Eastern Red-bellied Turtle.

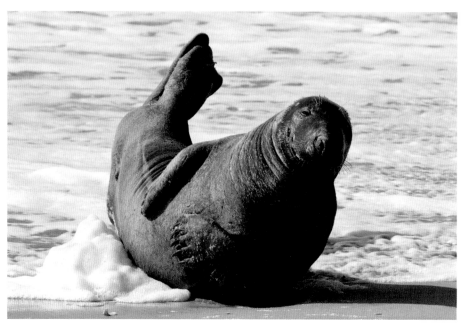

Gray Seal taking in the sun on Long Beach Island.

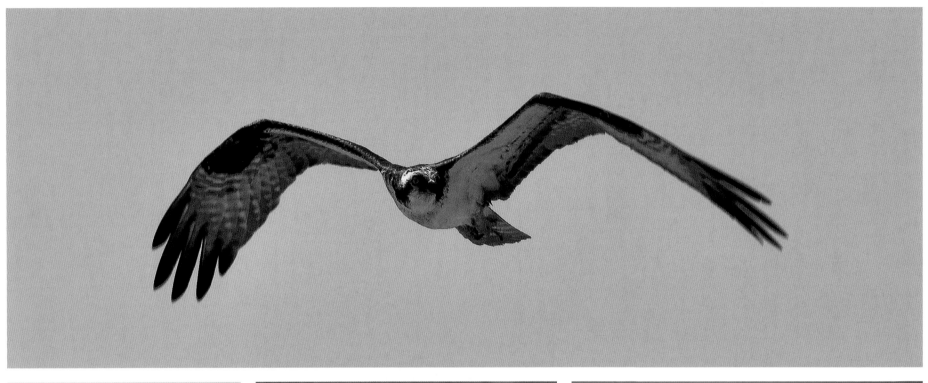

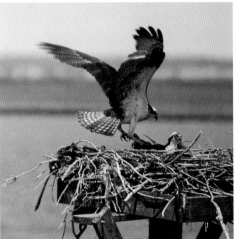 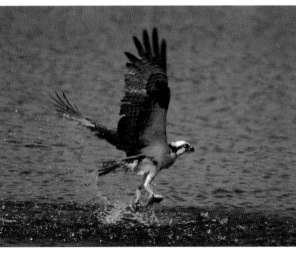 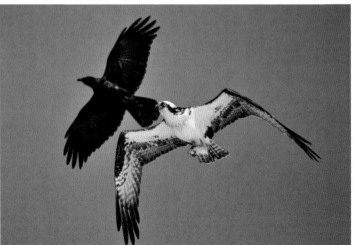

You always know when spring has arrived when Ospreys return from their southern wintering grounds to start building or repairing their nests. The Osprey is the only raptor that dives feet first into the water to catch the fish that it feeds on. After almost going extinct due to pesticides, these large birds have recovered well, though still threatened in the state, and they can easily be seen along the New Jersey coast on nesting platforms.

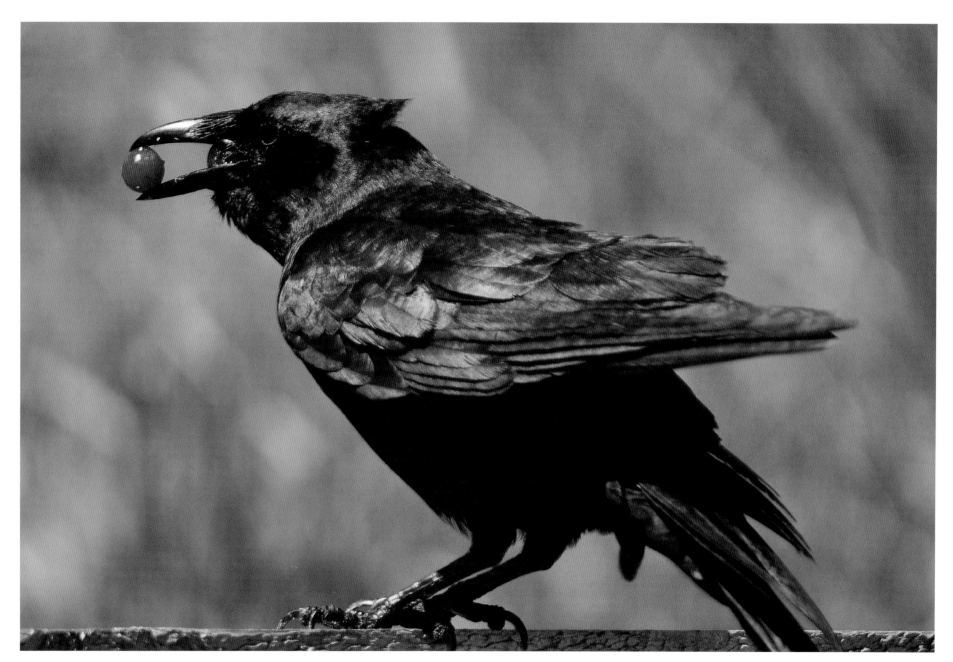

The Fish Crow is a bit smaller than the American Crow and hangs out at the beach. During the breeding season, these birds can decimate Piping Plover nests and Least Tern colonies of their eggs and young.

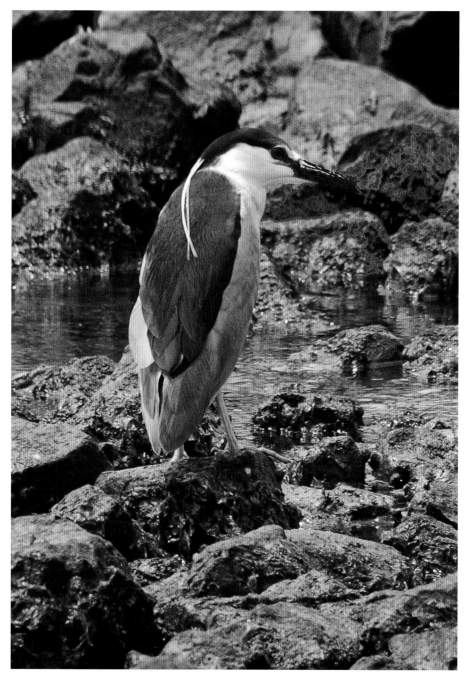

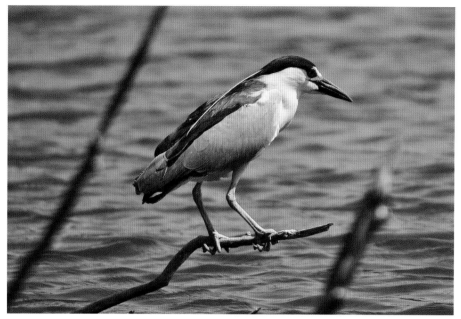

A threatened bird in New Jersey, the Black-crowned Night Heron is a short and stocky heron that roosts mainly during the day in trees and bushes and wades for fish at night. Having a black crown and back with a white body, two long white neck plumes appear during breeding season. Found in wetlands and marshes, usually a large group can be seen roosting on Silver Lake in Belmar during the winter months or breeding during the late spring at Heislersville Wildlife Management Area. The juvenile is mostly brown with white spotting and a pale bill.

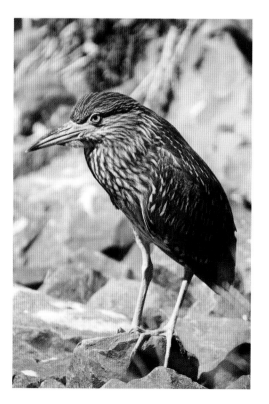

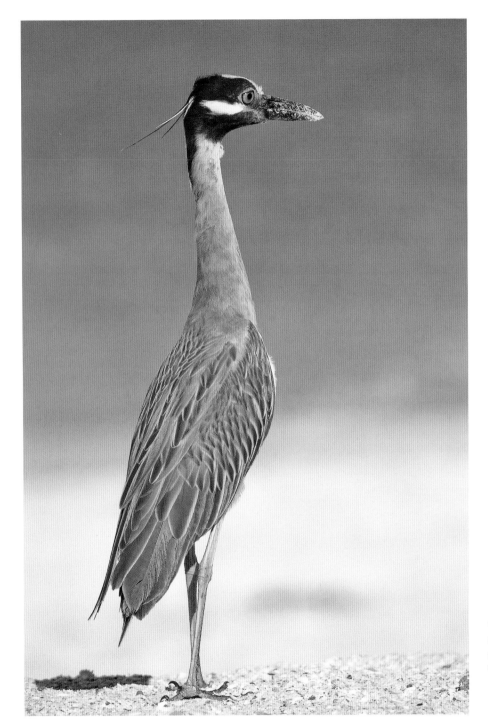

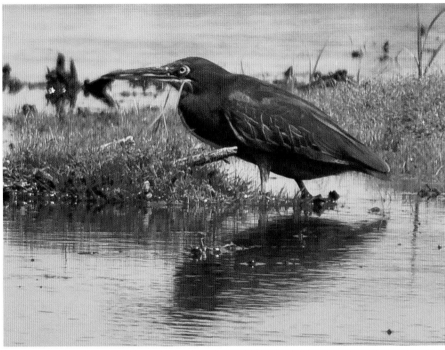

The smallest heron in North America, the Green Heron is a shy bird that can be hard to find in marshes and ponds. These herons are fairly common in New Jersey and do breed in the state.

Yellow-crowned Night Herons are also threatened in New Jersey, and seem to be much harder to find than Black-crowneds. Mostly gray with a distinctive black head with white cheeks and their yellow crowns, these herons form large colonies in trees to nest.

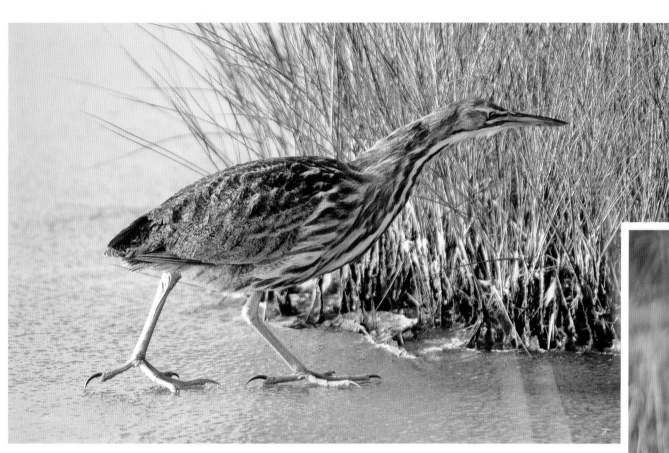

Find me if you can. The American Bittern, endangered in New Jersey, is incredibly difficult to find in marsh reeds as it blends in so well with its habitat. Dark brown and black streaks in brown plumage makes this slow wading, shy heron such a good find for birders. With luck you may find it standing perfectly still with its bill pointing upwards. And, if you don't believe that birds are descended from dinosaurs, just check out the feet on this one.

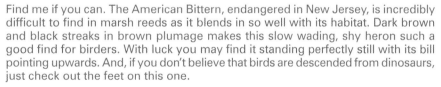

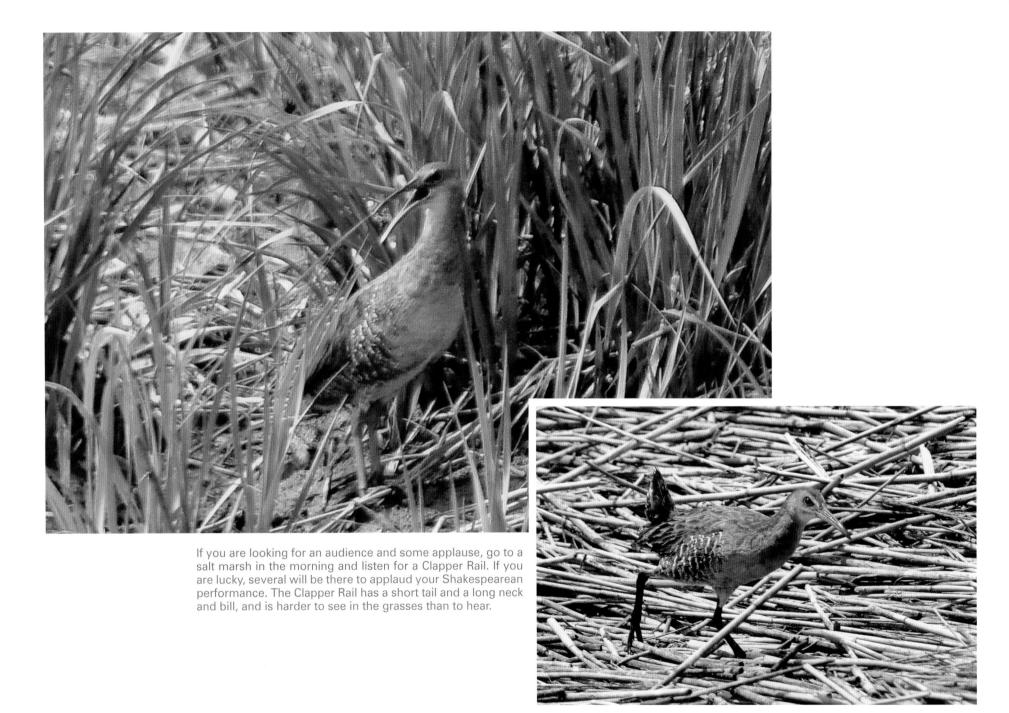

If you are looking for an audience and some applause, go to a salt marsh in the morning and listen for a Clapper Rail. If you are lucky, several will be there to applaud your Shakespearean performance. The Clapper Rail has a short tail and a long neck and bill, and is harder to see in the grasses than to hear.

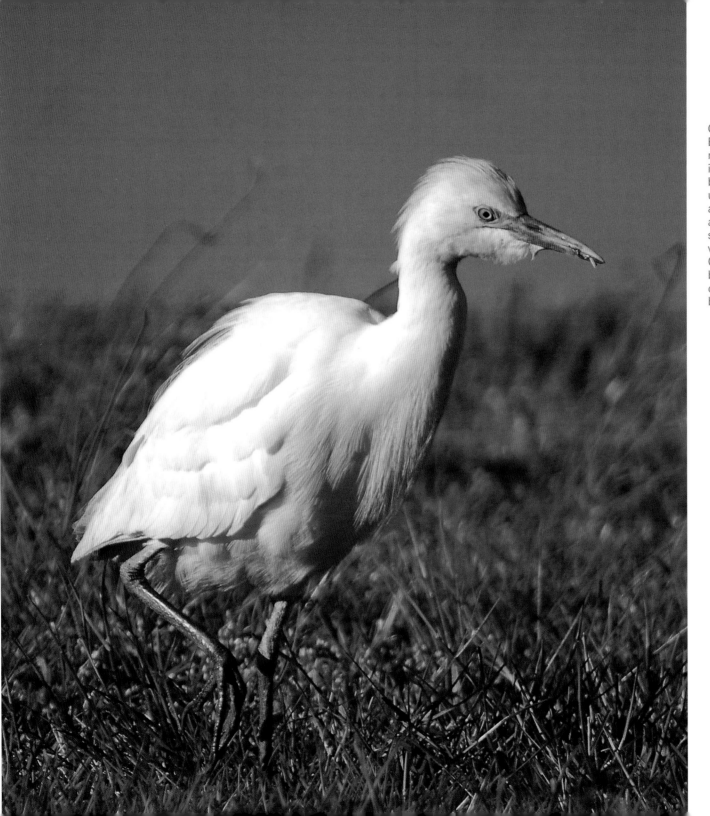

Originally from Africa, the Cattle Egret is expanding its region into most of the Americas. It has found its way into New Jersey and can be seen both along the coast and upland areas near livestock. This is an egret that eats insects and worms and avoids the water. A short and stocky egret that may be confused with the Snowy Egret at times, the Cattle Egret has a shorter yellow bill and develops orange plumage on its crown, back, and neck during breeding season.

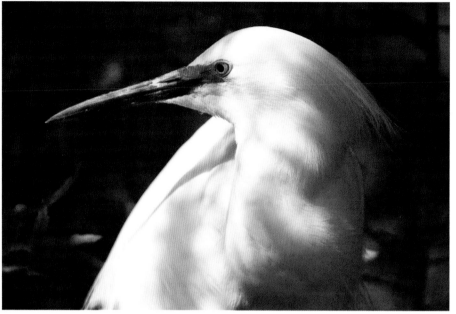

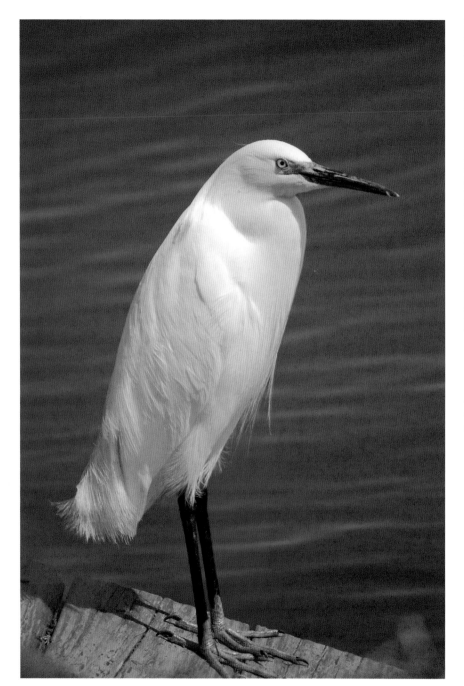

Bright yellow feet looking like a pair of galoshes help to identify the Snowy Egret. Smaller, with a black bill, and more slender than the Great Egret, they are both often seen feeding together around open water. During the late nineteenth century, the millinery industry's use of their lovely white lacy breeding plumage for ladies' hats almost drove these egrets to extinction. What a tragedy that would have been. This sparked the bird conservation movement, including the creation of the National Audubon Society and National Wildlife Refuges. Fortunately, they have made a great comeback due to conservation and are common around wetlands and lakes. During breeding season their lores may change from yellow to red. (Left, above, and opposite page)

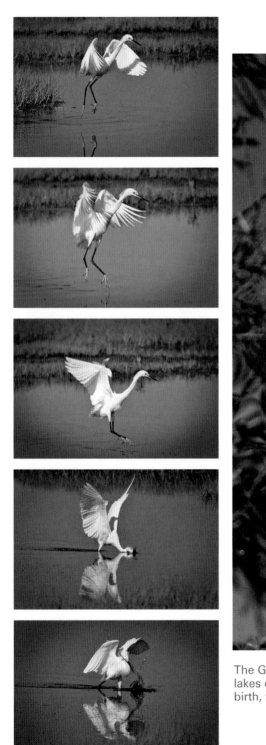

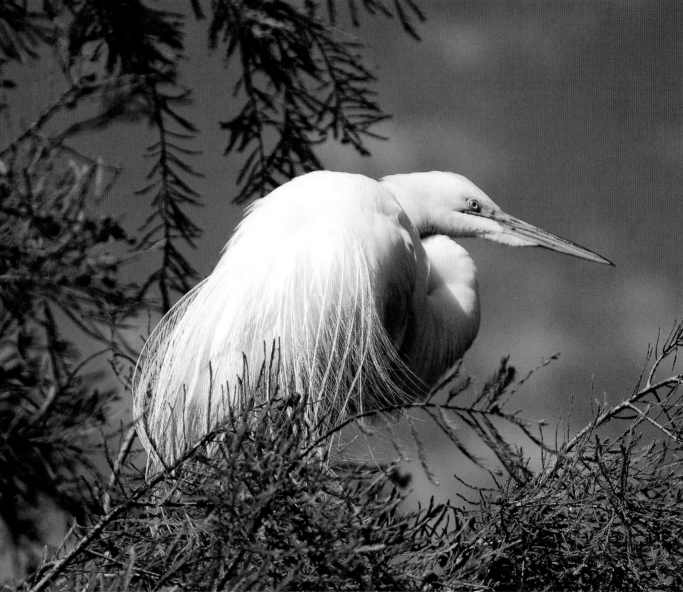

The Great Egret is the largest egret in North America, and is pretty easy to find along the wetlands and lakes of New Jersey. They are very social and nest in large colonies, usually in trees. All white from birth, they have black legs and feet, and a thick yellow bill. (Above and next two pages)

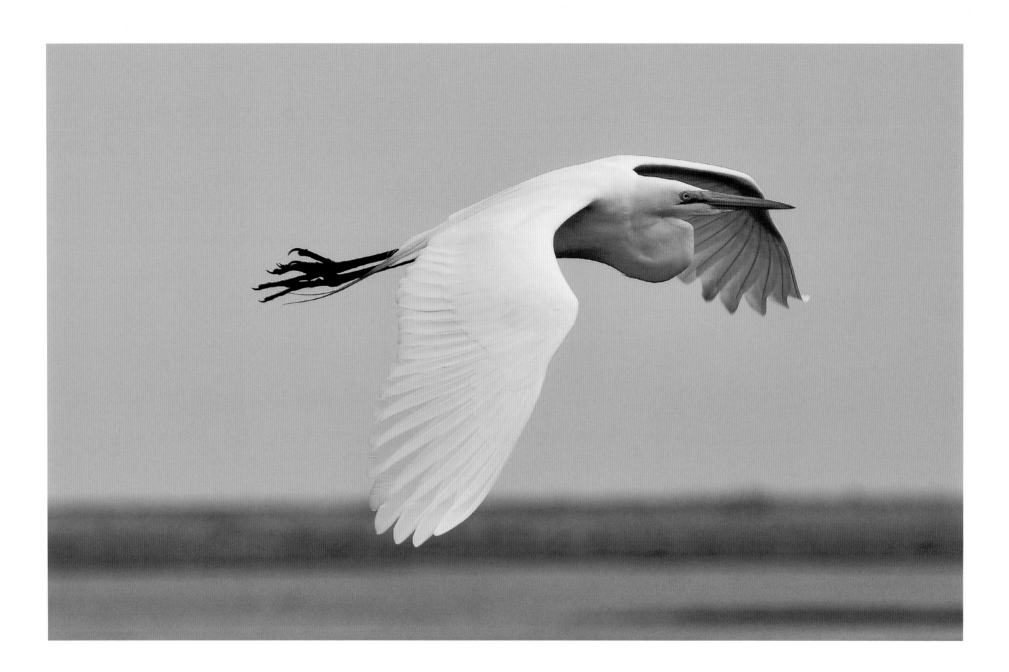

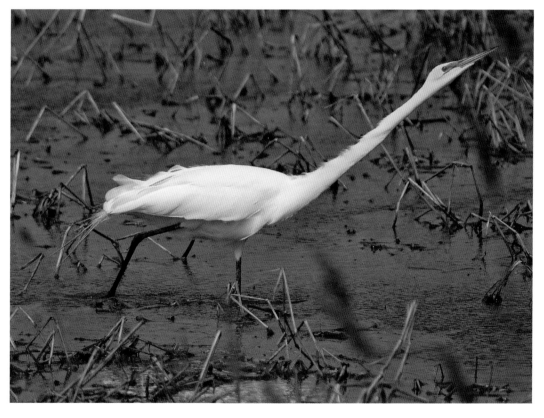

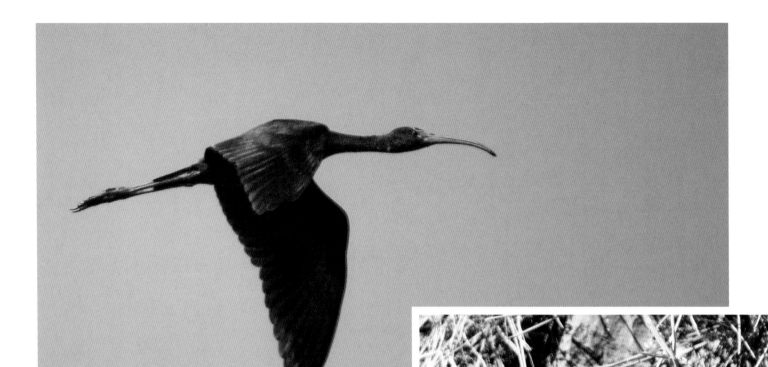

The long-legged Glossy Ibis is becoming a more frequent visitor to our marshes. Their dark plumage will look a glossy purple or green during breeding season depending on the light. Come autumn these snow birds head south, along with a good portion of New Jersey residents.

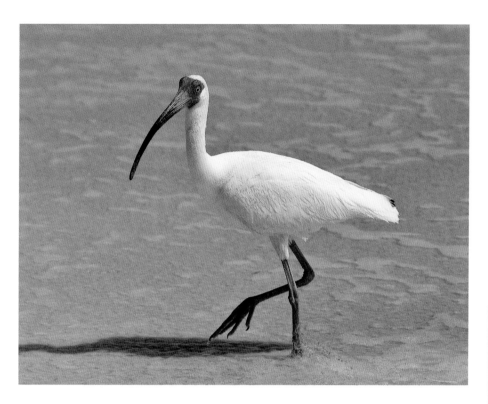

An infrequent visitor from the South during the summer months, the White Ibis has a striking red face and bill and all white body except for black tipped primaries. It seems that juveniles, who sport brown and white plumage, are the ones mostly likely to travel up north, probably trying to get away from the folks.

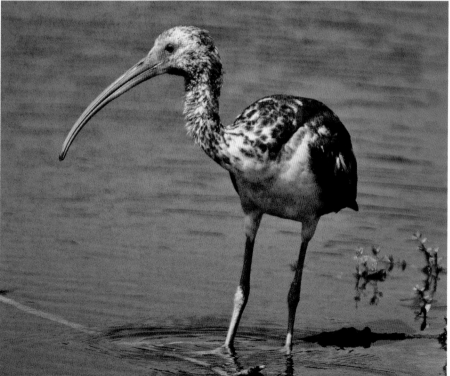

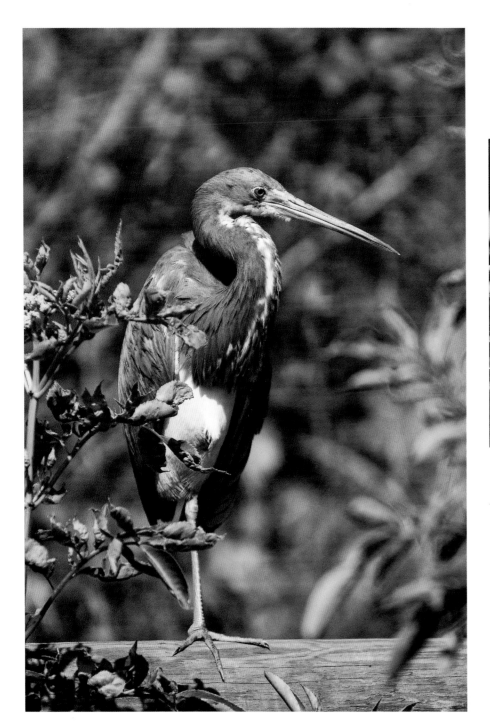

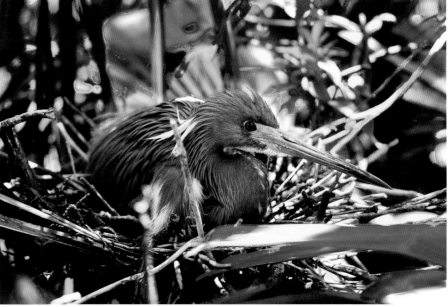

Found in southern New Jersey during the summer months, the Tricolored Heron is much smaller than the Great Blue. Formerly called the Louisiana Heron, this slender wading bird is dark blue with a white belly, and nests in trees or brush.

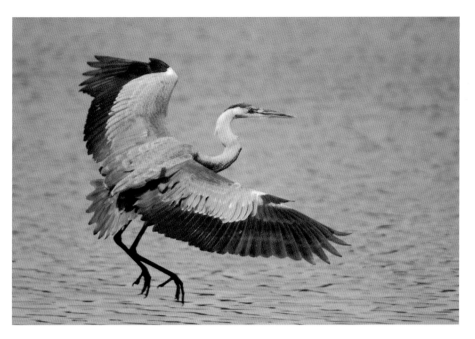

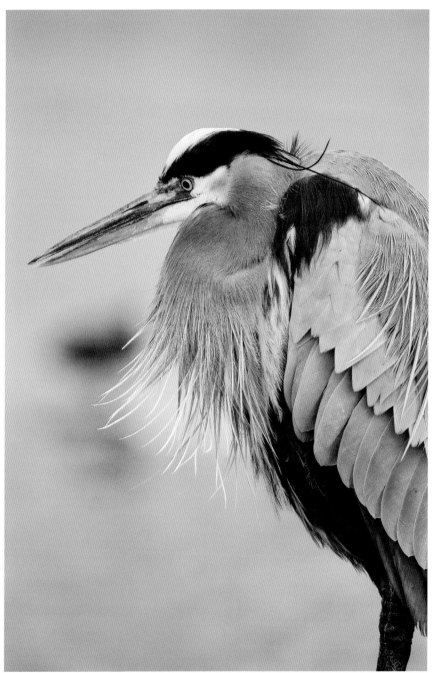

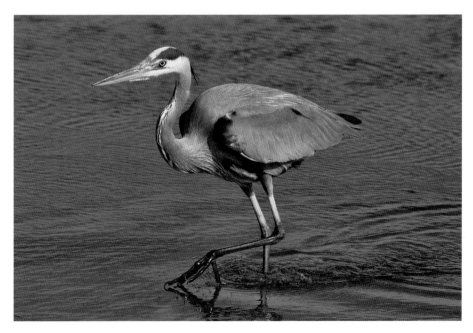

The largest of the herons, the Great Blue has a six-foot wingspan and gray-blue plumage, a white head with a black stripe. These herons are fairly solitary and can be found all over New Jersey, even in the winter. Patience is the name of the game for these large hunters, standing and waiting to spear a fish.

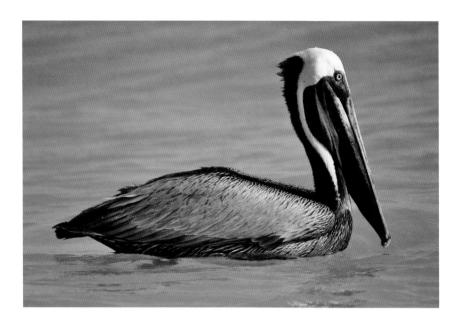

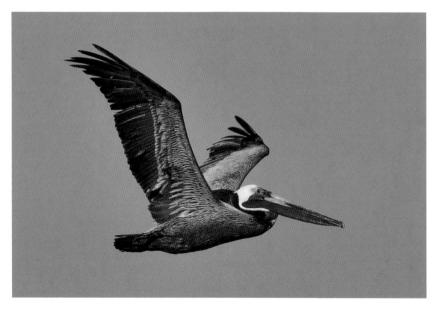

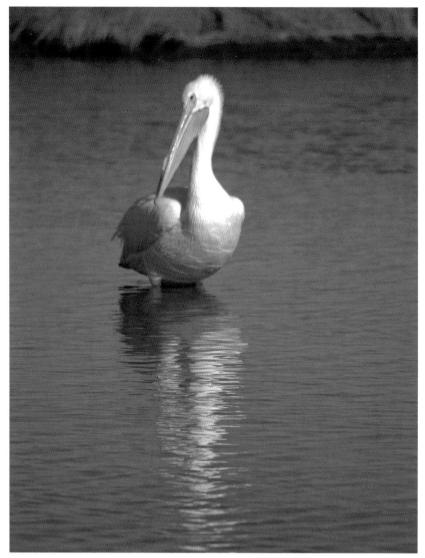

A very rare visitor to our coast, the American White Pelican is usually found in the west and along the Gulf Coast. Much larger than the Brown Pelican, this species is white with black wing tips and an orange bill. Occasionally, a few will find their way to Cape May, or this fellow, who one summer spent weeks at the Edwin B. Forsythe NWR.

Looking like something out of *Jurassic Park*, Brown Pelicans have made a comeback in New Jersey, with flocks seen at Barnegat Inlet and along the coast in the summer. Formerly endangered due to DDT, protection has worked well for these large fish eaters, who glide over the ocean waters, and then make a headlong dive into the sea to grab their meals.

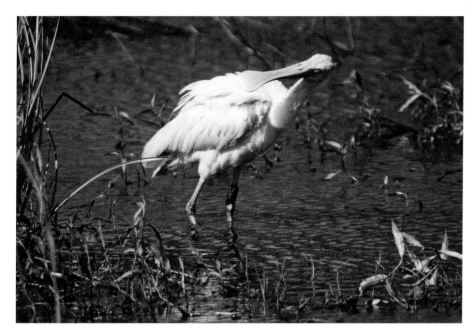

Related to ibises, the Roseate Spoonbill is very distinctive with its dark pink body and large, flat bill that it uses to find food while wading through shallow waters. In 2009, one spent the latter half of the summer attracting birders to the Edwin B. Forsythe NWR.

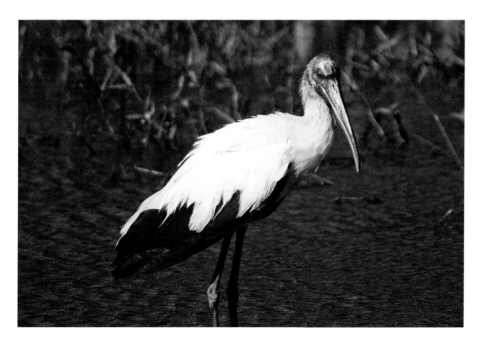

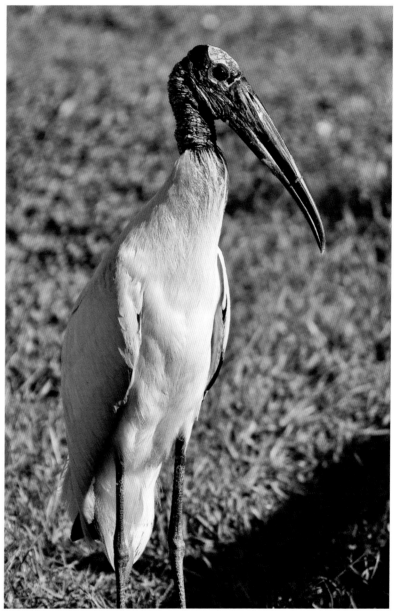

With about a dozen sightings recorded in New Jersey, the Wood Stork is considered an extreme rarity. This large, thick-billed bird normally resides in and around Florida. Occasionally, one may get wanderlust and travel up to the Northeast coast checking out late summer rentals.

Grasslands, Meadows, and Marshes

New Jersey is known as the Garden State, but these days you may see more housing developments than farms as you drive along our country roads. The grasslands and meadows that farms and open spaces provide are a significant part of the landscape for migrating and breeding birds. According to the New Jersey Division of Fish & Wildlife, grassland species comprise forty-one percent of New Jersey's endangered and threatened birds, and their populations are declining. Native grasses and wildflower meadows are usually low maintenance, are beautiful to look at, provide erosion control, and provide habitat for butterflies and a wide variety of other animals. In addition, many raptors depend on grasslands for their hunting grounds.

Birds also provide the plants and grasses the benefit of spreading their seeds near and far. Nest boxes can be found in many of these areas for Purple Martin and Eastern Bluebirds. Some of the best places to visit this habitat are Bright View Farm in Burlington County, Johnson Sod Farm in Cumberland County, Lakehurst Naval Air Station (with permission) in Ocean County, Alpha Grasslands in Hunterdon County, along with the Wantage Grasslands in Sussex County. Marshes along our coasts provide valuable habitat and protect our mainland, while wetland meadows and swamps help to filter fresh water. These marshes would include the Great Swamp, the Meadowlands, and Mannington Meadows.

Bright View Farm, a horse farm located in Burlington County.

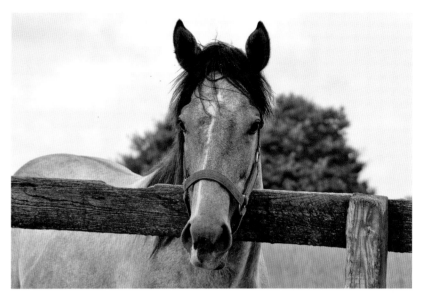

A Bright View Farm horse.

Many farms and grasslands are being lost to development; however, the state has instituted the Farmland Conservation Program, saving thousands of acres every year. Raptors, vultures, and other scavengers are also threatened by ingesting prey killed by pesticides and lead bullets, which may eventually kill them.

Richard W. DeKorte Park, Meadowlands, Bergen County.

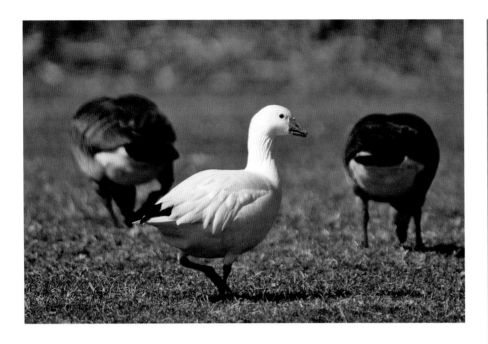

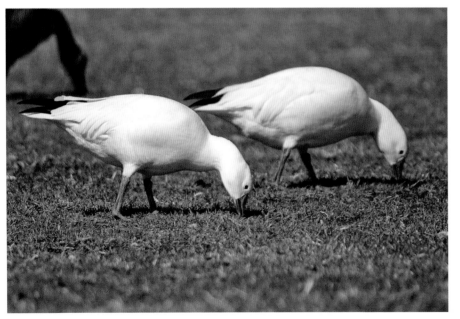

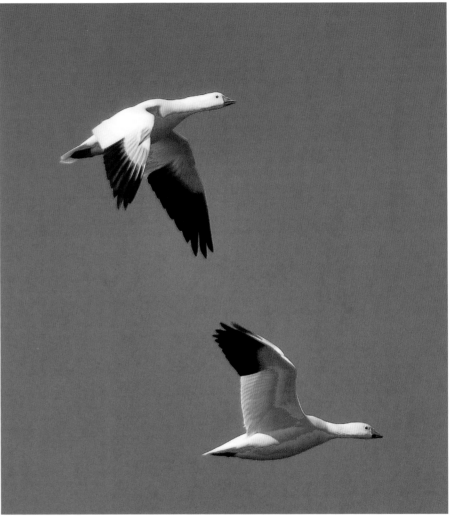

A rare winter visitor, the Ross's Goose looks very similar to the Snow Goose, but is smaller with a stubbier bill. A high Arctic breeder, they may be seen in flocks of Snow or Canada Geese eating in grasslands until it's time to fly north.

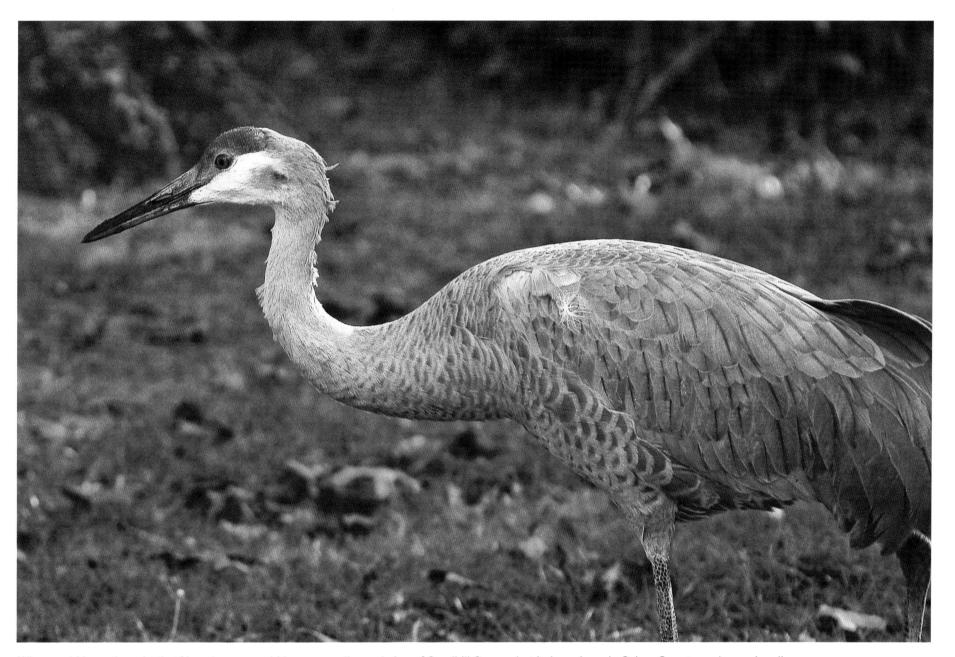

Who would have thought that New Jersey would have a small population of Sandhill Cranes, but it does down in Salem County, and occasionally in Cape May. Almost as tall as the Great Blue Heron, these large birds are gray with a white head, topped off with a red crown. They can be found in flock with several Common Cranes (a non-native Eurasian species) in open grasslands or meadows feeding on seeds and grain.

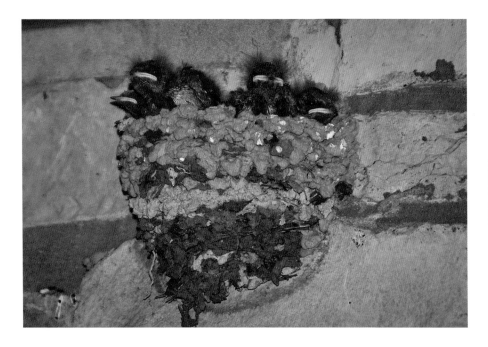

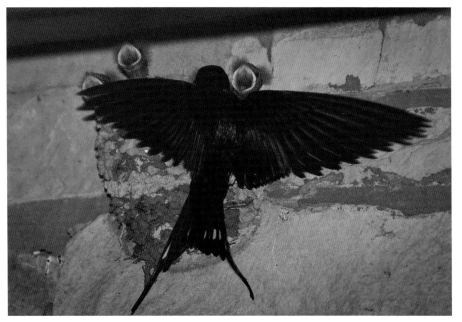

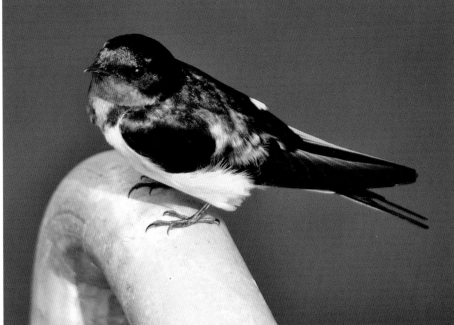

Flying swiftly across the meadows catching insects is the dark blue iridescent-backed, cinnamon-breasted Barn Swallow, which is the only swallow with a true swallow tail. Being able to photograph one of these speedy little birds sitting still is a great treat. They make mud nests all over North America, raising three to five chicks at a time, and then gather in large flocks for their migration to Central and South America for the winter.

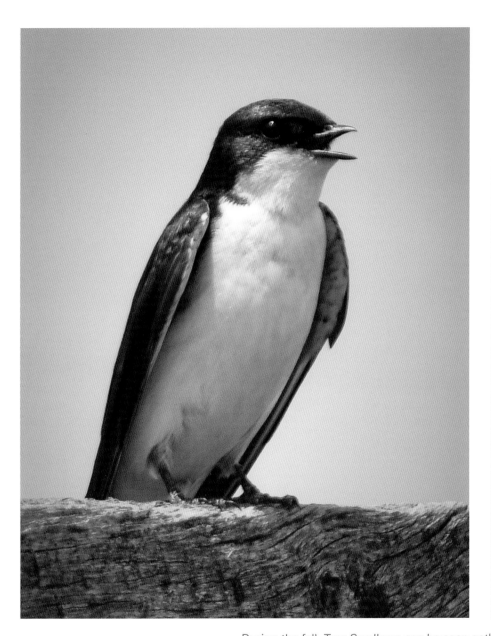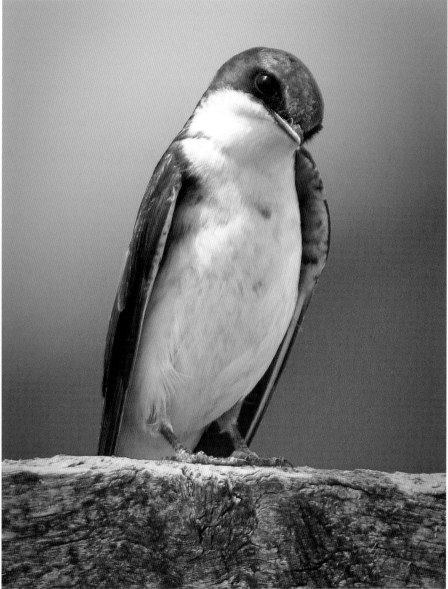

During the fall, Tree Swallows can be seen gathering en masse, usually near water, for their migration south. They seem to move as one, as thousands grab insects on the fly. Having an iridescent blue-black head and back with a white underbelly, they can be seen perching on wires or taking over bluebird boxes. The female has slightly duller plumage.

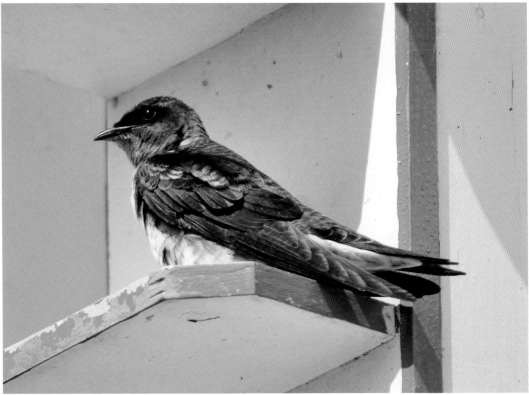

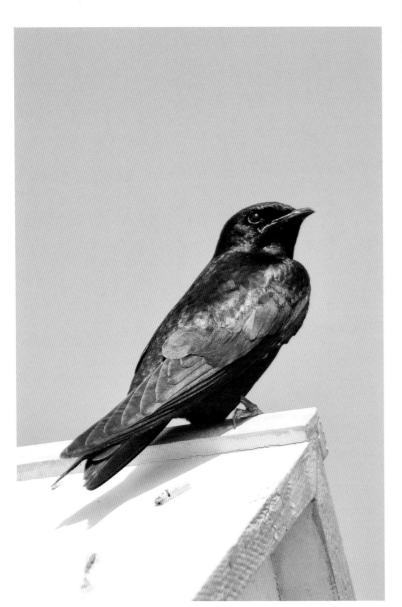

Purple Martins, the largest of the swallow family, are almost entirely dependent on humans for their homes. Communities of Martins can be found wherever anyone has set up a gourd or house for these spring migrants, usually in southern New Jersey. Towards the end of the summer, large flocks gather along the Delaware Bayshore, prior to their fall migration to Brazil. With their populations declining, let's hope that they are not a victim of the next housing bubble. (Left, above, and opposite page)

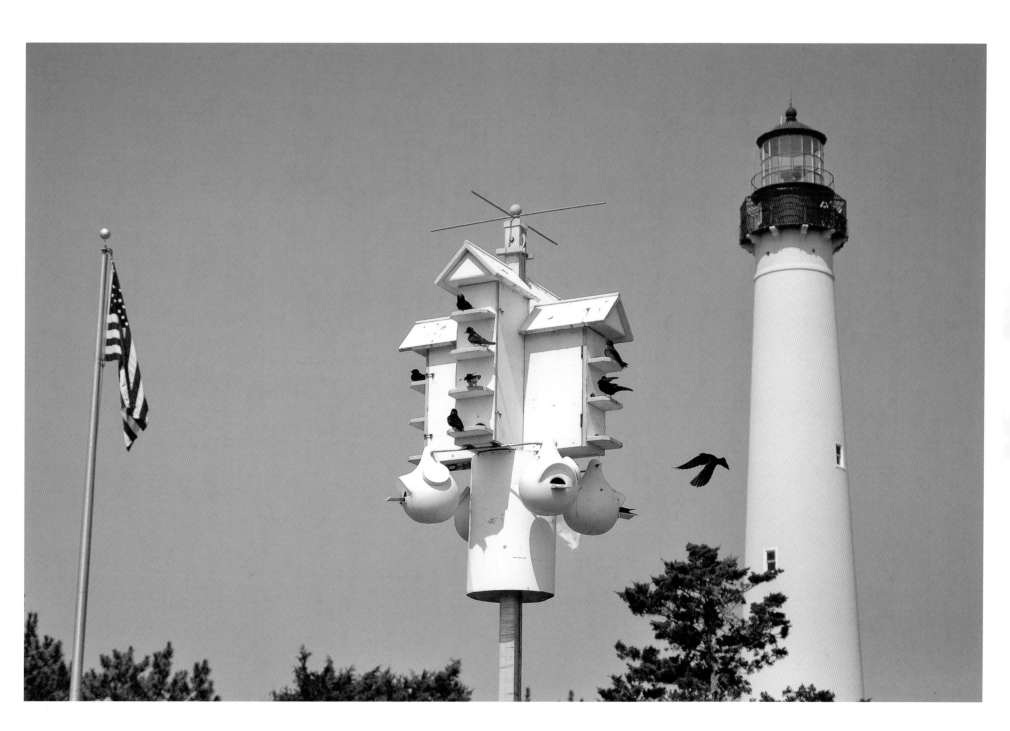

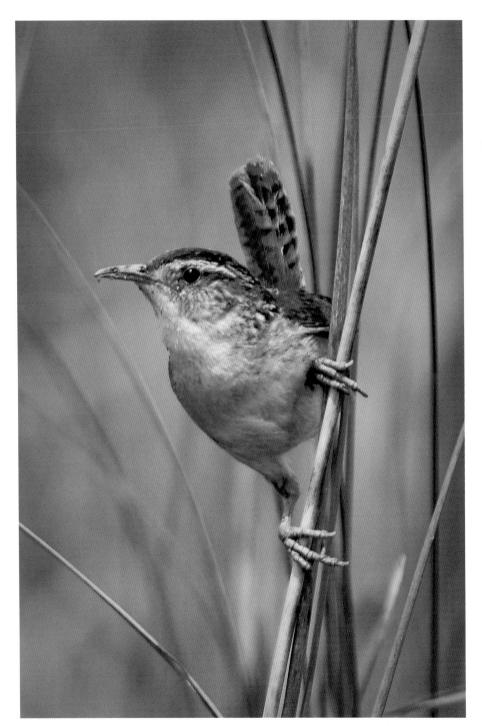

Making their ball-shaped nests of marsh grasses placed between reeds, the Marsh Wren is a small, chubby bird with a downward-curved bill and upward-turned tail. Often building a second faux nest to protect against predators, this little wren is common during the summer in swamps and marshes.

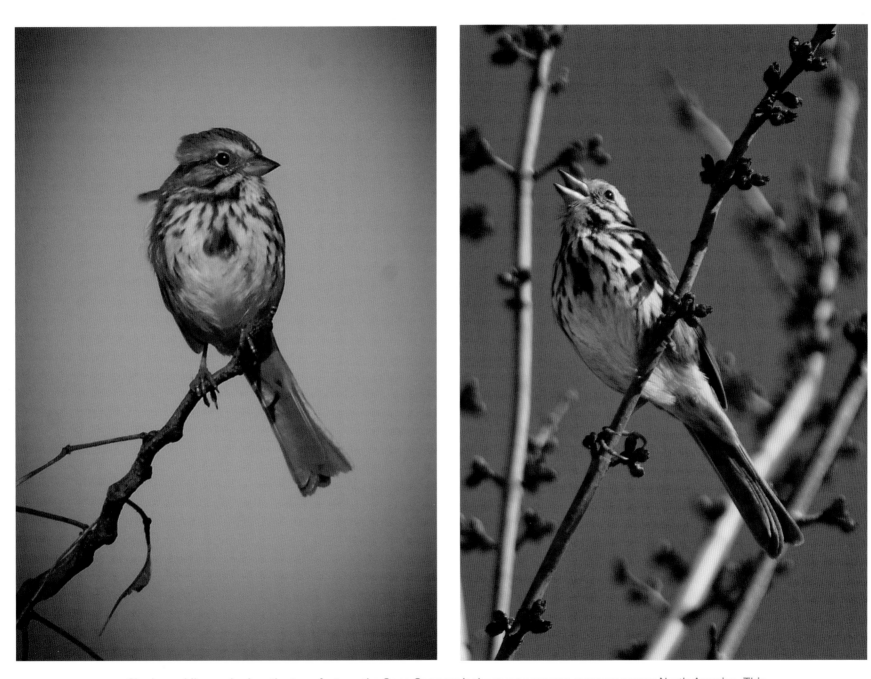

Singing, while perched on the top of a tree, the Song Sparrow is the most common sparrow across North America. This species of sparrow is easy to distinguish with its heavily striped breast, dark chest spot, and pinkish legs.

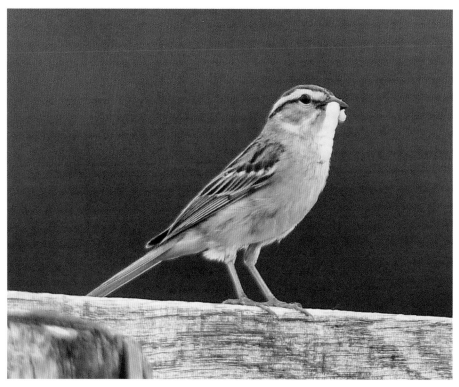

Very common in our state, the Chipping Sparrow eats seed, so can be found at your backyard feeder on any given day. With the rusty crown and white eyebrow, they have a black line extending from the eye to the ear, which helps to distinguish them from Field Sparrows.

The threatened Savannah Sparrow, seen sitting on a fence, can be found in our grasslands and wetland thickets during the colder months. They have plumage variations depending on geographic location, making identification all the more difficult for the beginner birder. The "Ipswich" subspecies, seen here on the ground, can sometimes be found during the winter at Barnegat Lighthouse State Park.

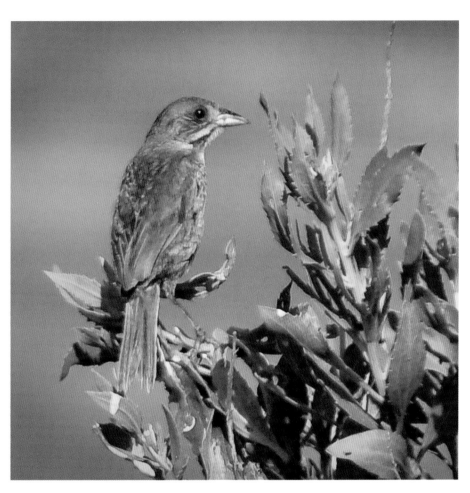

Commonly found in coastal salt marshes, the Seaside Sparrow is a chunky, thick-billed sparrow. They can be identified with a white throat and yellow lores perched on a reed, singing all day long.

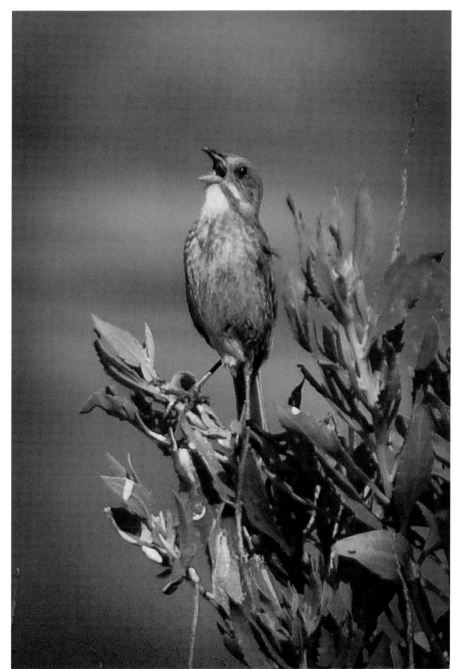

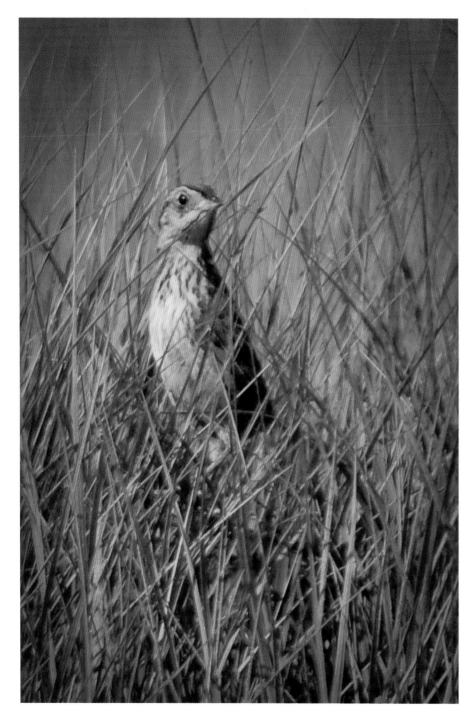

New Jersey grasslands.

As its name implies, the Saltmarsh Sparrow is found in our salt marshes during the summer months. It's the yellow-orange triangle on the face and deep streaking on the chest that helps identify this sparrow.

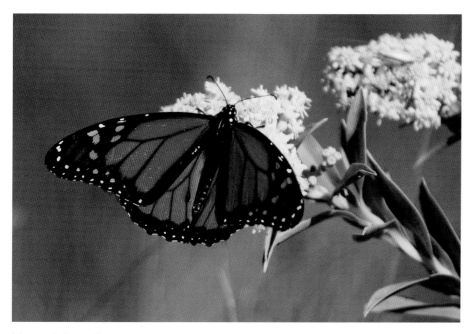

Monarch Butterfly.

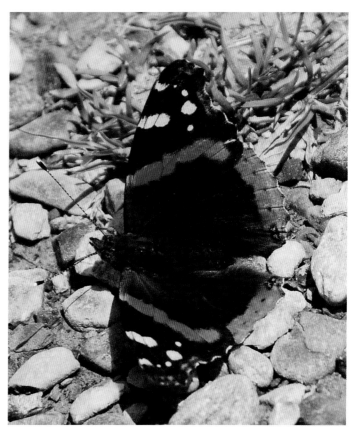

Red Admiral Butterfly.

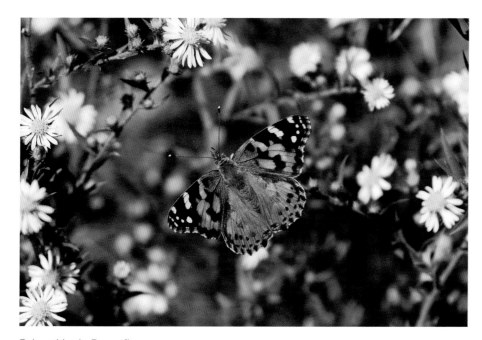

Painted Lady Butterfly.

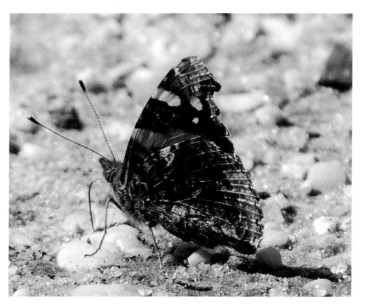

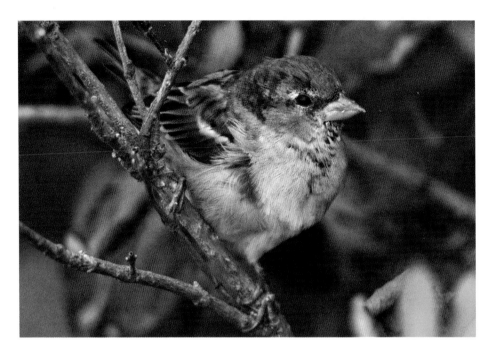

Found everywhere, the House Sparrow or English Sparrow, was first introduced to America in 1851, and the rest is history. They easily took to city life and can be aggressive, competing with native species for nesting spots and food sources.

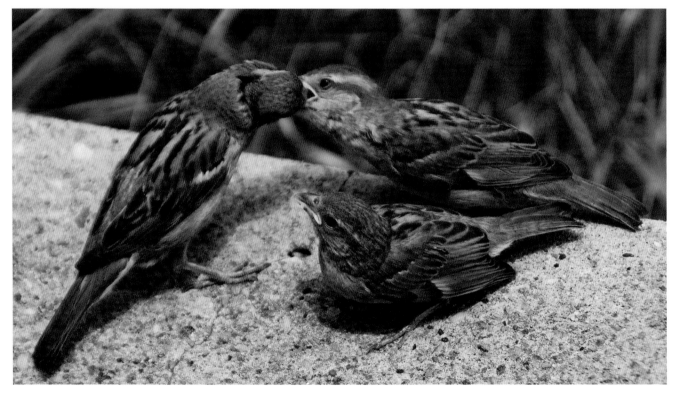

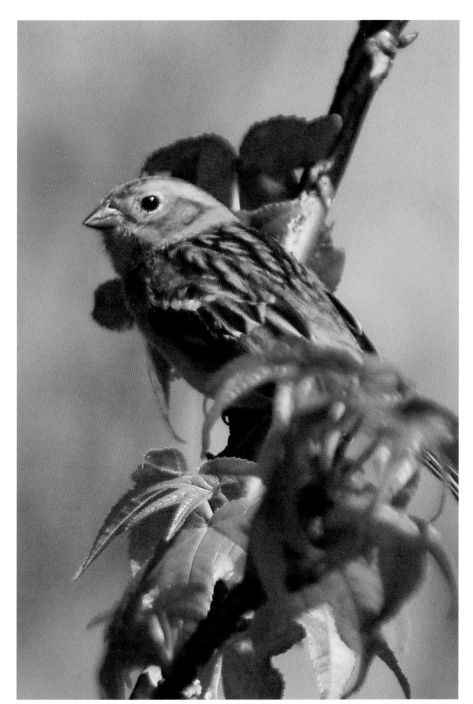

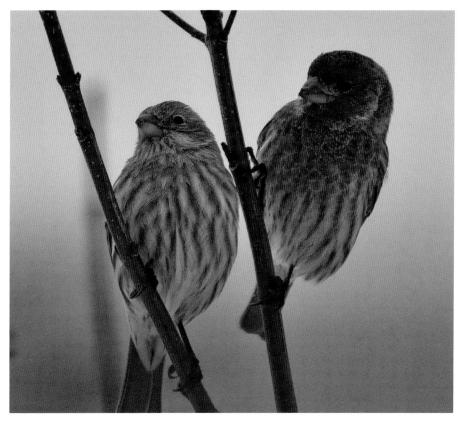

Often found at feeders, the abundant House Finch has the short thicker bill of a seed eater. The male has a bright red head and chest, while the female is more brown streaked. Its range in the east has expanded rapidly since introduction during the 1940s.

It's the pinkish bill that helps to identify the Field Sparrow to birders. This sparrow is a combination of gray, brown, and buff, and is fairly common in fields and thickets during the summer months.

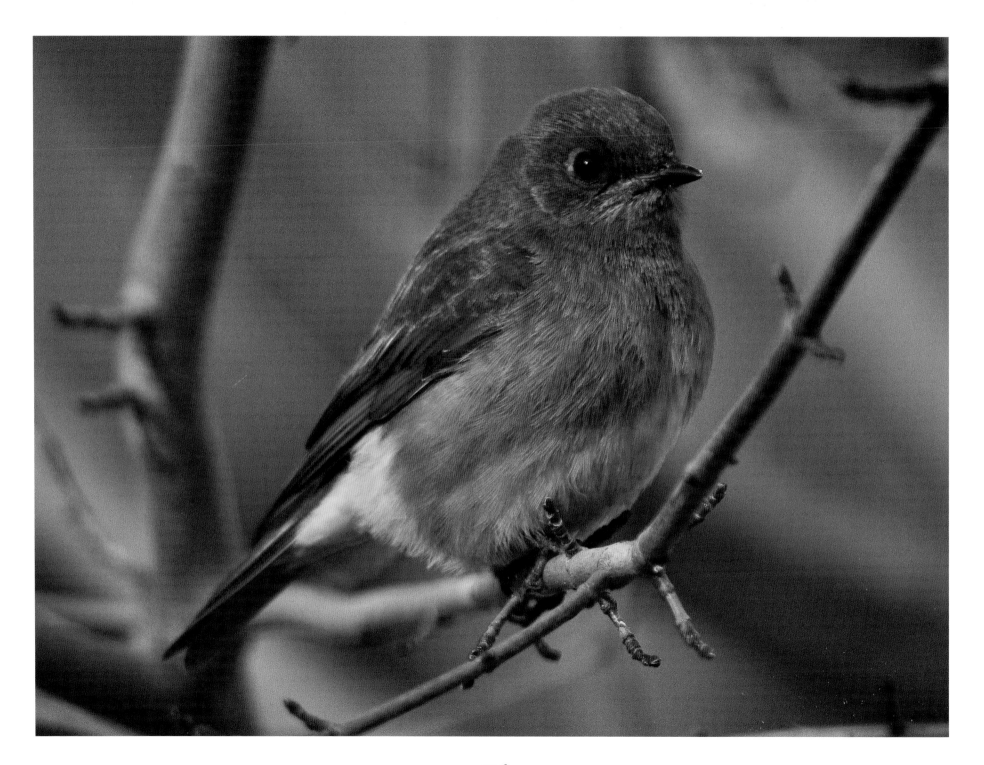

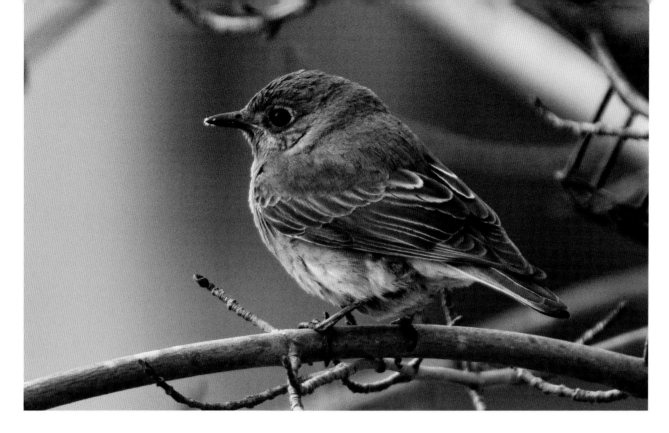

Who doesn't love bluebirds? With chestnut and white underside and deep blue above, the male Eastern Bluebird is just one beautiful bird. This member of the thrush family is trying to making a comeback as Starlings and House Sparrows compete for the best nesting sites. Having a nesting box and mealworms available may attract these birds to your yard. (Above, right, and opposite page)

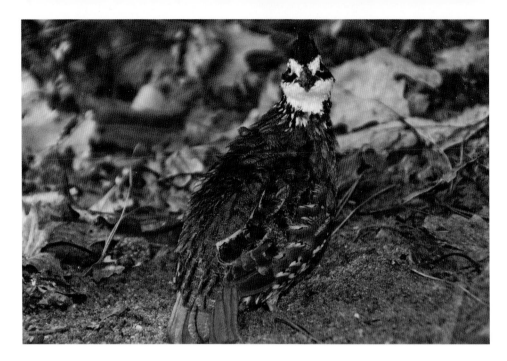

Endangered in New Jersey, due primarily to loss of habitat, the Northern Bobwhite is a small and secretive quail. In cold months, these adorable little birds form large groups called coveys to help protect themselves over the winter. It seems an oxymoron that people will raise Bobwhites in order to protect the species and then go out and hunt them; hard to wrap your head around that concept.

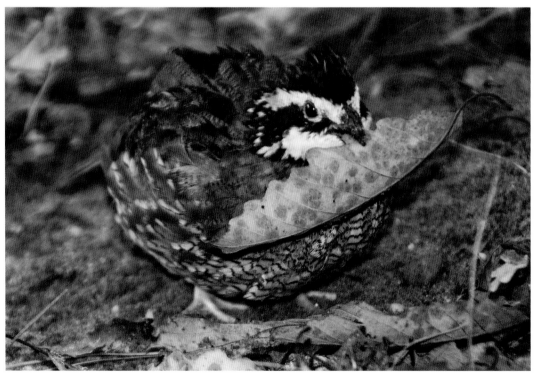

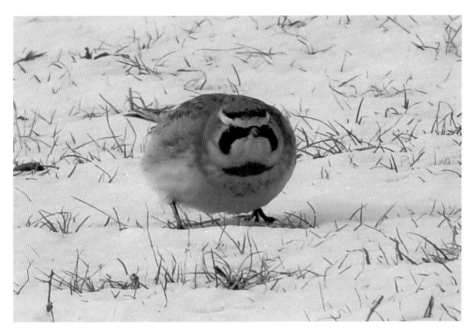

A winter migrant to open fields especially along the coast, the Horned Lark is the only true lark native to North America. With a black mask and chest band, the Horned Lark is named for short black "horns" on the top of its head. A ground feeder, they eat mostly grass seeds.

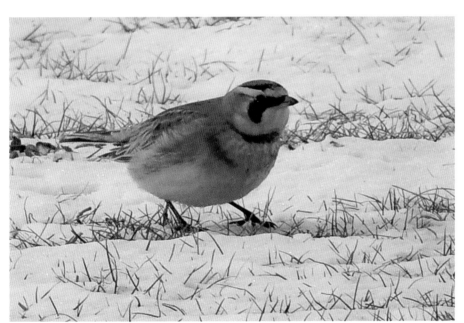

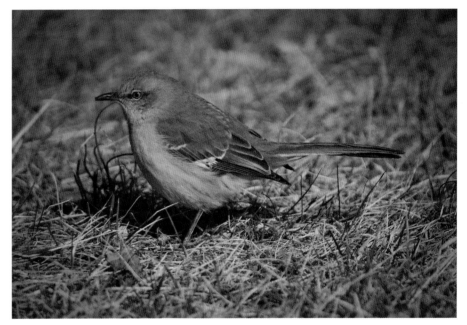

Just sit sometime and listen to a Northern Mockingbird's repertoire, which is capable of repeating over 100 songs, not to mention car, cell phone, and other sounds produced by their human neighbors. These wonderful mimics are found all over the state and can make the sounds of a warm spring day beautiful.

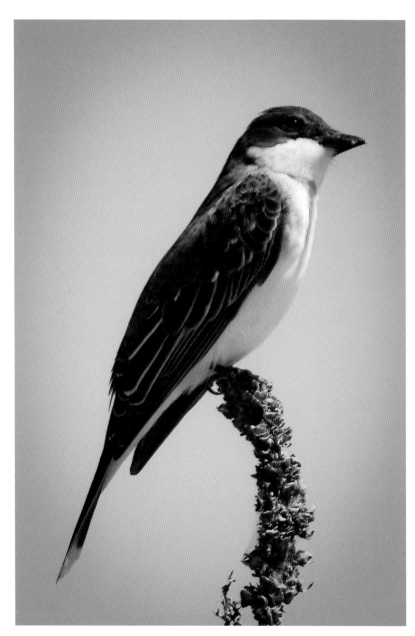

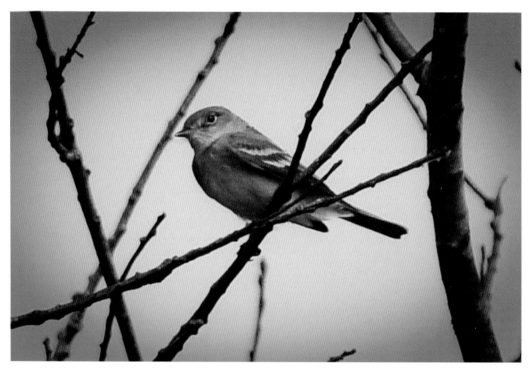

The Willow Flycatcher is one of many tyrant flycatcher species we have in New Jersey. Preferring the edges of wet marshes and thickets, they can be found during the summer from High Point down to Cape May. These drab little birds are almost impossible to identify from their various cousins, so have your field guide with you at all times.

The white-tipped tail feathers is a dead giveaway for the Eastern Kingbird, along with the black head, gray-backed with white belly. Commonly found in open meadows hunting for insects, kingbirds can be seen usually perched on wires or tree tops.

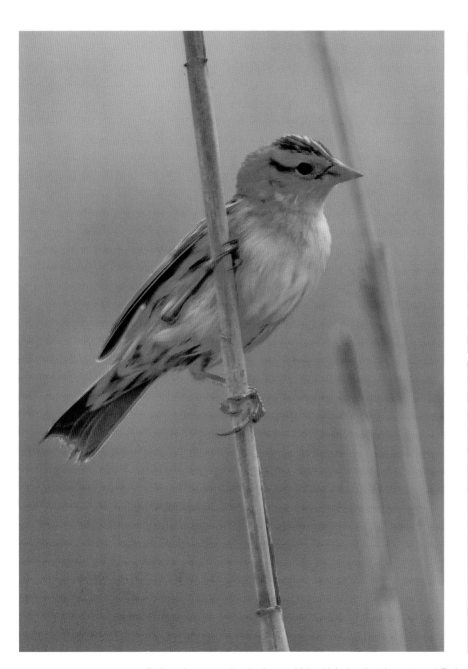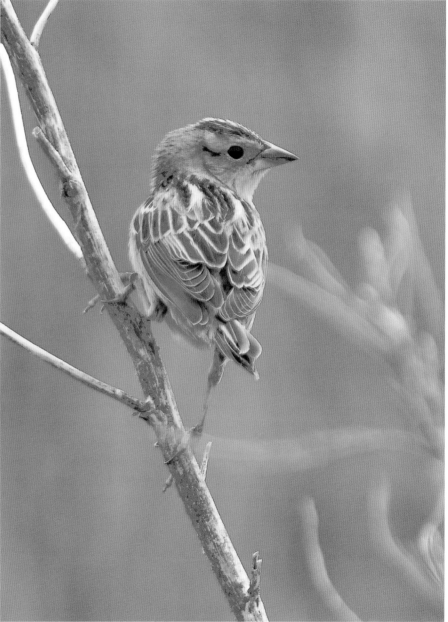

Related to meadowlarks and blackbirds, the threatened Bobolink has a shorter, more finch like bill. The male plumage is striking with black, white, and yellow. The female, shown here, is more buff and yellow with brown strips on her head. They can usually be found in grasslands during breeding and along the coast during migration.

Tiger Swallowtail Butterfly.

Eastern Black Swallowtail Butterfly.

Because the male Red-winged Blackbird's glossy black body and bold gold and red wing patch are so distinctive, the female, dark brown with streaks below, may at times be thought a completely different species. A common resident, they can be found almost anywhere, but prefer meadows and coastal marshes.

Bright View Farm, Burlington County.

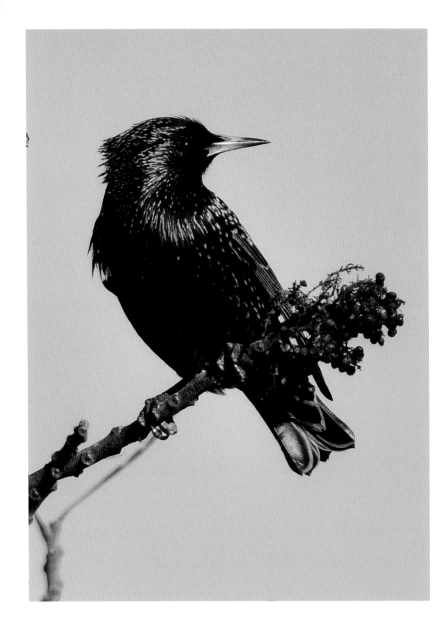

The European Starling is an aggressive, invasive species. Enough said.

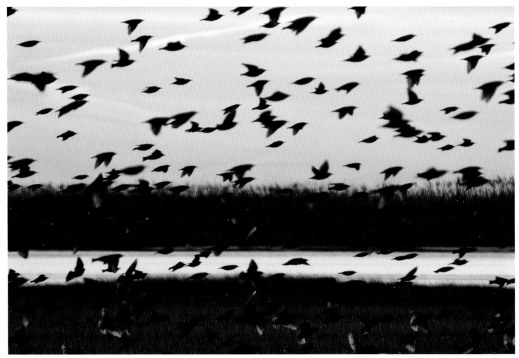

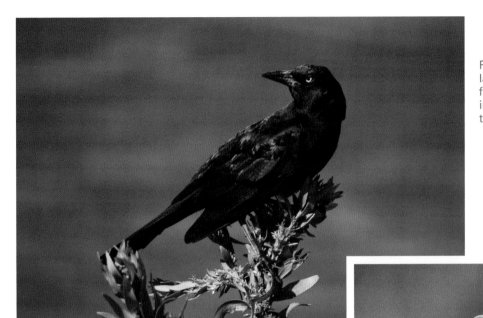

Rarely leaving coastal salt marshes, the Boat-tailed Grackle is much larger than its cousin, the Common Grackle. Large, noisy flocks can be found during the fall covering marshes and sitting on poles. The male is iridescent blue-black, while the female is cinnamon brown with darker tail and wings.

Found east of the Rockies in almost any habitat, the Common Grackle travels usually in large flocks, eating almost everything they can find. They have pale yellow eyes, and when well lit, the males sport iridescent purple plumage, while females are much duller.

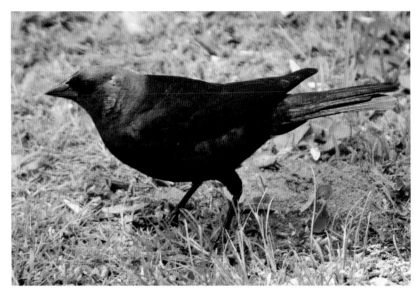

A member of the blackbird family, Brown-headed Cowbirds were once found primarily on the grasslands of the mid-west. Unfortunately, they have traveled all across the country and are now a resident bird in our state. Cowbirds parasitize other species by laying their eggs in the other species' nests, the benefits being their young are raised by the other species, and they do not need to build their own nests. They are one of many causes for the decline of song birds around the country.

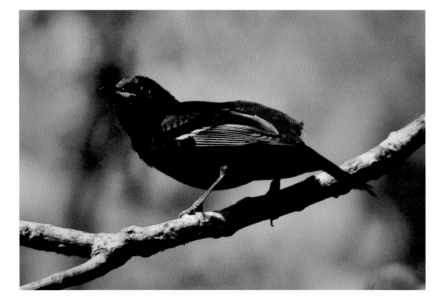

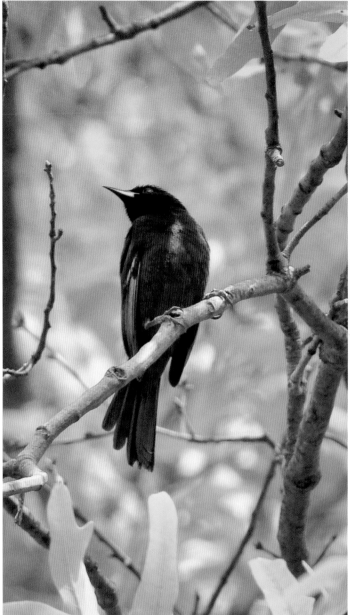

Although they don't have a baseball team named after them, the Orchard Oriole does have fruit farms named after them. A beautiful deep chestnut and black bird, this oriole can be found from the Great Swamp to Cape May.

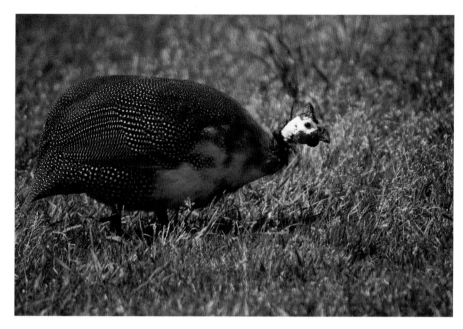

Originally from Africa, Helmeted Guineafowl have been introduced to the United States and have been domesticated and used to control ticks.

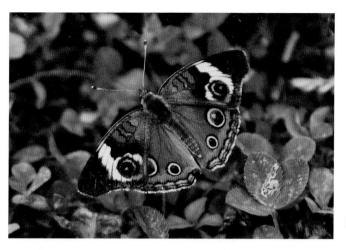

Buckeye Butterfly.

Variegated Fritillary Butterfly.

Common Sulpher Butterfly.

Grassland near Great Swamp, Morris County.

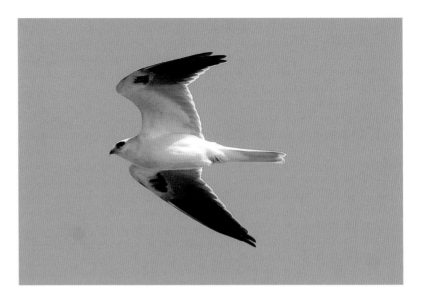

Only the fourth recorded sighting in New Jersey of a White-tailed Kite brought crowds of birders to Barnegat in January 2011. The Kite even accommodated photographers by flying over the Barnegat Dock, giving everyone wonderful views of this beautiful raptor. *Courtesy of Dr. Howard B. Eskin*

Groundhog.

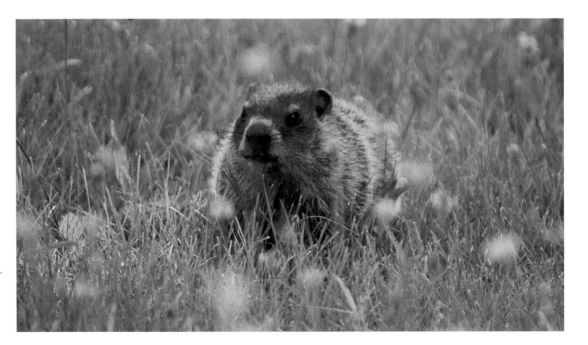

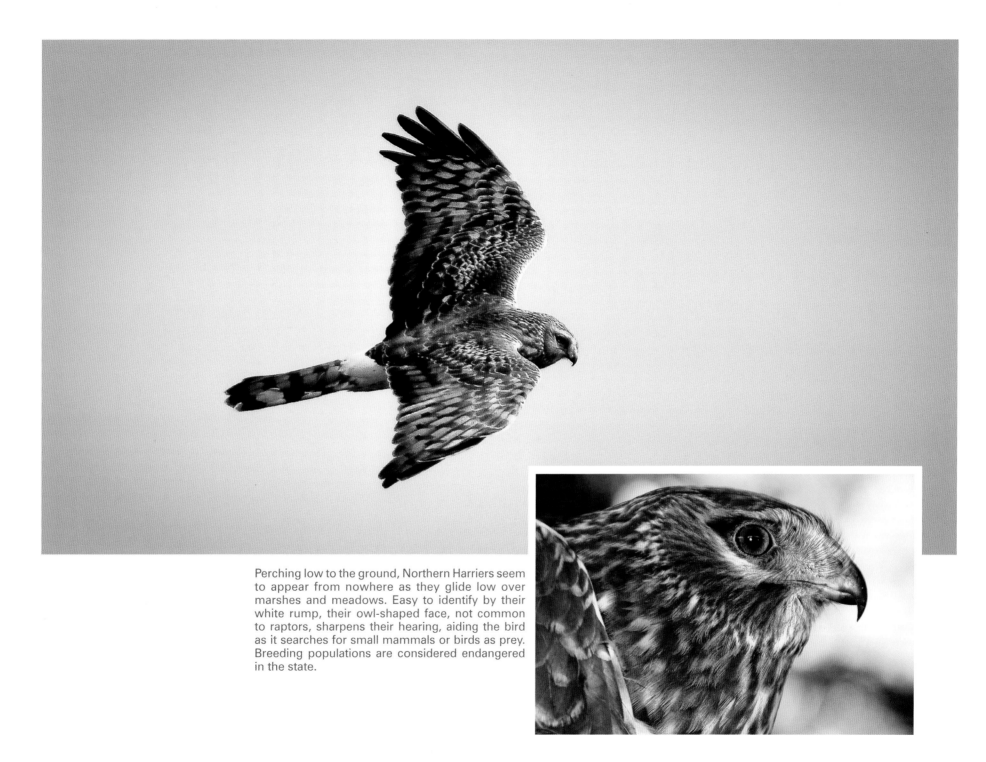

Perching low to the ground, Northern Harriers seem to appear from nowhere as they glide low over marshes and meadows. Easy to identify by their white rump, their owl-shaped face, not common to raptors, sharpens their hearing, aiding the bird as it searches for small mammals or birds as prey. Breeding populations are considered endangered in the state.

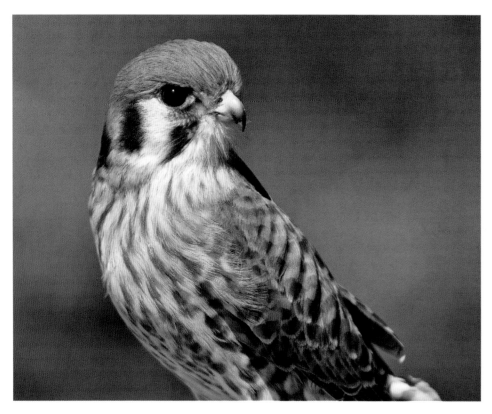

The American Kestrel is the smallest falcon in North America, and is listed as threatened in New Jersey due to loss of habitat. With its rufous back and tail, the Kestrel has a pair of black bars along the side of its white face helping make this beautiful little raptor unique and easy to identify.

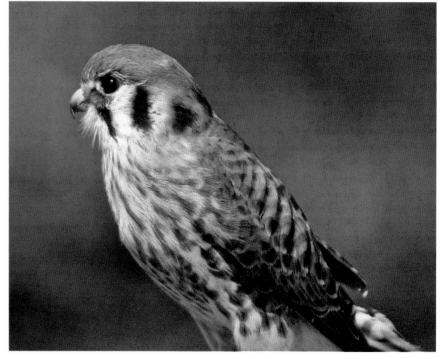

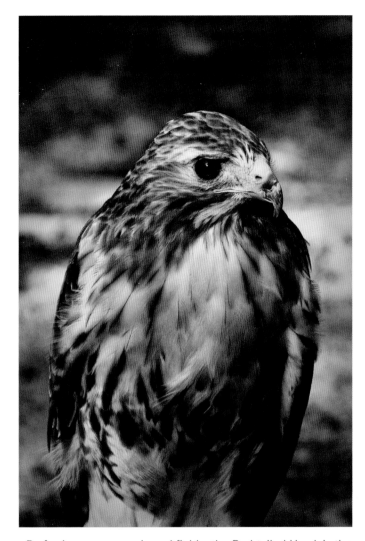

Preferring open woods and fields, the Red-tailed Hawk is the most common buteo hawk found in New Jersey. The red upper tail feathers and darker belly band are a dead giveaway if you are lucky enough to see them as the hawk soars overhead looking for a tasty rodent meal. Juveniles and adults during molt plumage are somewhat lighter than normal.

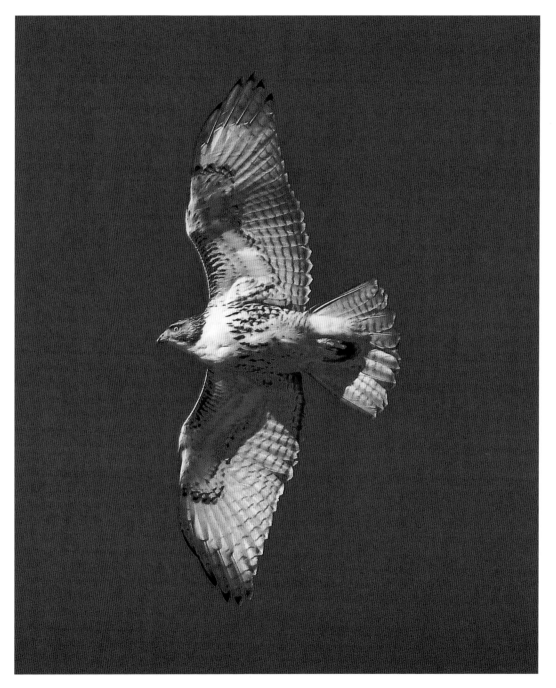

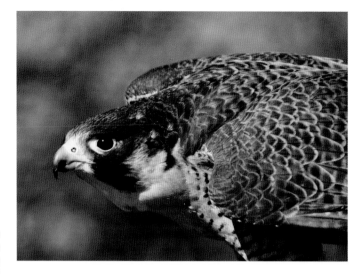

Speed is the game; Peregrine is the name. Almost lost because of DDT, the Peregrine Falcon has made a miraculous recovery and can now be found along our coastal areas or on top of bridges or towers. While diving to grab a bird out of the air, they can reach speeds of 200 mph. No wonder the head plumage looks like a helmet.

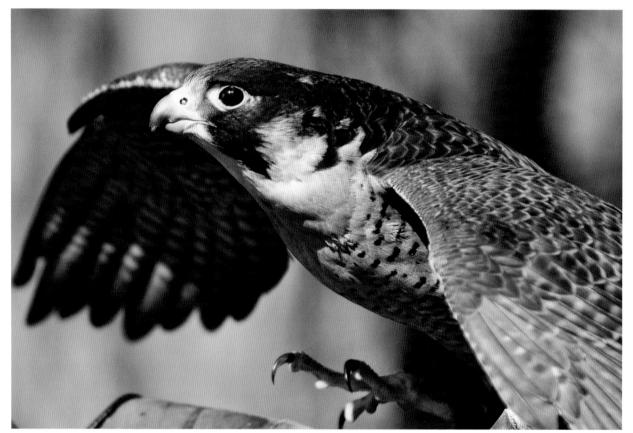

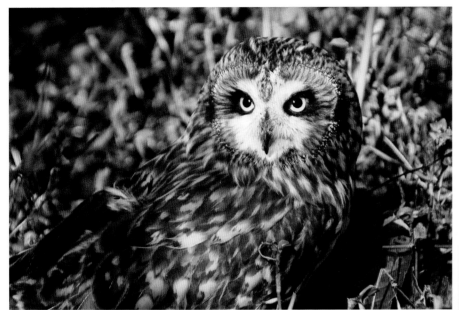

A ground nester, the state endangered Short-eared Owl can be found at dusk flying low over the marshes and meadows of Southern Jersey searching for small rodents. Not an owl to sit in trees, they will rest on the ground or low poles. Their ear tufts are more like a suggestion than actually being visible.

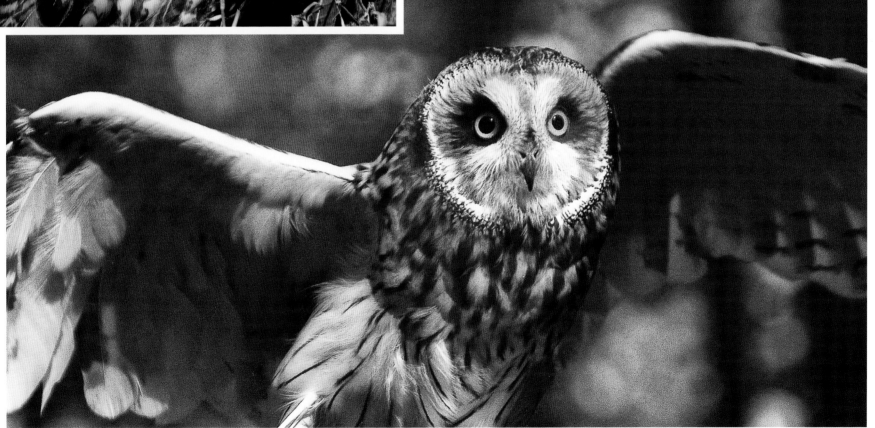

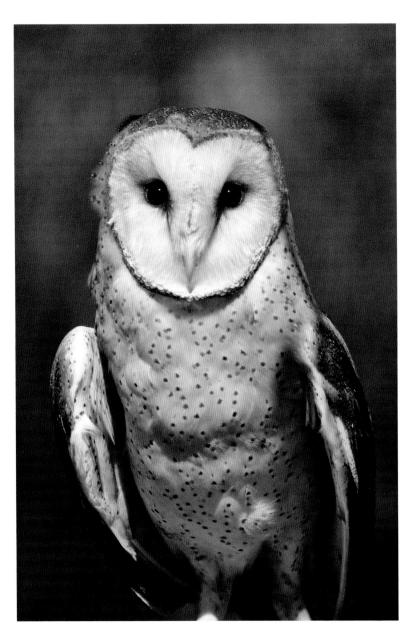

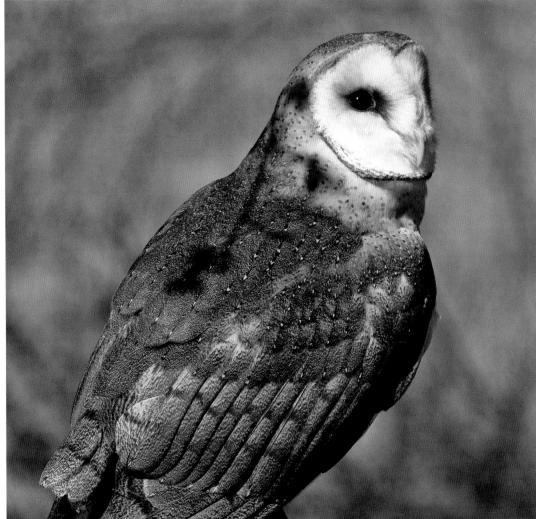

With its pale heart-shaped face, the Barn Owl is easy to identify; their populations are declining as more farms are sold to make room for housing developments. Owls have that great ability to swivel their heads almost completely to the back, sort of like Linda Blair.

Chapter 3
Woodlands and Lakes

The Highlands, the Skylands, and the Sourland regions of New Jersey still contain most of the contiguous woodlands and forests in the state. However, only about twenty percent of our forests are protected by state and federal ownership. Woodlands provide important habitat for a variety of birds, whether migrating neotropical birds heading north to breed or state residents. The freshwater ponds and lakes here are essential for supplying food for birds, such as amphibians, fish, and invertebrates.

Stokes State Forest, Sussex County.

Along the Delaware, Hunterton County.

These regions provide deep wooded areas of unfragmented forests, giving wind-protected homes to nesting birds that can not breed in isolated patches of woodlands. That is why more species of birds can often be found in the Wildlife Management Areas (WMA) or National Wildlife Refuges established in northwest Jersey.

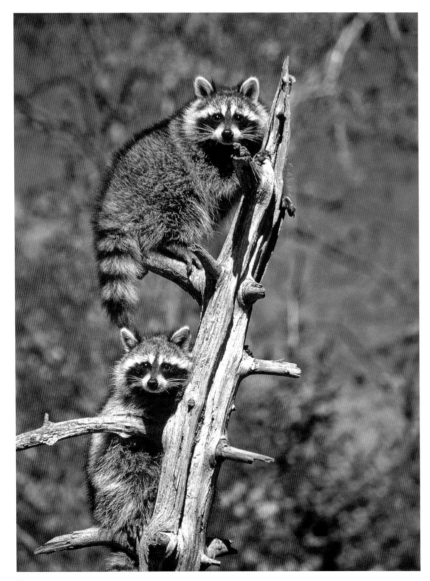

Raccoons.

Charles H. Rogers Refuge, Princeton, Mercer County.

Again, the major threat to this area is overdevelopment, which destroys trees, pollutes water supplies, and fragments the forest, thus eliminating the required habitat needed to support migrating and breeding birds that depend on woods for their survival in an ever shrinking environment. Predators of birds in this area would include foxes, coyotes, snakes, and raptors.

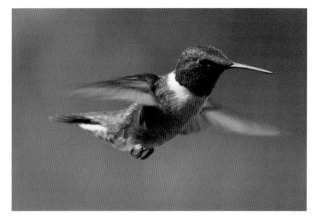

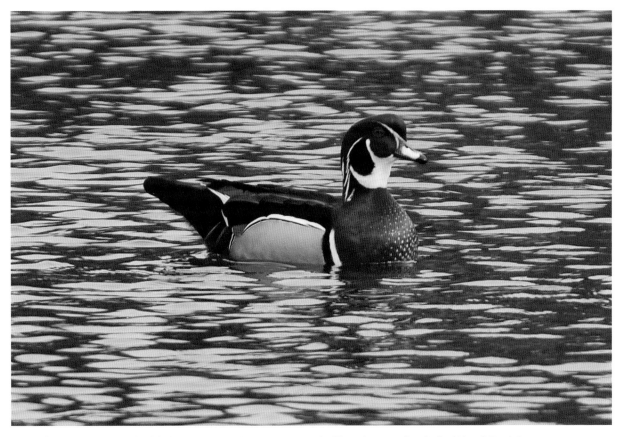

One of the most beautiful birds that is relatively common in New Jersey, the drake Wood Duck is a riot of colors with a unique rounded head with a drooping green crest and great red eyes. The female is mostly grayish with mottled flanks. They can be found in sheltered rivers and ponds with surrounding trees, but are shy and rarely come close to shore when people are around. The Wood Duck is also one of the few ducks to nest in trees and wood boxes.

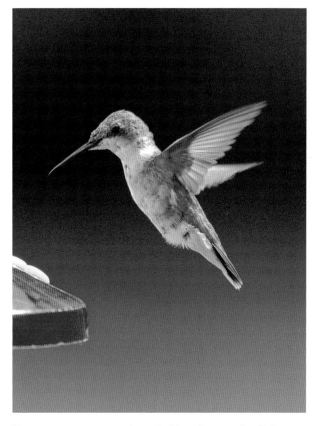

Very common everywhere in New Jersey, the Ruby-throated Hummingbird is the only hummingbird that nests in the state. Occasionally, a Rufous or Allen's Hummer may make an appearance here, but we can always count on our little Ruby-throated ones to be here every summer, bringing joy to all.

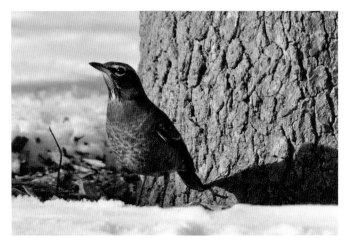

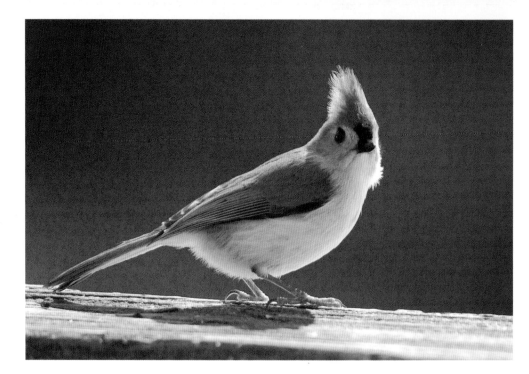

Common all over the state, the American Robin is usually the first bird that most folks become familiar with, as they are notable for their bright red-orange breasts. A member of the thrush family, they were thought to be the first sign of spring, but migrants from up north spend winters here, so they were always here year round.

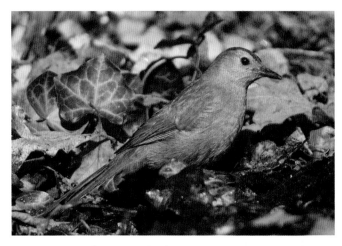

With a short gray crest, the Tufted Titmouse, is the largest in the titmouse family. They can easily be found at feeders around the state, especially during the winter, but prefer the woodlands during breeding season.

Related to the Northern Mockingbird, Gray Catbirds are relatively common. Dark gray with a black cap and chestnut under its tail, these birds stay mostly in the underbrush of woodlands, looking for insects by flicking away leaves and foliage. Also shown is a young fledgling Catbird.

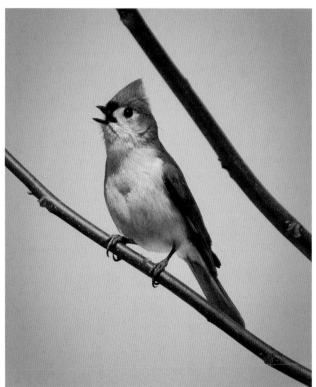

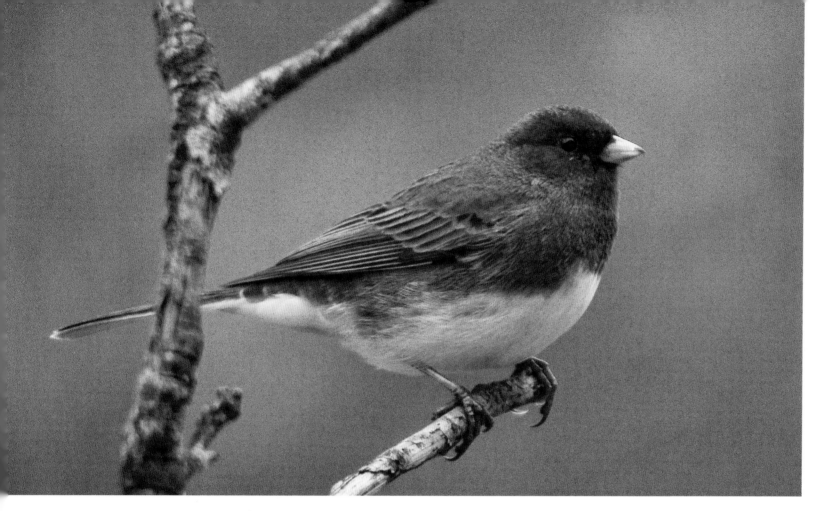

During the fall and winter, Dark-eyed Juncos can be found searching for food on the ground in fields and woodlands. They especially like food tossed out of feeders by picky eaters. In summer, they head north to breed and may be found up in the Skylands areas of New Jersey.

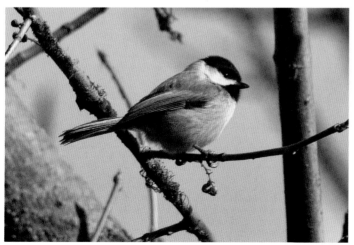

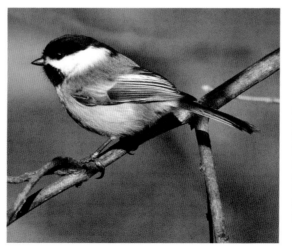

The best way in New Jersey to determine if you are seeing a Carolina Chickadee (facing right) or a Black-capped Chickadee (facing left) is location. Split the state along the Raritan River and Canal, Black-cappeds are north with Carolinas in the south. Both Chickadees breed in woodlands and on forest edges, and love feeders. Good luck trying to tell them apart if you are in an area where populations overlap. *Black-capped Chickadee courtesy of Dr. Howard B. Eskin*

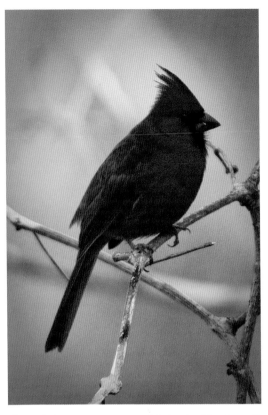

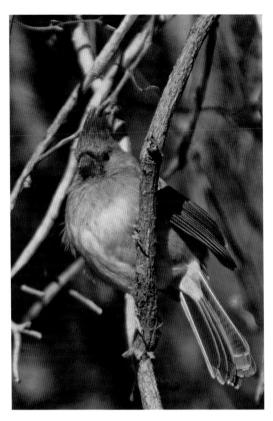

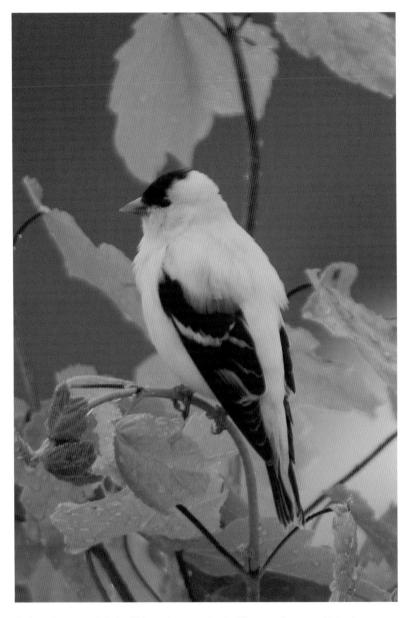

One of the most common birds, the Northern Cardinal is a rhapsody in red. Yet another example of the male being more brilliant than the female, and so as not to make her feel bad about it, they mate for life. During breeding season a male cardinal may attack its own reflection in a window thinking it's a rival.

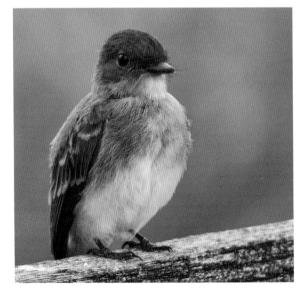

Another migrate common during the warmer months is the Eastern Phoebe, a flycatcher that can be found throughout the state. With a brownish-gray head and body and pale underbody, these birds catch those pesky insects for in-flight meals, thus, being better fed in the air than we.

Being the state bird of New Jersey, the brilliant yellow and black American Goldfinch can be found at any feeder that has Niger seed (thistle). Again, with this species the male is most colorful during the summer, while both sexes have a similar gray/olive plumage in winter.

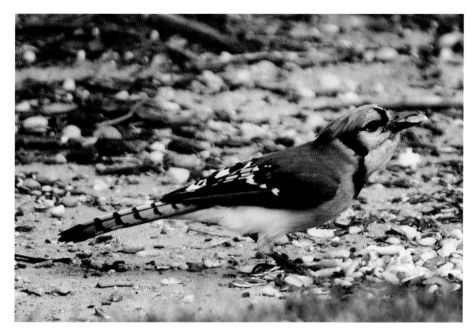

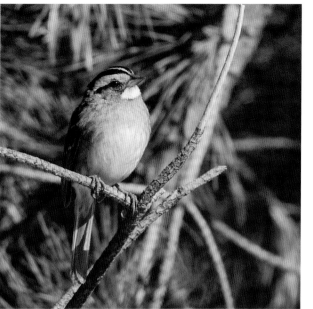

One of several species of sparrows that winters in New Jersey, the White-throated Sparrow is a pretty diminutive bird that lives up to its name. It also has black and white head stripes with a yellow patch above the eye; it can be found under trees, thickets and brush, and likes feeders. You may think all sparrows look alike, but this charmer is a good find when out birding.

The very aggressive Blue Jay can be found almost anywhere there are trees. This colorful bird has a myriad of calls and can mimic other birds, especially the predator Red-shouldered Hawk.

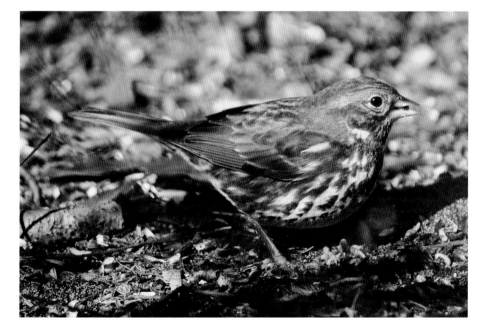

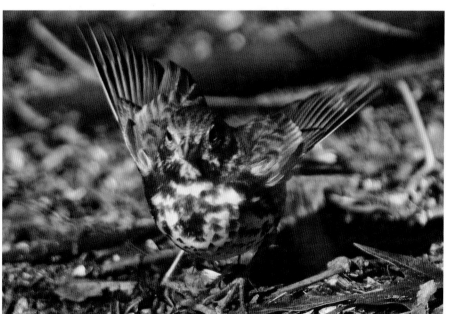

Most likely to be seen during the colder months, the Fox Sparrow is a real beauty. With deep rufous streaking along the breast, this chunky sparrow breeds up in the Arctic and migrates throughout New Jersey's woodlands during the winter.

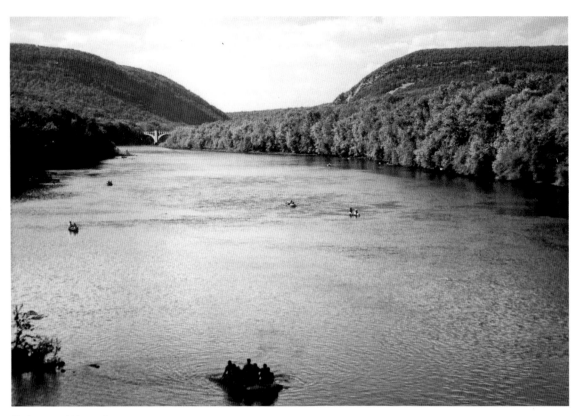

Delaware Water Gap.

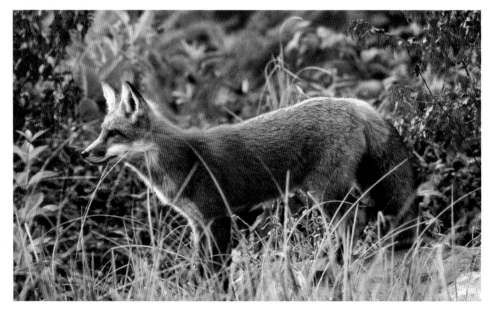

High Point State Park, Sussex County.

Red Fox and kit.

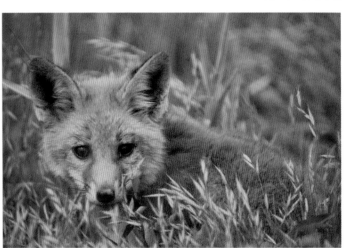

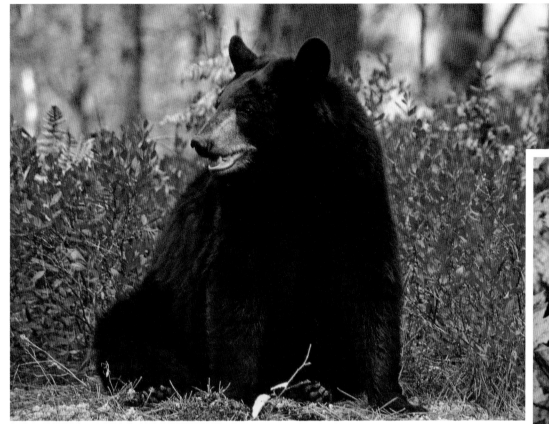

Black Bear.

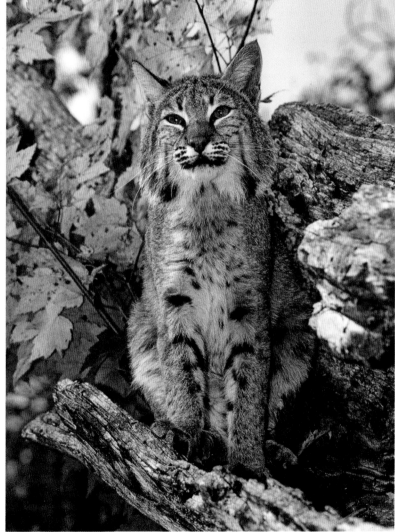

Bobcat.

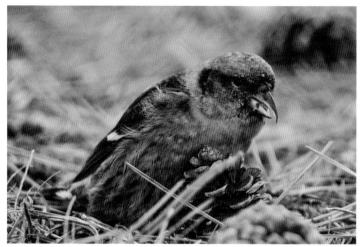

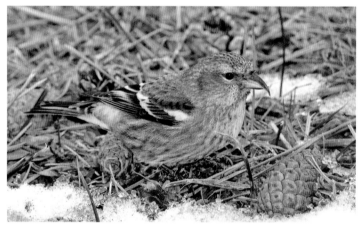

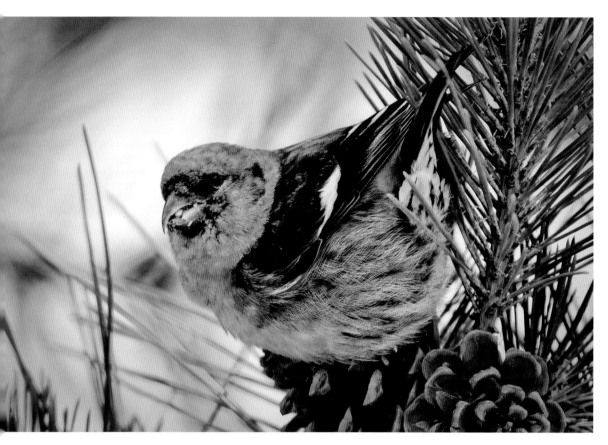

Rare winter visitors to New Jersey, Crossbills, both White-winged and Red, are a special treat for birders. Members of the finch family, Crossbills have exactly that—crossed bill tips that are used for extracting seeds from pine cones. The White-winged species have two prominent white wing bars, with the male being pinkish in the winter and turning bright red in spring. The female is more an olive to yellow color. The Red Crossbill does not display any wing bars and is less likely to feed on the ground.

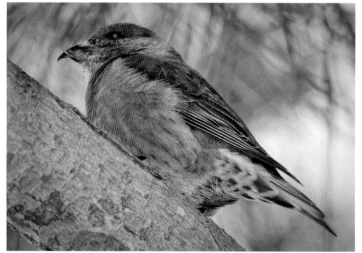

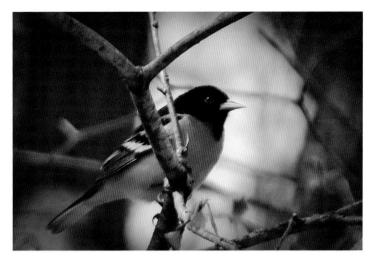

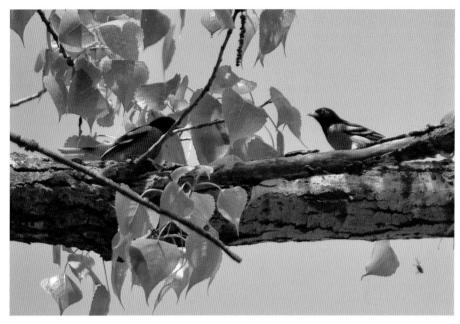

Brilliant black and orange helps identify the Baltimore Oriole, a common state summer resident and breeder during the warm months. They look for insects in trees but will also feast on fruit, especially oranges put out by a feeder.

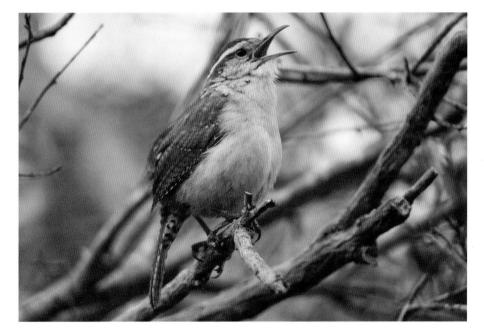

The petite Carolina Wren has a song that belies its size, and is easily heard around the underbrush of swamps and woodlands. With a slightly curved bill and a rusty brown head and back, the Carolina Wren's striking white eye stripe helps make it easy to identify.

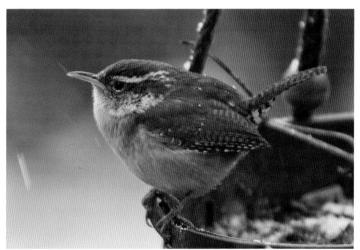

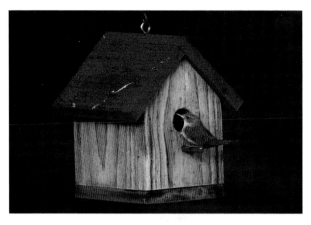

A common summer resident, the House Wren is one of several wren species seen in New Jersey. They can be heard singing while nestled in thickets or raising a family in nesting boxes. As with all wrens, they have a slightly downward curved bill and when alert, an upward pointing tail. Here a House Wren has a nest in a bluebird box.

Climbing up a tree, the Brown Creeper is almost impossible to see as its plumage blends in so well with the bark. Its curved bill helps it to search for insects and larvae in the bark of the tree. As the tail flattens along the tree, it provides extra balance for the bird.

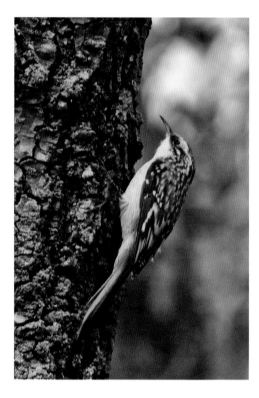

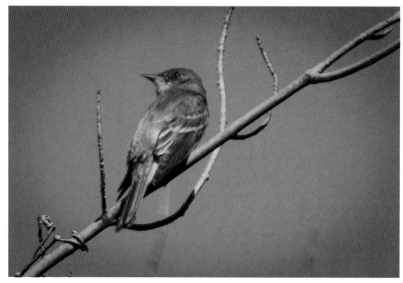

A member of the tyrant flycatcher family, the Eastern Wood-Pewee is a rather drab fellow with characteristic white wingbars and the song of PEEawee. Why "tyrant" you may ask: They eat insects caught on the fly. This family is also the largest in the bird world with over 400 species.

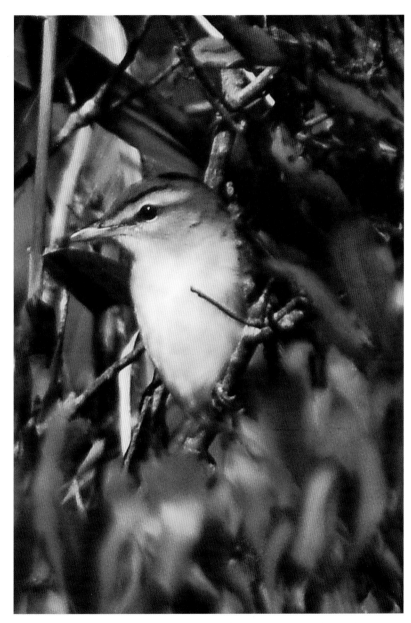

Stokes State Forest, Sussex County.

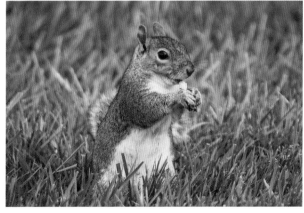

Gray Squirrel.

A small songbird, the Red-eyed Vireo is fairly common in New Jersey woodlands as a summer resident who migrates to winter in South America. With its large, hooked bill, it feeds on insects and berries.

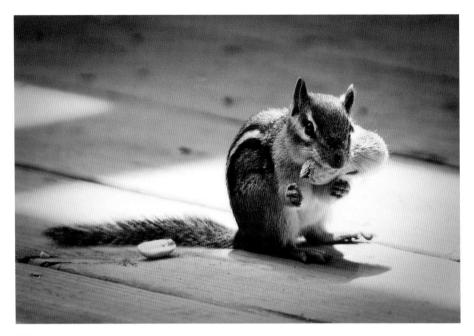

Chipmunk.

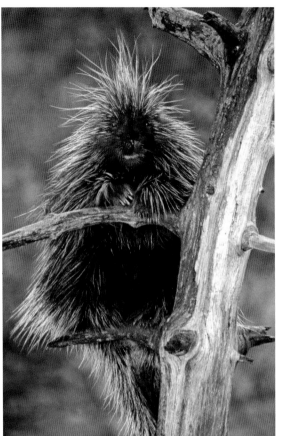

Porcupine.

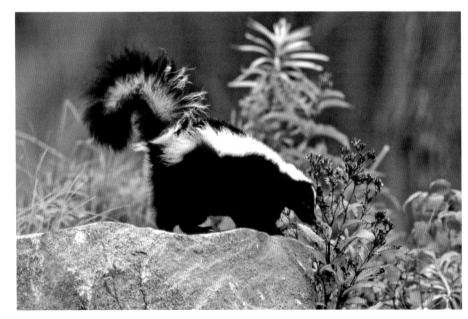

Skunk.

Mayapple.

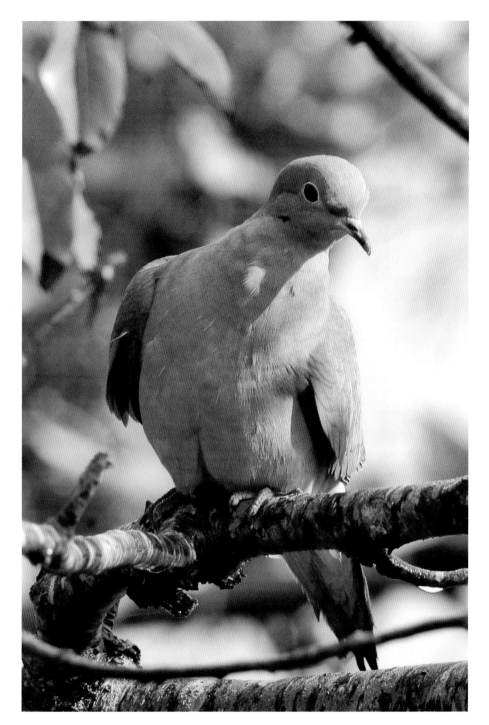

You're walking in the woods and you suddenly see a flash of brilliant red. It doesn't have crest, but does have black wings. It must be a Scarlet Tanager, a beautiful but secretive bird found in our forests during the warm months that migrates to South America for the winter.

The gentle Mourning Dove is one of the most abundant and one of the most hunted birds in the country. They can be found in almost any habitat and on most telephone wires. With their distinctive mournful cry, maybe they're sad about an upcoming hunting season.

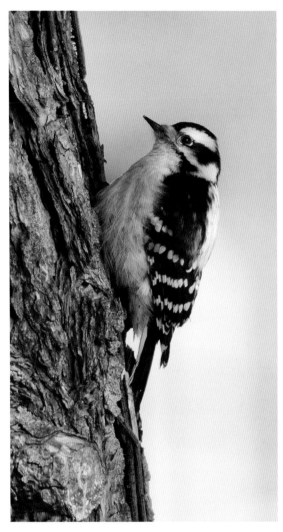

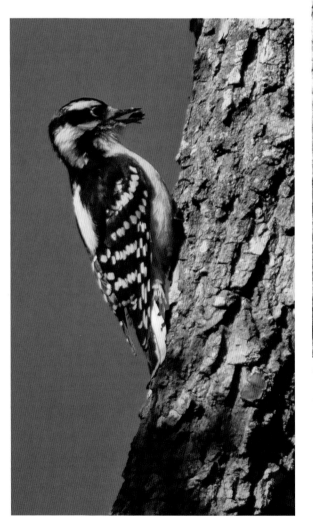

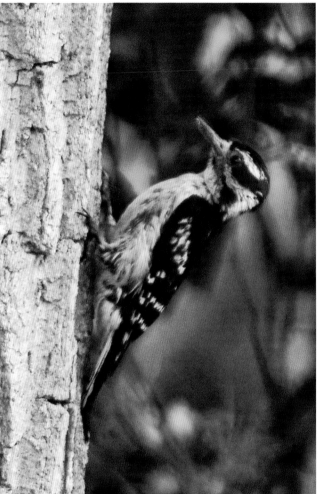

The smallest woodpecker is the Downy, a smaller version of the Hairy. They are very similar in looks and only the much shorter bill and size helps with identification. Both are fairly common and love suet, but their natural habitat is the forest.

With a black and white body and a splash of red at the back of the head, the Hairy Woodpecker is much larger than the Downy, with a longer bill. Both are permanent residents of the state, and fairly easy to find or at least hear in the woods.

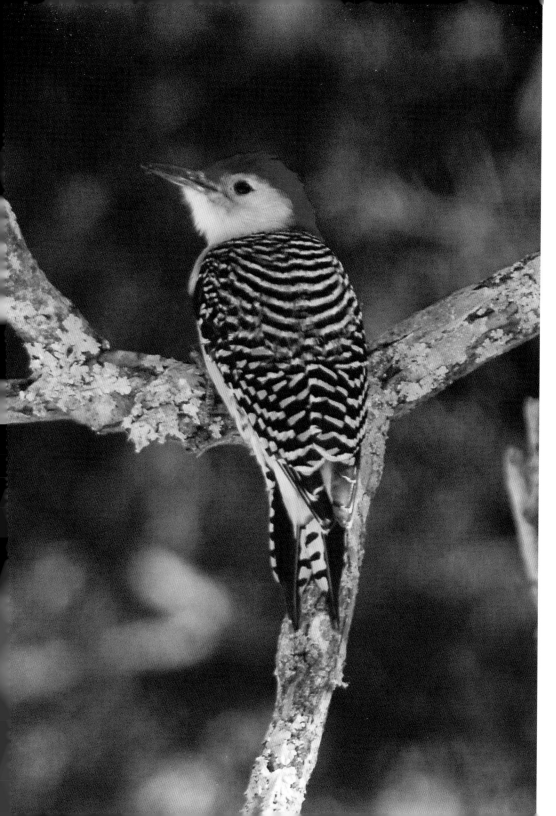

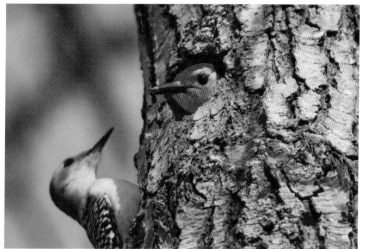

Common across the eastern United States, the Red-bellied Woodpecker male has a beautiful crown, neck of brilliant red, and a dash of red tint on its belly, so of course, it is named the Red-bellied. Go figure. At a tree nearby, a European Starling (an invasive species brought to America in the 1890s) attempted to take over this pair's nest hole. Outcome: a draw as neither used the nest hole.

A member of the woodpecker family, the Northern Flicker is fairly common in our woodlands. They are larger than other woodpeckers, and here in the east, the Yellow-shafted sub-species is prevalent. With a brown barred back, these flickers have a red crescent on the nape of the neck.

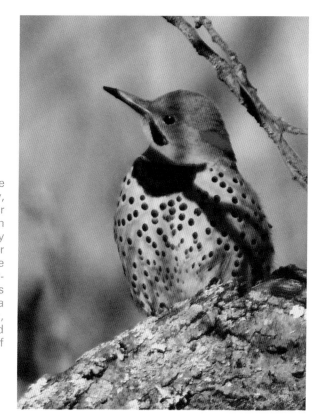

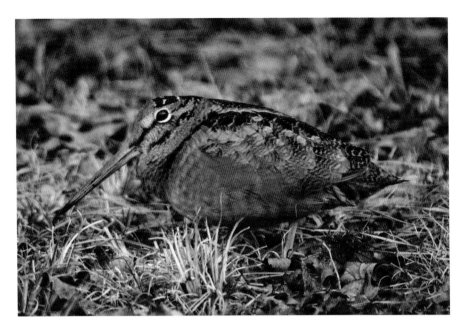

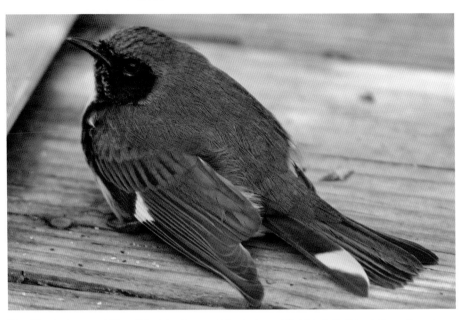

The American Woodcock is one odd little bird. It's a chubby, long-billed shorebird who prefers damp woodlands to beaches and is also known as a "Timberdoodle." As it is mostly nocturnal, the Woodcock is rarely seen, but if you do see one, check out the strange little walk it does while feeding. The males top off their mating calls called "peenting" with dazzling flight displays in grassy fields, usually around sunset in late March.

The Black-throated Blue Warbler is a strikingly beautiful bird. Its black throat and deep blue upperparts make it easily recognizable. This little guy flew into a window and needed to regain his composure and dignity before flying off into the shrub understory.

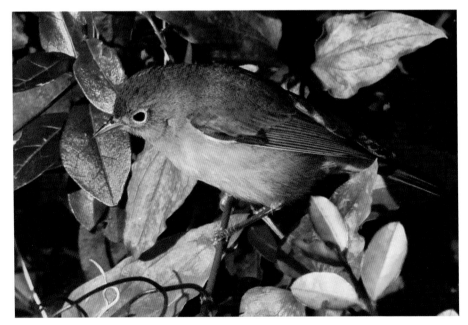

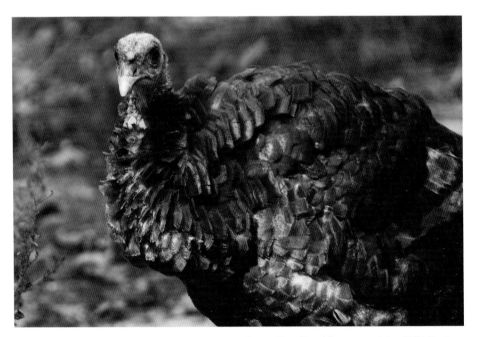

The bold white eye ring stands out against the olive gray head helping make the Nashville Warbler easier to identify. One of the smaller warblers, these migrants can be found in New Jersey from High Point to Cape May, preferring open woods and bog habitats.

Everyone knows the story of how Ben Franklin wanted the Wild Turkey to be the national bird, but the Bald Eagle won that contest. The Wild Turkey is the largest game bird. It is fairly common in wooded areas around the state, ambling around feeding on nuts and insects.

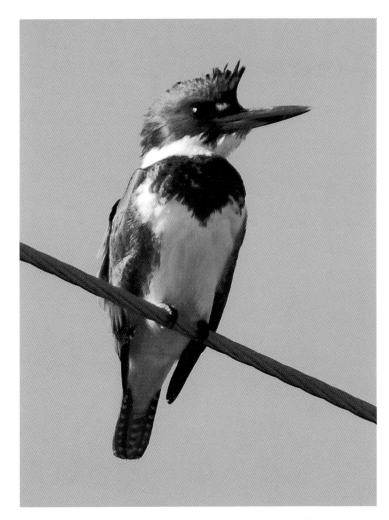

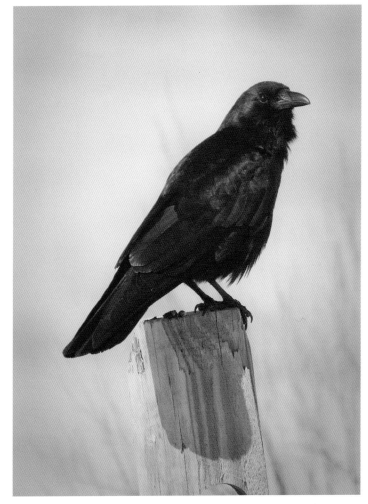

Highly intelligent, the American Crow suffered greatly during the outbreak of West Nile Virus a few years ago, but can be seen almost everywhere these days. The largest crow in America, they are all black with a thick bill, and have adapted to living even in big cities.

The only kingfisher in the state, and in fact, in most of North America, the Belted Kingfisher has a broad white band around its neck, and a predominately slate blue and white body. These birds are rather stocky and have a ragged crest on top. Fairly common in the summer along ponds and lakes, but in winter it can be found along coastal waters.

Palmyra Cove Nature Park, Burlington County.

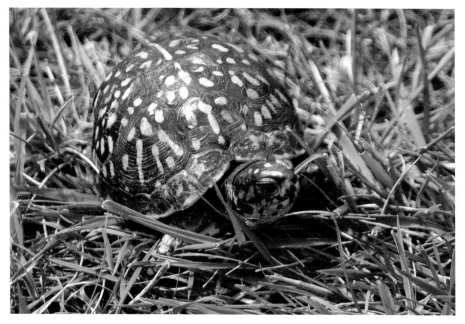

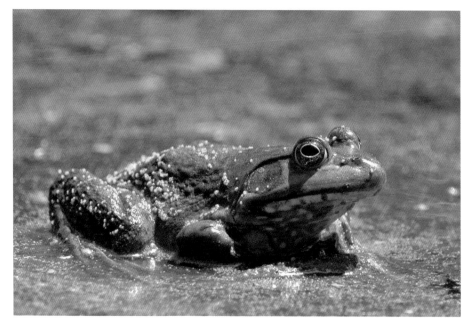

Box Turtle.

Bullfrog.

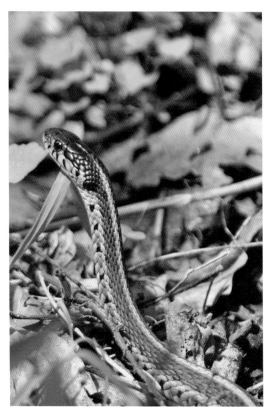

Garter Snake.

Woodland ferns.

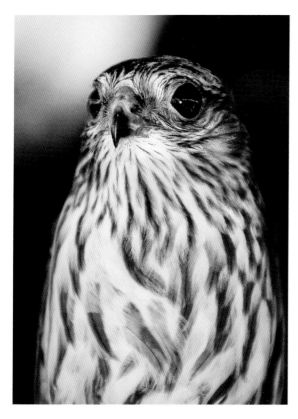

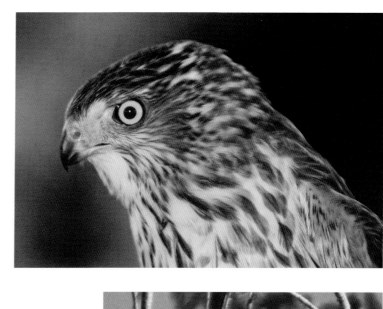

The Sharp-shinned Hawk is one of three accipiter species that can be found in the state, usually during the fall migration. This group of hawks has shorter, rounded wings with longer tails, giving them more agility for hunting in woodlands. Sharpies are the smallest of the three, and to the untrained eye can often be confused with the Cooper's Hawk; however, the Sharpies will have a much faster wing flap and straighter tail as compared to Cooper's.

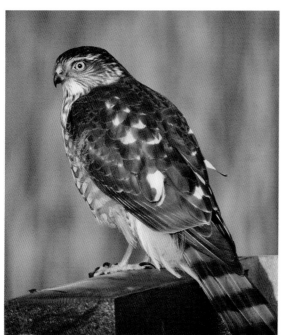

Becoming more common in New Jersey, the Cooper's Hawk is another accipiter hawk that hunts for birds among the trees in wooded areas. Visit the Cape May hawkwatch platform during the fall migration, and you just may see a Cooper's swoop out of the trees and grab a pigeon for a squab dinner.

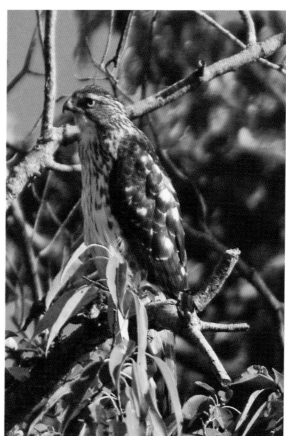

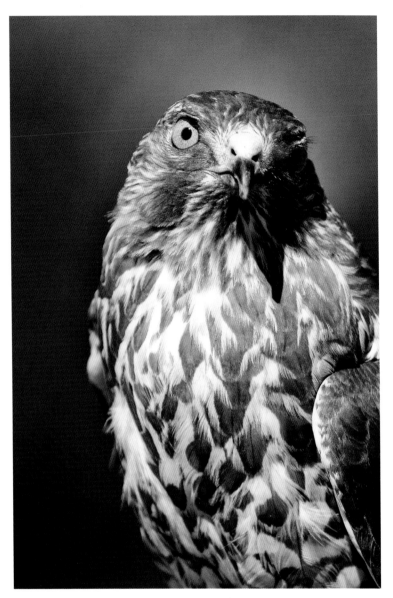

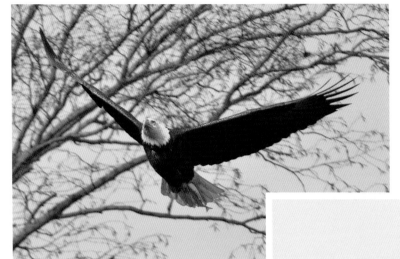

As our national bird, the Bald Eagle has recently been removed from the Federal Endangered Species list but is still endangered in New Jersey. These majestic birds can be found from Cape May to High Point, and the breeding numbers are increasing. Juveniles take four years to get their distinctive white head and tail plumage.

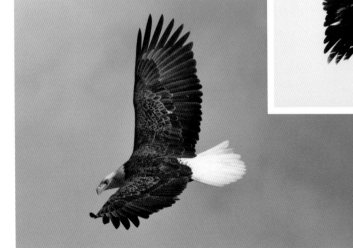

Come October, large numbers of migrating Broad-winged Hawks can be seen flying in large groups called "kettles" from Raccoon Ridge to Cape May. The smallest of the buteos, the Broad-winged has light underwings with dark edges, along with a banded broad tail.

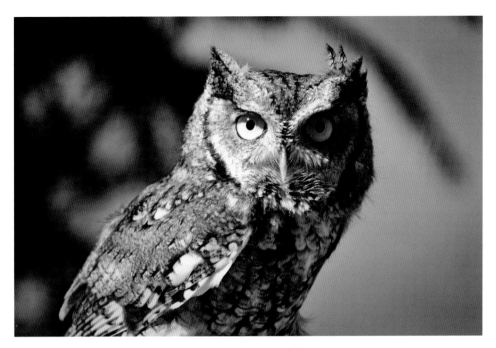

The Eastern Screech Owl comes in two different colors or morphs; this one is a gray morph. One of the smallest owls found in New Jersey, they are fairly common in the northern part of the state, and nest in tree cavities or man-made boxes.

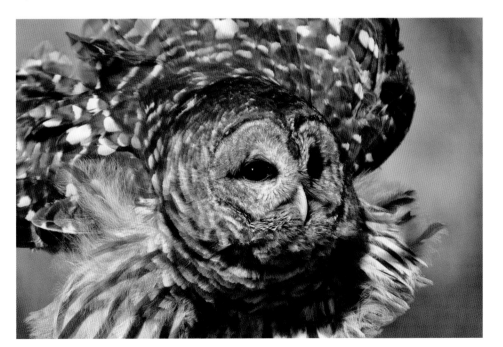

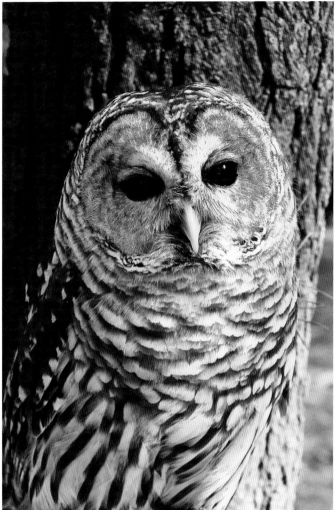

Found in dense woods, the Barred Owl is one of the largest owls found in New Jersey. It can be identified by its chunky body, rounded head, and dark vertical bars on the chest. Mostly nocturnal, but occasionally found roosting on a branch, these birds of prey will feast on small mammals and reptiles.

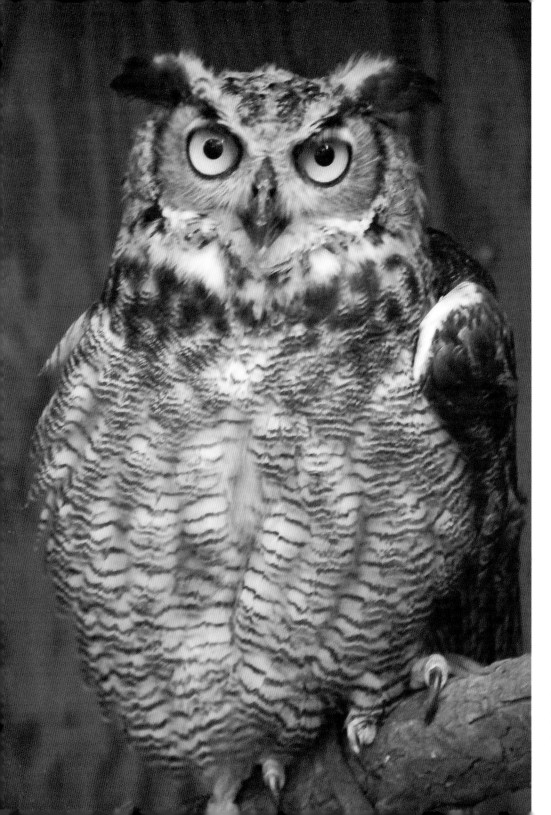

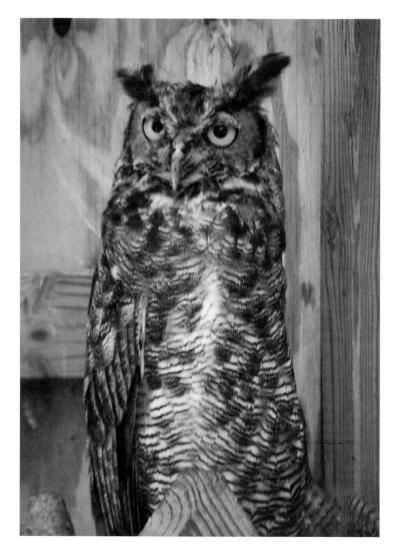

Rarer and smaller than the Great Horned Owl, the Long-eared Owl is seldom seen during the day when it is roosting deep in the forest. These slender owls hunt quietly under the cover of darkness, looking for small mammals.

Largest of the resident owls in the state, the Great Horned Owl has the oval face and long ear tufts that one associates with owls. With their unique plumage, owls are virtually soundless in flight as they hunt at night. These owls will go after larger prey, such as rabbits and grouse, and can be found throughout North America.

Pine Barrens

Covering over one million acres, the Pine Barrens in Southern Jersey is one of the most unique places on the Eastern Seaboard. Formed after the Wisconsin ice sheet retreated at the end of the last great Ice Age, the Pine Barrens has pine and oak forests, dwarf pines plains, white cedar swamps, carnivorous plants, and the Kirkwood-Cohansey aquifer beneath it, containing over 17 trillion gallons of fresh water. It is home to thousands of species, both animal and plant, and, of course, the Jersey Devil.

Swamp Pink.

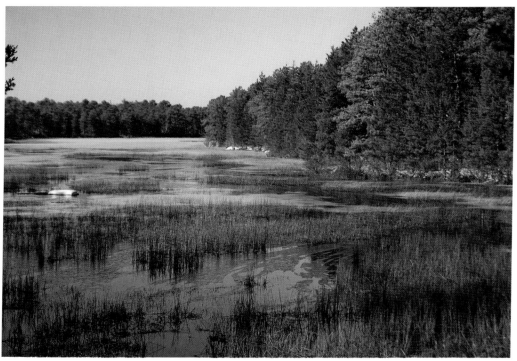

Lake Oswego, Bass River State Forest, Burlington County.

The blueberry was first cultivated here, and the numerous cranberry bogs make New Jersey one of the three top cranberry producers in the United States. People have tried for centuries to exploit the treasures of the Pines, only to fail or move industries west. Rare native plants also make this area a botanist's dream.

Threats today in this wondrous place are primarily due to overdevelopment, forest fragmentation, invasive species, and climate change. Certain areas have been set aside for development, but more is always desired by builders and holding the line is a constant battle. Forest fragmentation is caused by the so-called good intentions of people leaving small pockets of trees that are not capable of sustaining the needed populations of plants and animals. Climate change also brings new insects and diseases to the forests, and in turn, changes to the life cycles of species that have lived here for thousands of years.

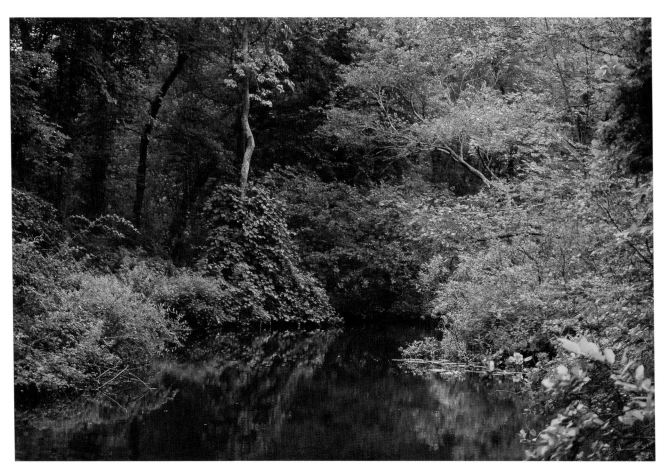

Parvin State Park, Cumberland County.

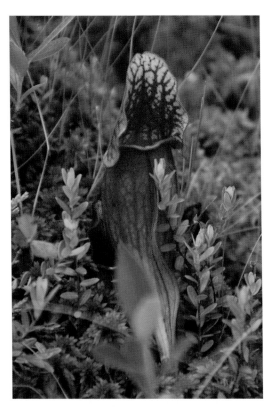

Northern Pitcher Plant.

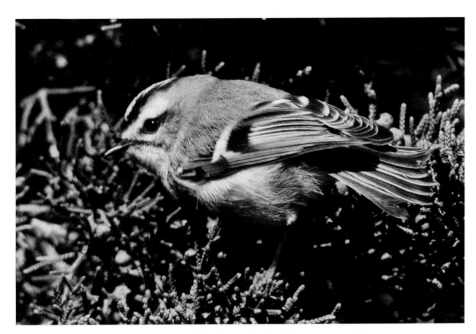

The smaller of the two species of kinglets, the Golden-crowned Kinglet sports a jaunty yellow patch on the top of its head along with bold black and white face stripes. Preferring conifers, the Golden-crowned will often hang upside down to feast on small insects.

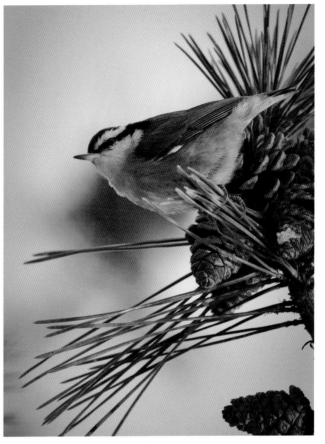

If you see a bird climbing down head first on a tree or branch, it is probably a nuthatch, and if it has a rusty belly, you are looking at a Red-breasted Nuthatch. With a short tail and short upturned bill, the Red-breasted is slightly smaller than the White-breasted Nuthatch, but both are great fun to watch.

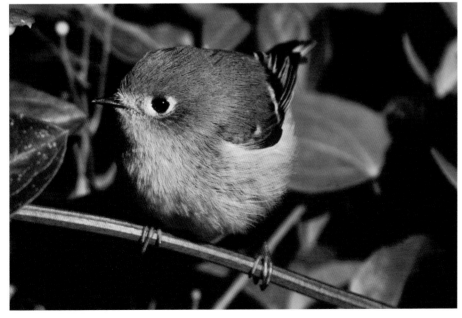

The larger of the two species, the Ruby-crowned Kinglet is amazingly active finding insects, but prefers woodlands and thick brush. These kinglets do not sport any face stripes, and the male keeps his ruby crown hidden unless he is excited.

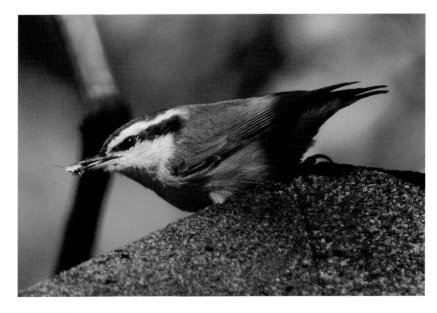

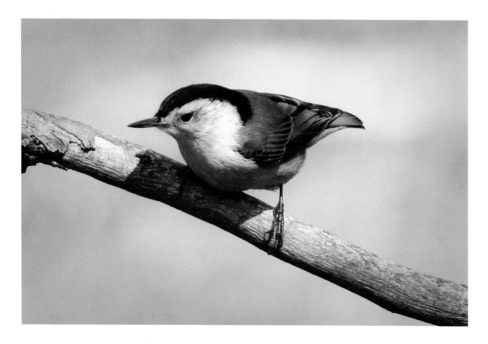

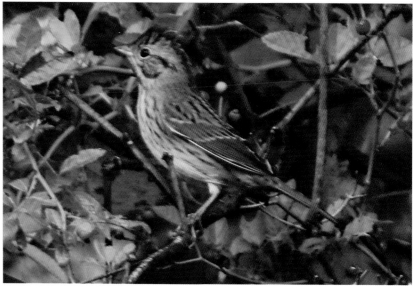

Relatively rare in the state, the Lincoln's Sparrow is a spring and fall migrant who likes bogs and brush. With a buffy breast and thin streaks, the Lincoln's Sparrow will raise a small crest when distressed. They breed up in Canada and winter along the Mexican border.

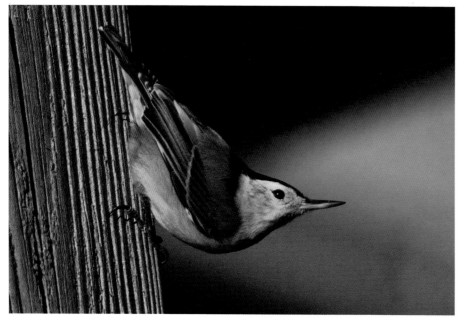

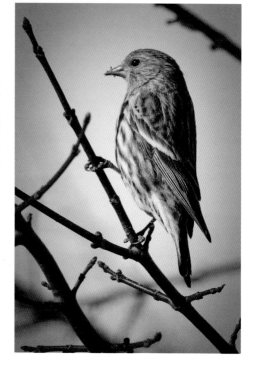

Common to rare, depending on the year, Pine Siskins may be at your feeder and you may think they are Goldfinches. Winter visitors, the Pine Siskin has black and yellow streaking on its wings and a thinner bill than Goldfinches. The 2008-09 winter saw a great influx of siskins, the next year none appeared, then they returned in 2010-11.

Seeing a White-breasted Nuthatch move around a tree is a sight to behold. It can go up and down and all around a tree looking for insects and seeds. The only nuthatch with a completely white face, they have a gray-black back and slightly upturned bill, and they are true acrobats of the avian world.

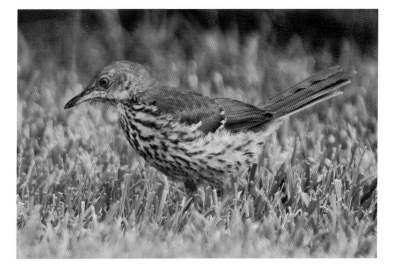

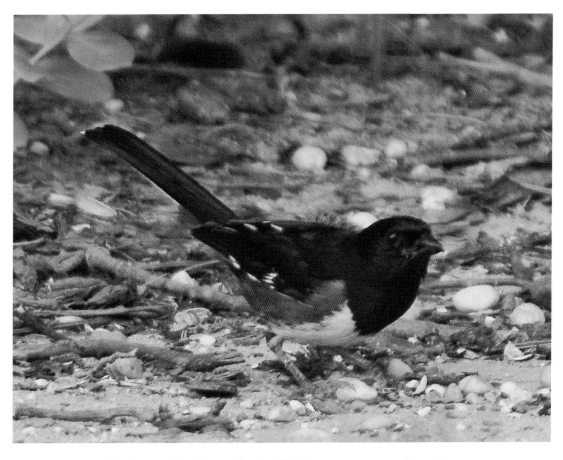

The Rufous-sided Towhee and the Eastern Spotted Towhee were once considered the same species. Now they are separate species. The Eastern Towhee shown here is black-backed with chestnut sides and white belly. This striking bird can be found in dense shrubs and pinelands looking for insects, berries, and seeds. Easily found in the Pine Barrens, its populations are declining elsewhere due to habitat loss.

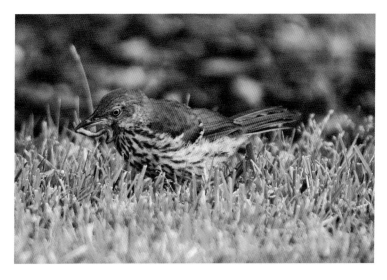

Related to Gray Catbirds and Northern Mockingbirds, the Brown Thrasher can be found hopping along dense brush looking for insects and worms. With reddish-brown on top and dark streaks below, this bird is one of the best songsters in the avian world.

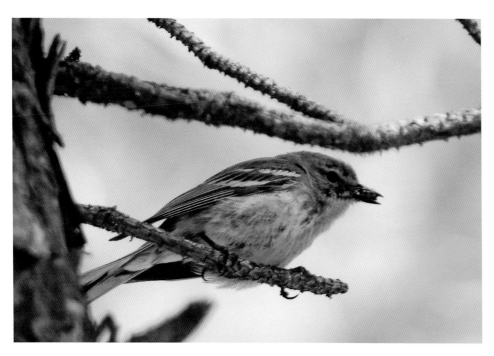

Fairly common during the summer, the Pine Warbler is one of the many warblers that inhabit the Pine Barrens. A long-tailed, stocky bird, the Pine Warbler is olive-greenish above, with yellow streaks on the head and sides. Some hardy birds will spend the winter if there is a good food source.

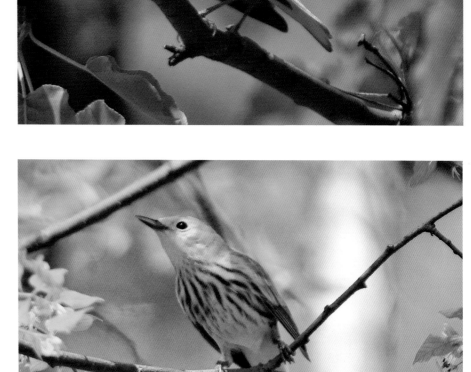

Arriving in New Jersey in the spring from their winter home in Central and South America, the Yellow Warbler is like a whirling dervish looking for insects in the trees. Yellow all over with red chest streaking, this warbler is easy to find but very difficult to photograph.

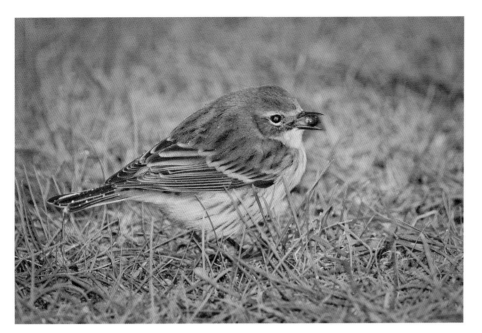

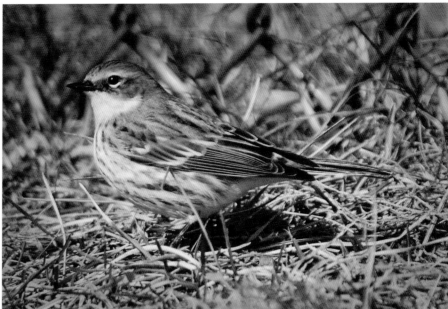

Affectionately called a "butter butt," the Yellow-rumped Warbler is known as the "Myrtle" Warbler in the east. This warbler has yellow patches on the crown and sides, with a distinctive bright yellow rump. Very common along the coast during the winter when their plumage is duller, at various times of the year they can be found from High Point to Cape May.

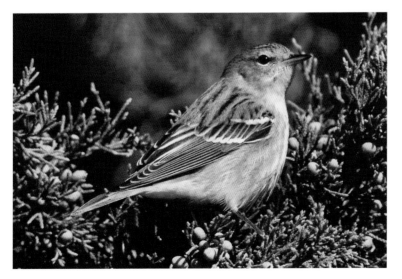

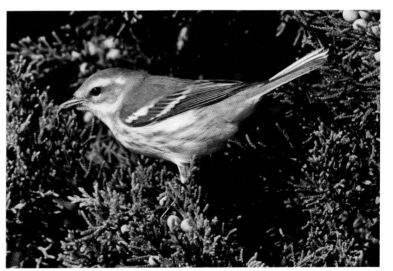

Another of the wood warblers found in New Jersey is the Blackpoll Warbler, seen here in non-breeding plumage. This little four-inch bird will migrate all the way to South America, after nearly doubling its weight with stopover feedings along the East Coast.

This female Black-throated Green Warbler may lack the black throat of the male, but still has the bright yellow face with the olive crown. They are pretty common during spring and fall migrations from northern forests to the Pine Barrens.

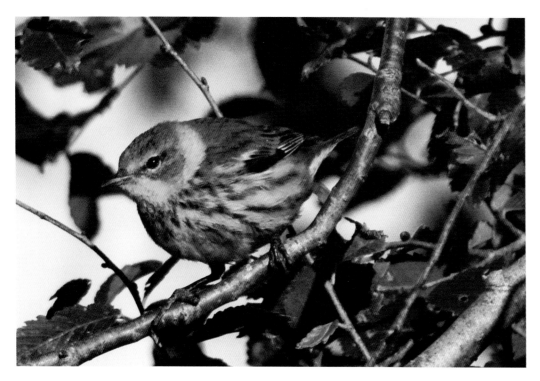

This male Cape May Warbler is still sporting some of his breeding chestnut cheek when found in his namesake town during fall migration. This species was first described by Alexander Wilson in Cape May over 100 years ago.

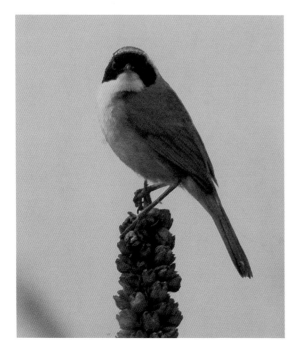

Looking like Zorro with his black mask, the Common Yellowthroat is a warbler commonly found in marshes, shrubs, or swamps around the state. These shy little birds can be found singing their witchy-witchy-witchy-witch call on cattails.

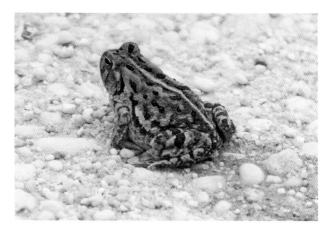

Fowler's Toad.

Ground Skink.

Brendan Byrne
State Forest,
Burlington County.

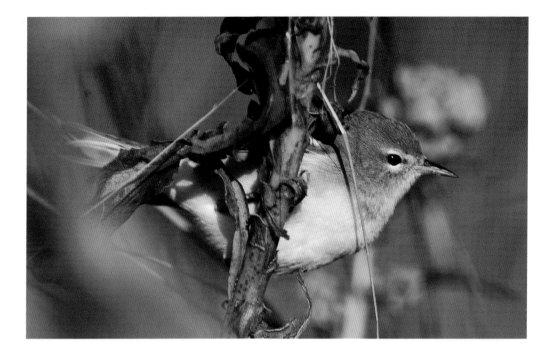

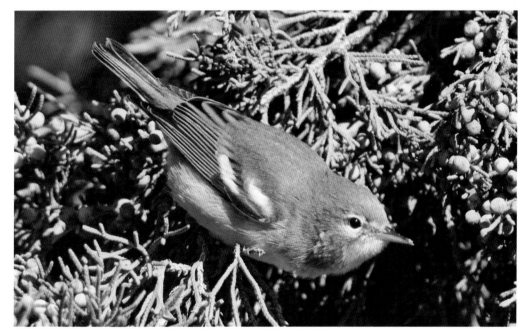

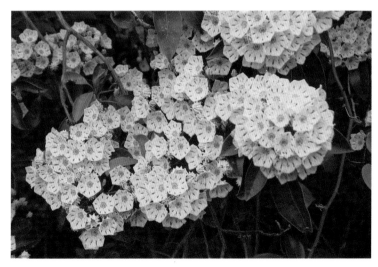

Mountain Laurel.

A migrant through New Jersey, the Northern Parula is one of the smallest wood warblers. This bird has an odd distribution in that it is seen usually in the eastern half of the country and none in the western half. During the fall migration the best place to look for them is the state's coastal area.

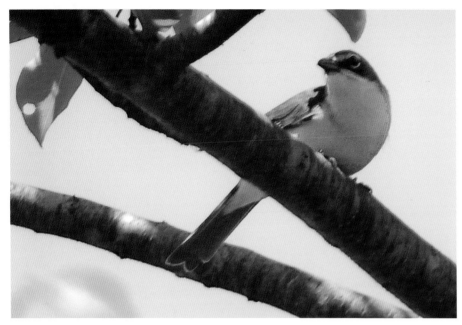

Common but hard to find in the trees of southern Jersey, the Yellow-breasted Chat is another wood warbler and the largest warbler in North America. They are a warmer weather resident in the state, and will migrate south during the winter.

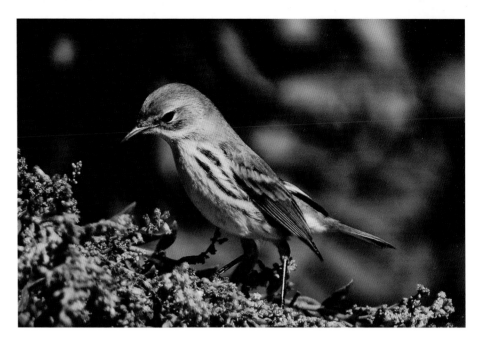

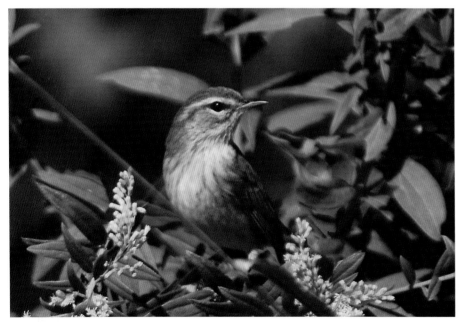

Trying to photograph warblers can drive one crazy. They are fast, small, and at a glance, all look alike. Palm Warblers breed up north in Canada and pass through New Jersey during the spring and fall migrations. The tail wag while feeding is a good identifier for this little visitor.

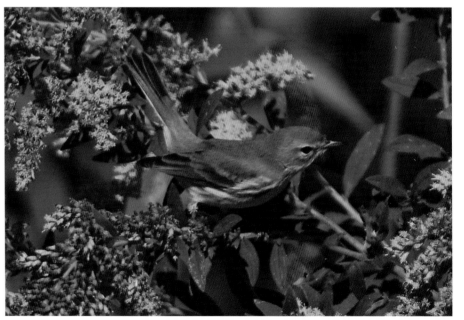

A frequent summer resident in the Pine Barrens and other shrubby habitat around the state, the Prairie Warbler loves to feed on goldenrod seeds during the fall migration. Like the Palm Warbler, the Prairie also tail wags while feeding; however, he has black streaks along the neck and body that help identify this species.

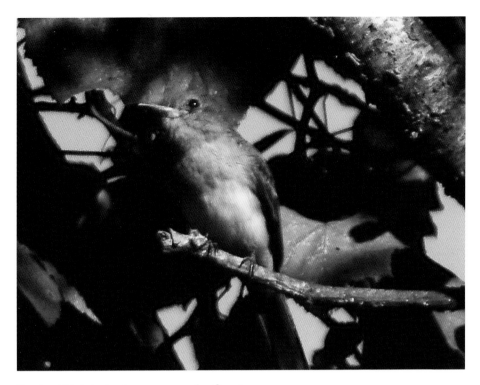

Perched high in the tree canopy, the Great-crested Flycatcher can be seen flitting back and forth feeding on insects. Fairly common throughout our woodlands and Pine Barrens, its loud call from the tree tops will help to locate and identify this attractive flycatcher.

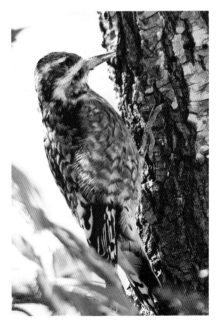

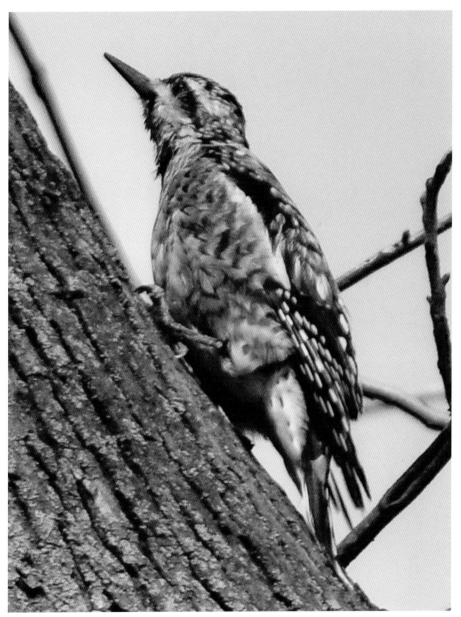

The Yellow-bellied Sapsucker blends in so well with the tree bark that it may be easier to hear tapping on a tree than to see the tapper, especially the juvenile that doesn't sport the red crown. These are the only migratory woodpeckers in eastern North America. Look for trees ringed with holes that they make in order to get sap and insects.

Rose Pogonia Orchid.

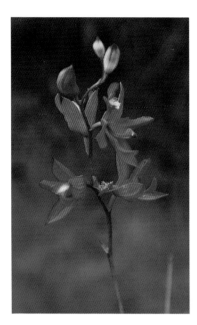

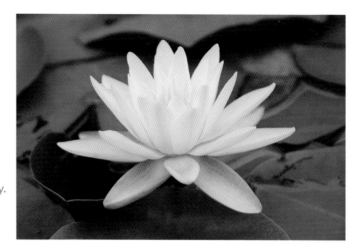

Fragrant Pink Water Lily.

Pine Barrens in Winter.

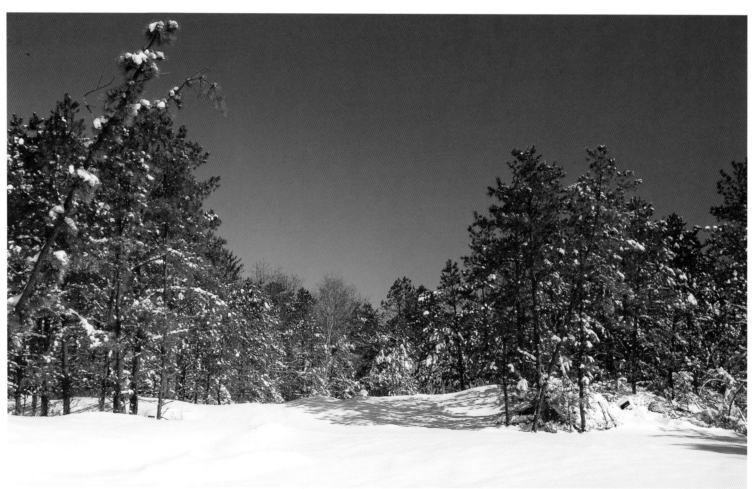

Cranberry bogs, Burlington County.

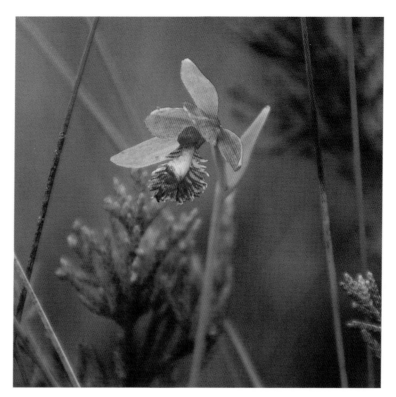

Grass Pink Orchid.

Orange Milkwort.

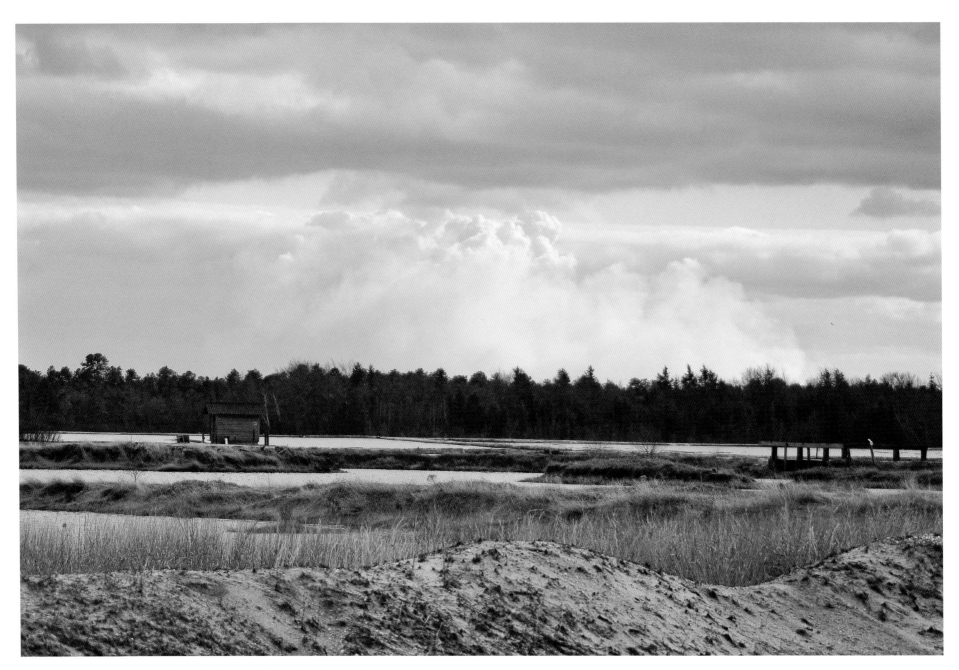

Controlled forest fire; view from Whitesbog Village, Burlington County.

Leopard Frog.

Sundew.

Green Frog.

You may think that all the cuckoos live in Trenton or Washington, but the Yellow-billed Cuckoo lives in dense woods and bush where they feed on caterpillars. Related to the Roadrunner, the Cuckoo has a downward curved bill, yellow below, gray above, and a distinctive long tail with large white spots. Hard to find in the dense tree cover, when located, it is a birder's delight.

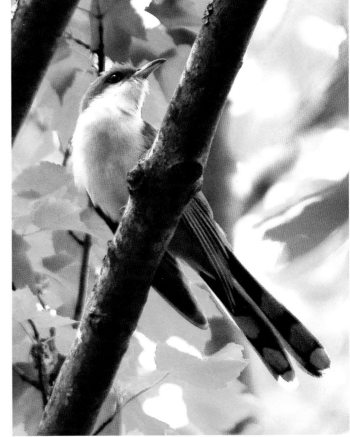

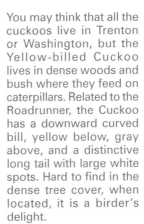

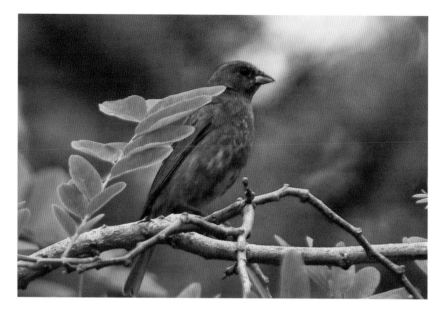

Sporting deep blue plumage, the Indigo Bunting is one beautiful bird. Preferring brushy woodland edges, they feed on small insects, berries, and seeds. These buntings are summer residents and breeders in New Jersey, migrating in the winter to Central America. The male in this photograph is a first year juvenile.

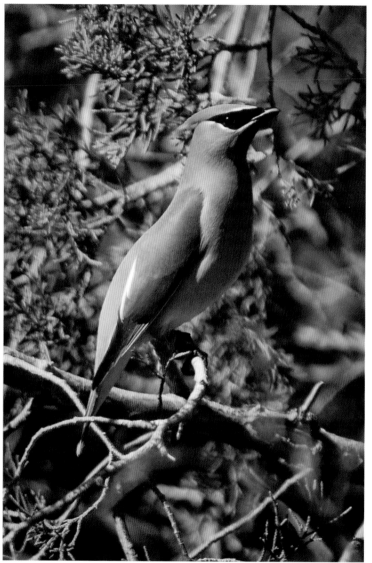

The only waxwing found in the East, the Cedar Waxwing is a sleek, subtly beautiful bird. With a pale brown and yellow body, a black mask, a red spot on the wings (which is actually wax), and yellow tipped tail feathers, the waxwing can be found eating its preferred food, Red Cedar berries.

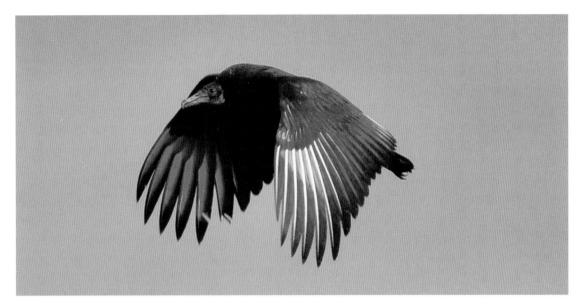

The Turkey Vulture, with its bumpy red head, will never be called attractive, but it fills a necessary niche feeding on carrion. Late morning, early afternoon they can be seen taking advantage of the thermals as they rise on the currents. Once aloft, they soar through the sky, their wings, which span 5.5 feet, tipping ever so slightly into a "V" shape, all the while scanning the landscape for a meal. They are one of only a few birds that find food using scent.

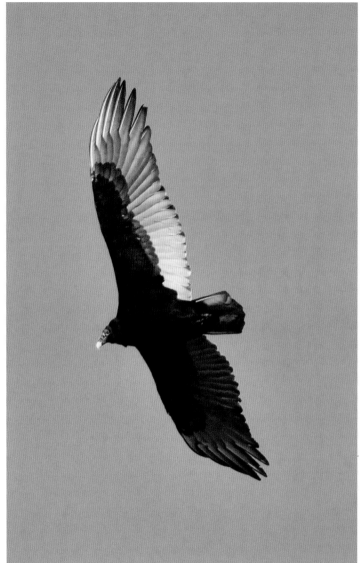

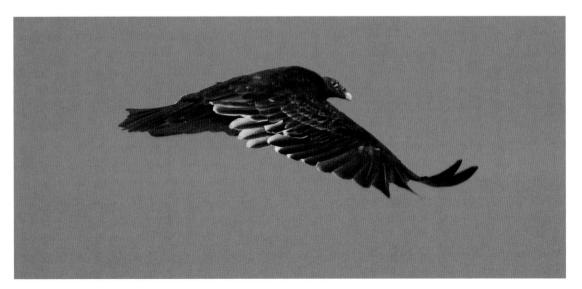

New Jersey being the northern most point of the Black Vulture range, this black-headed scavenger is not as common as the Turkey Vulture but is considered a resident of the state. Soaring through the sky, it can be distinguished from its cousin by its flatter wing span along with the white primary feathers that can be seen at the end of the wings. Unlike the Turkey Vulture, this bird hunts by sight. (Left and next page)

Bibliography

Boyle Jr., William J. *A Guide to Bird Finding in New Jersey*. New Brunswick, New Jersey. Rutgers University Press, 2008.

Crossley, Richard. *The Crossley Guide Eastern Birds*, Princeton, New Jersey. Princeton University Press, 2010.

National Geographic Field Guide to the Birds of North America—Fourth Edition. Washington, D.C. National Geographic. 1994

Peterson, Roger Tory. *A Field Guide to the Birds East of the Rockies—Fourth Edition*. Boston, Massachusetts. Houghton Mifflin Company, 1980.

Sibley, David Allen. *The Sibley Guide to Birds*. New York, New York. Alfred A. Knopf, Inc., 2006.

Index